THE FRENCH KINGS

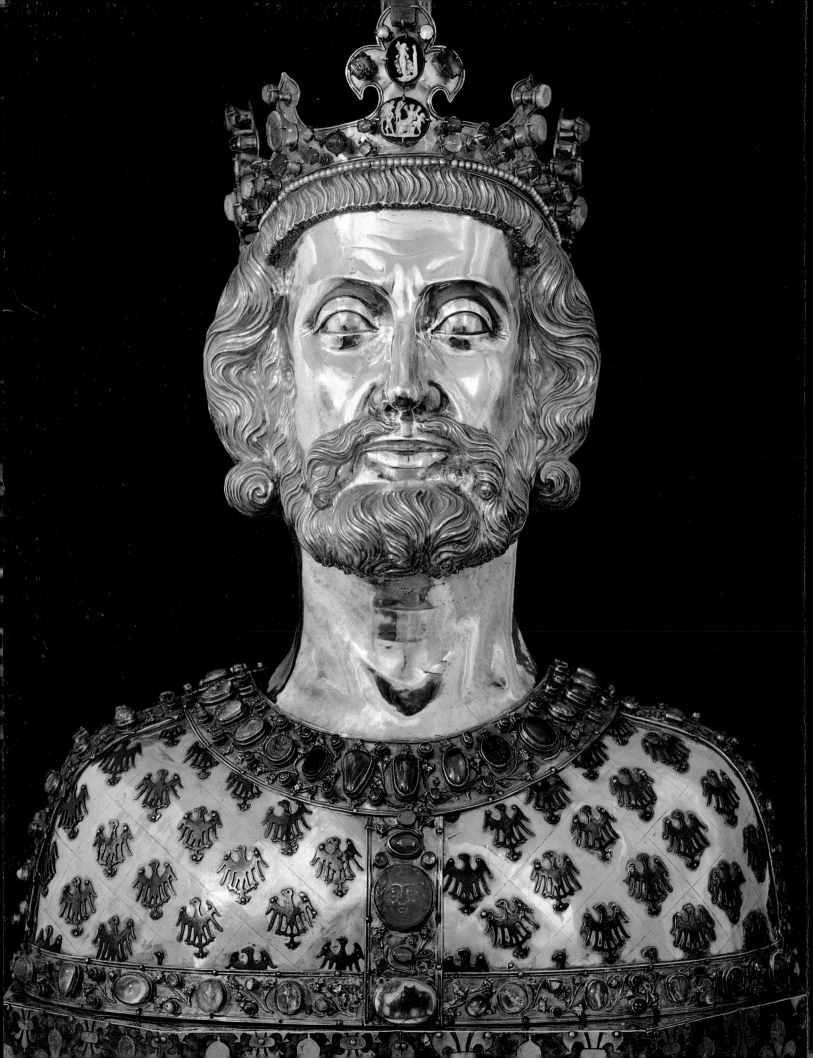

TREASURES OF THE WORLD

THE
FRENCH KINGS

by

Frederic V. Grunfeld

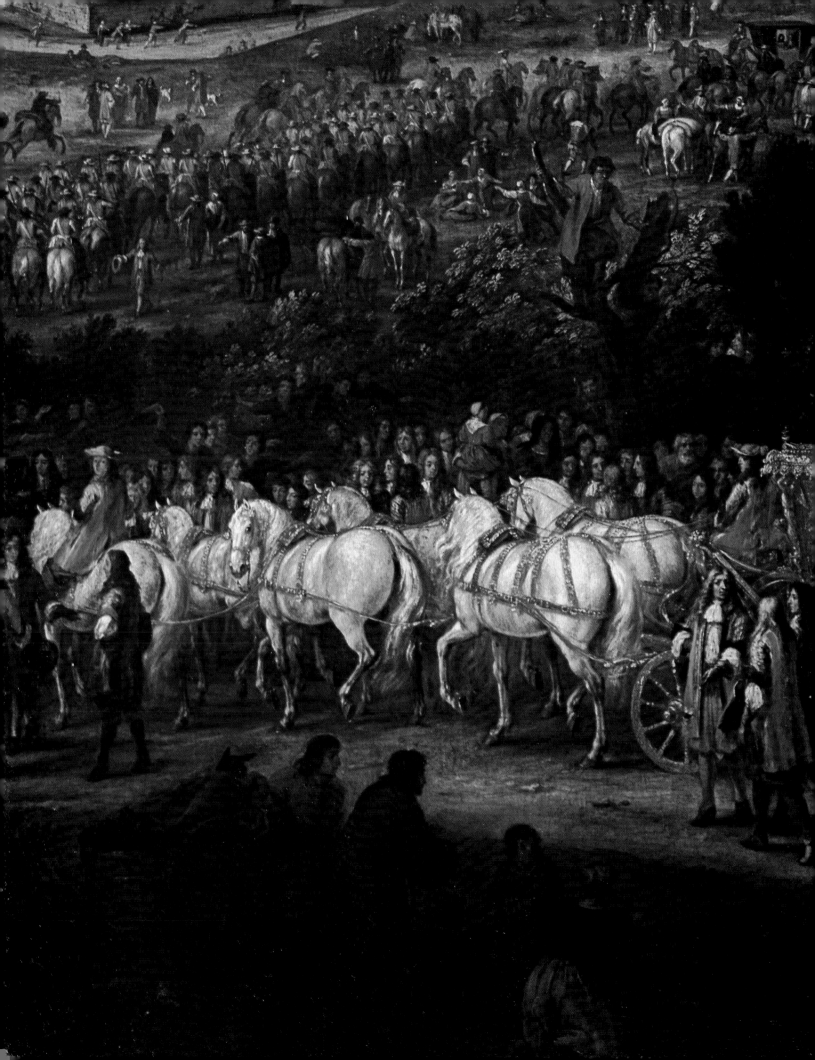

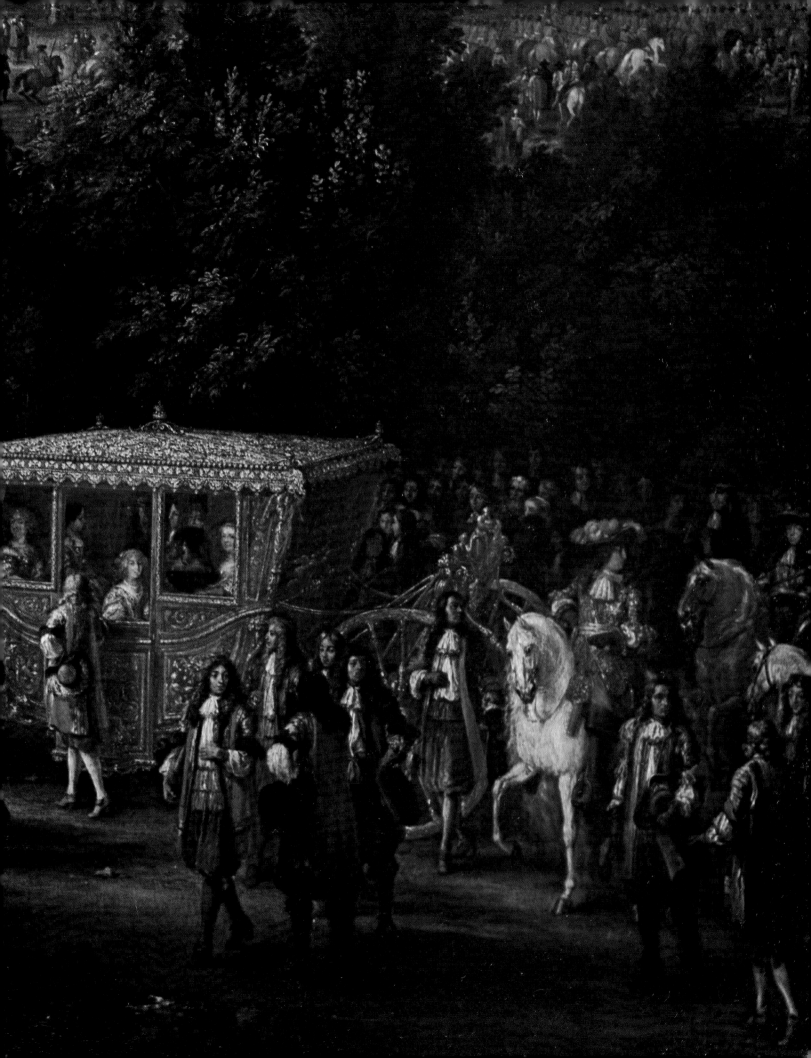

Treasures of the World was created and
produced by
TREE COMMUNICATIONS, INC.

PRESIDENT
Rodney Friedman
PUBLISHER
Bruce Michel
VICE PRESIDENTS
Ronald Gross
Paul Levin

EDITOR
Charles L. Mee, Jr.
EXECUTIVE EDITOR
Shirley Tomkievicz
ART DIRECTOR
Sara Burris
PICTURE EDITOR
Mary Zuazua Jenkins
ASSOCIATE EDITORS
Thomas Dickey Vance Muse Henry Wiencek
ASSISTANT ART DIRECTOR
Carole Muller
ASSISTANT PICTURE EDITORS
Carol Gaskin Charlie Holland
Deborah Bull
COPY EDITOR
Fredrica A. Harvey
ASSISTANT COPY EDITOR
Michael Goldman
PRODUCTION ASSISTANT
Eric Goldin
EDITORIAL ASSISTANTS
Martha J. Brown Carol Epstein
Holly McLennon Wheelwright
FOREIGN RESEARCHERS
Rosemary Burgis (London) Sandra Diaz (Mexico City)
Eiko Fukuda (Tokyo) Bianca Spantigati Gabbrielli (Rome)
Mirka Gondicas (Athens) Alice Jugie (Paris)
Traudl Lessing (Vienna) Dee Pattee (Munich)
Brigitte Rückriegel (Bonn) Simonetta Toraldo (Rome)
CONSULTING EDITORS
Joseph J. Thorndike, Jr.
Dr. Ulrich Hiesinger

The series is published under the supervision of
STONEHENGE PRESS INC.

PUBLISHER
John Canova
EDITOR
Ezra Bowen
DEPUTY EDITOR
Carolyn Tasker

THE AUTHOR: Frederic V. Grunfeld's best known work is *Prophets Without Honor*, a
background to Sigmund Freud, Albert Einstein, Franz Kafka, and their world. He
is also the author of many articles for *Horizon* on the music, history, and art of
France and Spain.

CONSULTANT FOR THIS BOOK: Edgar Munhall is curator of The Frick Collection in
New York City and an authority on eighteenth-century French art.

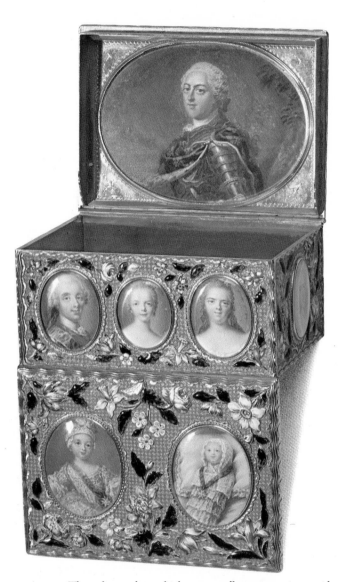

COVER: *The salamander, which supposedly can survive amid
flames, was the royal emblem of François I. This one, writhing
beneath the French crown, is part of the decor above a doorway
in the king's château at Blois in the valley of the Loire.*

TITLE PAGE: *This fourteenth-century bust of Charlemagne is a
reliquary of silver, gold, and precious stones. It holds part of the
skull of the ruler of the medieval Frankish empire.*

OVERLEAF: *Riding a white horse behind the queen's carriage,
Louis XIV accompanies his armies to Flanders in 1667. There
he observed his troops—at a safe distance from the fray.*

ABOVE: *Portraits of Louis XV (at top) and the royal family
adorn this gold snuffbox, three inches long, decorated with
enamel flowers. Such boxes, double-hinged to open from either
side, were the rage in eighteenth-century France.*

CONTENTS

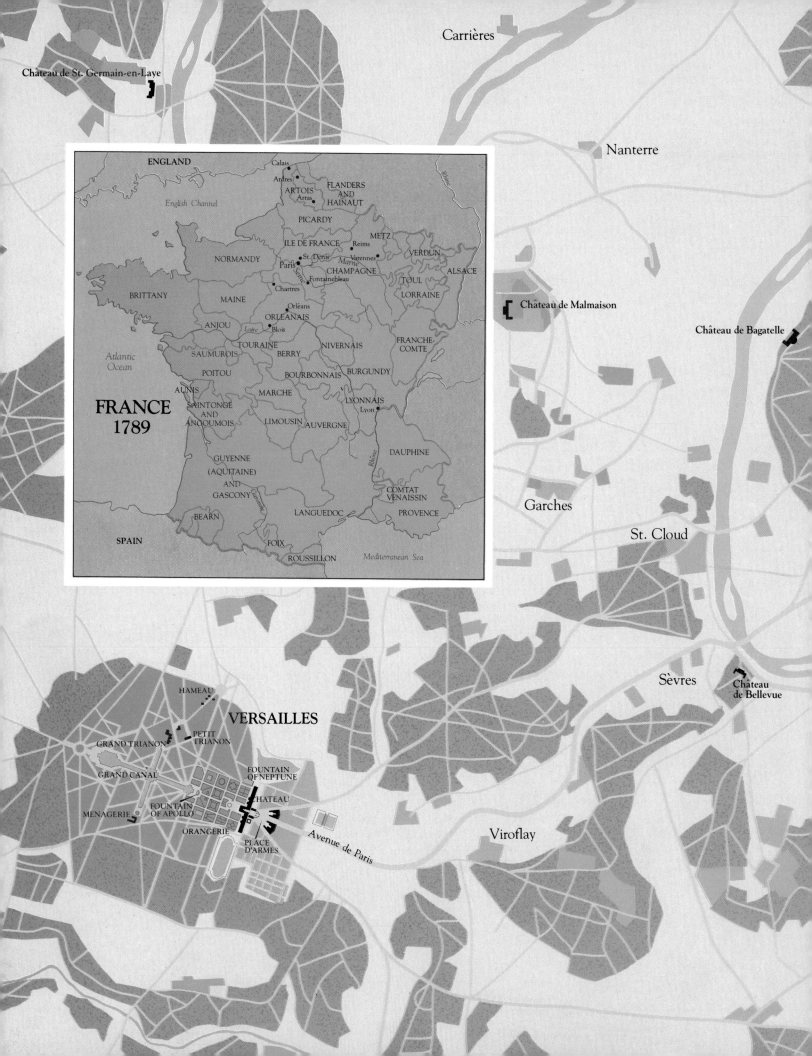

Carrières

Château de St. Germain-en-Laye

Nanterre

ENGLAND

English Channel

Calais
Ardres •
FLANDERS
AND
HAINAUT
ARTOIS
Arras •

PICARDY

METZ
ILE DE FRANCE
Reims •
VERDUN
St. Denis •
Marne
Varennes •
ALSACE
NORMANDY
Paris •
CHAMPAGNE
Seine
TOUL
Fontainebleau •
LORRAINE
Chartres •

BRITTANY

MAINE
Orléans •
FRANCHE-
COMTE
ORLEANAIS
ANJOU
Loire
Blois •
TOURAINE
NIVERNAIS
*Atlantic
Ocean*
SAUMUROIS
BERRY
POITOU
BOURBONNAIS
BURGUNDY
AUNIS
MARCHE
SAINTONGE
AND
ANGOUMOIS
LIMOUSIN
AUVERGNE
LYONNAIS
Lyon •

**FRANCE
1789**

GUYENNE
(AQUITAINE)
AND
GASCONY
Rhône
DAUPHINE

BEARN
Garonne
COMTAT
VENAISSIN
LANGUEDOC
PROVENCE

SPAIN
FOIX
ROUSSILLON
Mediterranean Sea

Château de Malmaison

Château de Bagatelle

Garches

St. Cloud

Sèvres
Château
de Bellevue

HAMEAU

VERSAILLES

GRAND TRIANON
PETIT
TRIANON

GRAND CANAL
FOUNTAIN
OF NEPTUNE

CHATEAU

MENAGERIE
FOUNTAIN
OF APOLLO

ORANGERIE
PLACE
D'ARMES

Viroflay

Avenue de Paris

ROYAL LANDMARKS 1789

Clichy

Montmartre

To St. Denis

Belleville

FAUBOURG ST. HONORE

BOIS DE BOULOGNE

HOTEL D'EVREUX

CHAMPS ELYSEES

PLACE DE LOUIS XV

PALAIS DES TUILERIES

PALAIS ROYAL

LOUVRE

Charonne

HOTEL ROYAL DES INVALIDES

PALAIS DE JUSTICE

HOTEL DE VILLE

ROYAL MILITARY SCHOOL

NOTRE DAME

BASTILLE

FAUBOURG ST. ANTOINE

SEINE

JARDINS DU LUXEMBOURG

Vincennes

PARIS

VILLA DES GOBELINS

BOIS DE VINCENNES

Vanves

Gentilly

MARNE

Meudon

Vitry

On the eve of the Revolution, the seat of the doomed monarchy was still Versailles, remote and enormous. But Paris, with over 800,000 people, dominated France. Royal landmarks, châteaux, and parks appear on the large map. The inset map shows the old provinces of France and her main towns.

To Fontainebleau

To Vaux-le-Vicomte

Sceaux

I

CHARLEMAGNE

THE ROYAL ROAD TO SPLENDOR

Before France existed there was a king of France. He was not, strictly speaking, a French king. He spoke no French, for in 742, when he was born, the language did not yet exist. A brilliant king and art patron, he never learned to read or write. He was a Frank—that is to say a German—rather than a Frenchman, and historians east of the Rhine still revere him as Karl der Grosse. But the French remember him as Charlemagne. He was to become more powerful as a legend than he had been as a man. He performed the same service for his countrymen that the legendary King Arthur performed for the British: he somehow made himself the source of a lasting sense of nationhood. His treasures, his relics, and the stories of his exploits have become the heart of France.

In the beginning the nation now known as France was a jigsaw puzzle of smaller states, the boundaries of which were largely determined by the courses of rivers and the contours of mountain ranges. Julius Caesar, who conquered ancient Gaul for the Roman Empire between 58 and 51 B.C., mentions its principal divisions in the first

Charlemagne, enthroned in the detail opposite from a fourteenth-century scepter, ruled an empire extending from the North Sea to the Mediterranean.

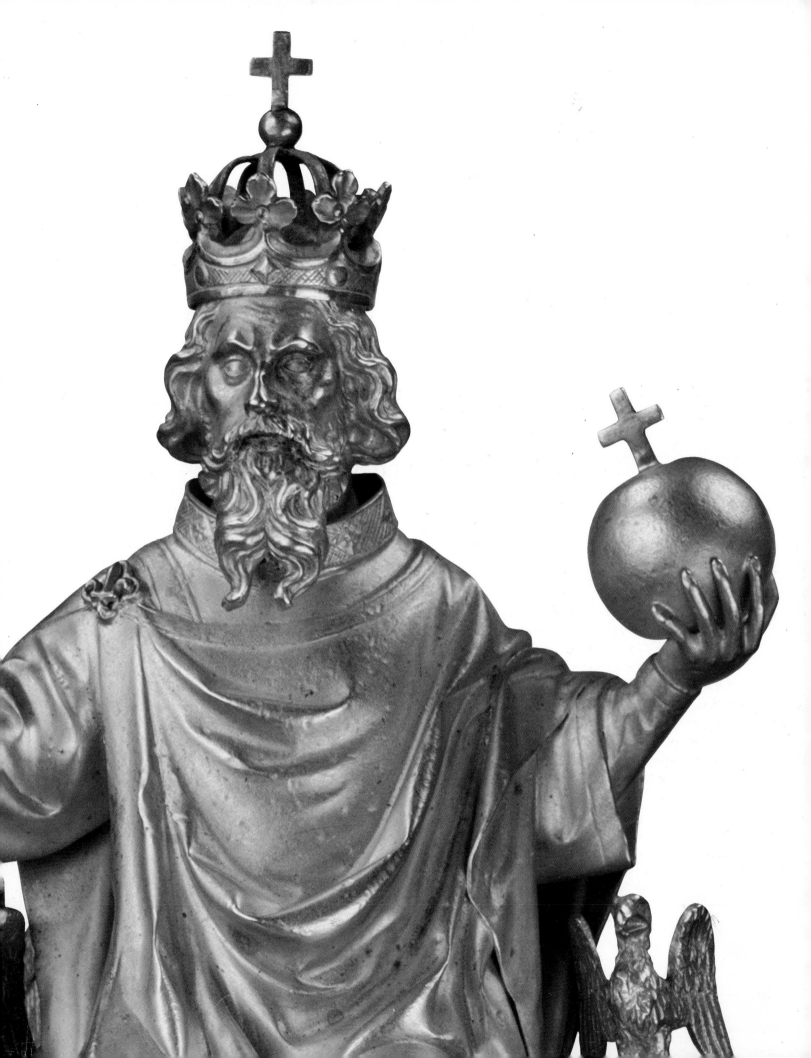

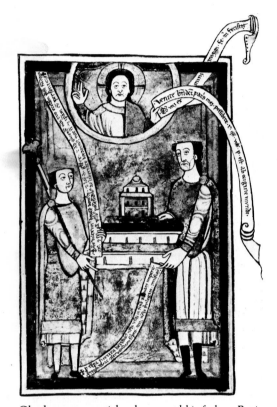

Charlemagne, at right above, and his father, Pepin the Short, pledge their support to a Rhineland abbey as God blesses the benefactors from above. This scene is from a thirteenth-century manuscript made by monastic scribes and artists.

sentence of his *Commentaries on the Gallic War*, the famous opening line with which every schoolchild used to begin the study of Latin. *Gallia omnia est divisa in partes tres*. . . . "All Gaul is divided into three parts," namely the land of the Aquitani, south of the Garonne; that of the Celts, or Veneti, which extended from Brittany east to the Seine and Marne; and the land of the Belgae, stretching from the Seine to the Rhine.

In Caesar's day these regions were, in fact, inhabited by a great diversity of warlike tribes, but five centuries of Roman rule transformed these people into peaceable citizens of four of the most prosperous provinces of the Empire. Lugdunum (Lyon) served as the political and intellectual captial of Roman Gaul; it was the center of a network of roads and bridges that facilitated a flourishing trade between north and south.

There has always been a palpable dividing line between the upper and nether halves of France. The north is rich in fertile farmland and has abundant rainfall; the south—*le Midi*—is dry and rocky, with more sun than rain. Between them lies the forbidding Massif Central, the mountainous region of the Auvergne, which has always separated the butter eaters from those who cook with olive oil. In early times the Rhône furnished the only comfortable route from north to south, hence the importance of Lyon and of the fortifications that controlled movement along the river and its banks.

When the Empire became too feeble to defend its frontiers, a succession of Germanic tribes overran the Gallic provinces. Two of them—the Vandals and Visigoths—subsequently moved farther south into Spain and even into North Africa. Others, notably the Burgundian and Frankish tribes, established permanent settlements and took over what remained of Roman administration.

The first kings of the Franks—the Merovingians, who wore their hair to their shoulders as a sign that they were descended from a god—converted to Christianity and allied themselves with the last of the Roman emperors. Eventually they extended their authority to all of northern France. But Charlemagne, whose father had in 751 deposed the last of the Merovingians, became the first monarch to

rule over the whole of what now appears on the map as France (except Brittany, the westernmost province and irreducible bastion of the Celts).

At age twenty-six, in the year 768, Charlemagne was crowned king of the Franks (or of most of the Franks), not at Paris but in the tiny northern town of Noyon, the center of his modest domain. He took this kingdom and, by conquest as well as by persuasion, acquired all of France as well as large portions of what are now Germany, Switzerland, and Italy. The culmination of his power came on Christmas in 800 at the altar of St. Peter's in Rome, when Pope Leo III anointed Charlemagne as Holy Roman Emperor, the ruler, in effect, of a united states of Europe.

Charlemagne cut an imposing figure: he was a natural leader who commanded the absolute loyalty of his followers. "Big and robust in frame," according to one of his scribes, "he was tall, but not excessively so, measuring about seven of his own feet in height. His eyes were large and lustrous, his nose rather long and his countenance cheerful." Unlike some of his successors, he was neither neurasthenic nor overbearing. He loved hunting and swimming and enjoyed playing with the children of his wives (he had five, sequentially) and concubines—a family man, after the polygamous Frankish fashion. Despite the fact that he never learned to write, he was a great patron and admirer of scholarship and the arts. He had the customary laws of the German tribes committed to writing—but he superseded them with numerous laws of his own.

Charlemagne was not so much a great warrior as a strategist, organizer, and logistician. His armies were well provided for and equipped; he saw to it that there was effective civil administration to support his campaigns. The iron stirrup, which had come to Europe from Asia during the eighth century, was introduced by Charlemagne in his armies, thereby effecting a revolution in warfare that was to have far-reaching consequences for the structure of European society. Horsemen with stirrups, seated firmly in the saddle, developed techniques of shock combat that nullified the old method of fighting on foot from behind a wall of shields.

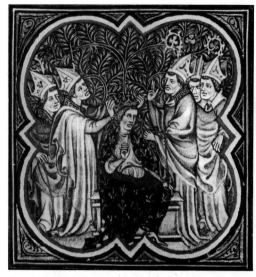

Roman bishops flank Charlemagne at his coronation in A.D. 768 in this detail of a manuscript made some six centuries later. He wears a robe embroidered with fleurs-de-lis, a royal emblem since the fourteenth century. Thus the miniaturist linked later French kings to their great predecessor.

Charlemagne's horsemen were equipped with the first real cavalry swords and spears; for a time the cavalry became king of the battles. But horses and fodder, as well as arms and armor, were far too costly for the sturdy plowmen who made up the Frankish militia. The fighting man on horseback had to become a professional soldier, a knight with special duties and prerogatives. Thus the stirrup and all it implied led inevitably to the age of *chevalerie*, a word that originally meant merely horsemen equipped for battle and gradually came to denote the knightly skill and the ideals of honor and courtesy that were expected from the man in the saddle.

In the course of his forty-six-year reign, Charlemagne amassed an enormous amount of treasure, for although the Franks were newcomers to classical civilization they were quick to appreciate its worth. They prized fine jewelry and patronized the goldsmiths who carried on the great tradition of Greek craftsmanship, which had been transplanted to the Roman west during the halcyon days of the Empire. Like their Roman predecessors, the Carolingians—so called from the Latin form of Charles, Carolus—proclaimed their wealth and power through glittering works of art that also embodied the most complex technologies of the day: iron buckles damascened with gold and silver; enameled caskets studded with cameos and jewels; psalters in silver filigree covers, ornamented with carved ivory and precious stones.

Scores of surviving Carolingian treasures furnish eloquent testimony as to the skills and attitudes of that distant epoch. Most of them are objects intended for church use—reliquaries, crucifixes, coffers, crosiers, chalices, book covers—and fortunately many found their way into the vaults of the oldest abbeys and cathedrals of France, at Saint-Denis, Reims, Saint-Riquier, Luxeuil, and Auxerre. The predominance of religious pieces attests to the church's importance in medieval life. But it may also be attributable to the fact that sacred objects were better preserved in their monastery cellars than secular treasures exposed to pillage and destruction in the castles from which the incessant wars were waged. In any case little or nothing remains that may actually have belonged to

A SONG OF HEROES

In 778 Charlemagne, ever protective of his Christian subjects, mustered an enormous cavalry to invade northern Spain, where Arabs had established a powerful caliphate, the western outpost of the Muslim world. The mission, led by Roland, Charlemagne's most trusted count, emerged as one of the great legends of the Middle Ages, inspiring "The Song of Roland," a glorious eleventh-century poem. The song in turn gave rise to other works of art, including the Charlemagne window (in detail at right) in Chartres cathedral. The epic of Roland that so stirred the Franks became in time the national epic of the French.

The poem, which many poets composed, takes what was actually a minor skirmish and turns it into a holy, hero-making crusade. Not written down until over two hundred years after the event it describes, the poem casts Charlemagne as superman and saint, and Roland as his headstrong but virtuous servant.

After celebrating the Franks' initial attack on the Muslims, the poem then describes how Charlemagne dispatched a vassal named Ganelon to negotiate their surrender. But the emperor's choice of emissary was fatal, for Ganelon was jealous of Roland's favored position with Charlemagne and deceived both the Franks and Muslims in a plot to murder his rival. Believing that Ganelon had made peace, the Franks goaded their horses home across the Pyrenees. Roland, with his sword and ivory horn, brought up the rear. Suddenly, the poem relates, thousands of "Muslim warriors" (they were, in fact, mountain-dwelling Basques) descended upon the last of the retreating Franks:

The battle raged full wild and wondrously,
In wrath the Franks fought on. They thrust

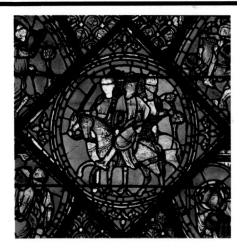

Charlemagne, accompanied by Roland and an archbishop, sets off to destroy Muslim strongholds in Spain. The sections of stained glass above and at right are from the grand windows in the twelfth-century cathedral of Chartres that illustrate the emperor's life and the story of Christianity.

Roland, pictured twice in the stained glass at right, stands above his slain comrades. After striking his sword on a rock to render it useless, he sounds his horn to call back the Frankish troops. The hand of archangel Gabriel, above the haloed portraits of Roland, guides the hero to heaven.

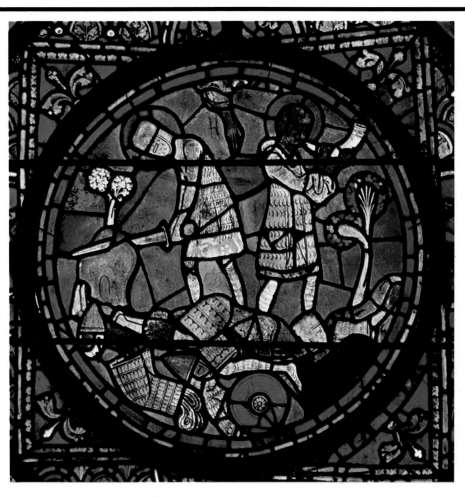

and hewed,
And found, beneath the glittering coats of
 mail,
The flesh and bone. And the red blood ran
 down. . . .

Though the Basques quickly decimated his troops, Roland would not call for help. He sounded his horn only after he was mortally wounded:

And Roland, with a wild and fearful blast
Winded his horn, so that his temples brake,
And from his mouth leapt the bright blood. . . .
And the king cried: "It is the horn of Roland!"

As Charlemagne and his men rushed back, Roland collapsed:

*Under a lofty pine he lay. . . and called to
 memory many things—*

*The lands that he had conquered, and sweet
 France,
His kindred, and Great Charles, who
 cherished him
As his own son. . . .*

Back home the grieving Charlemagne tried Ganelon for treason and ordered his executioners to dismember the man whose hands were stained with the blood of Roland.

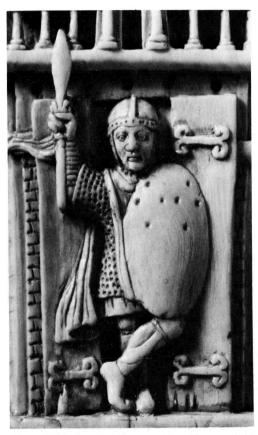

On guard before a doorway, this soldier, with his spear, armored tunic, helmet, and large shield, is typical of his time. The detail is from a tenth- or eleventh-century ivory vessel for holy water, carved at a monastery workshop.

Charlemagne's court. He had no stationary capital and no main palace. The court moved from place to place, as it had under Charlemagne's predecessors. The one architectural monument he left was the exquisite octagonal chapel and palace at Aix-la-Chapelle (or Aachen: the town is now in Germany). Inside it are his throne and his tomb.

Yet more important than any physical relics were the legends he left behind and the guiding principle of a France united under a single monarch, a political legacy that was to have an enduring effect on French history for over a thousand years. The greatest of his literary legacies is "The Song of Roland," the favorite chanson de geste—the phrase means "song of deeds"—of the Middle Ages. Roland is the valiant fighter who heads Charlemagne's rear guard on his return from an expedition against the Saracens in Spain. At the pass of Roncevaux, in the high Pyrenees, he and his men are set upon by a vast army, but he refuses to sound the horn that will summon Charlemagne to his aid. At the end of the battle only the mortally wounded Roland is left alive; with his last strength he blows the horn once more and hears the approaching sound of Charlemagne's avenging battle cry, *"Montjoie!"* It has been said that the sound of Roland's horn, at once commanding and melancholy, echoes down the whole of French history.

Charlemagne died in 814, aged seventy-one—a long life span for that epoch. Under his heirs his empire rapidly disintegrated into its major components: Lorraine, Aquitaine, Burgundy, Flanders—the old geographical divisions reasserted themselves. Later they were fragmented still further into feudal countships. The Franks lacked the organization to keep their state intact. They were warriors and agriculturists, indifferent to trade and impatient with life in the towns. They allowed the Roman roads to fall into disrepair, the bridges to collapse. Trade languished, and life in France reverted to the primitive life-style of the peasant villages before Roman times.

While rival claimants fought for the throne, the Vikings raided the northern coast, and Muslim armies sacked the cities of the Midi. No peasant could plow his land in expectation of being able to

harvest his crops in peace unless he lived in the shelter of a donjon keep or enjoyed the protection of an overlord in command of armed men to defend the villages against marauders. In the interests of security, the whole of society formed itself into a military hierarchy: the feudal system. The knights and barons, in their fortified manors and hilltop castles, were obliged to provide armed service to their count; the counts, in turn, were vassals of their duke. Local nobles asserted their independence against distant rulers who were unable to compel obedience, and petty warfare became endemic. The belligerent barons considered it a sort of sport, more challenging and profitable than boar hunting.

The troubadour poets of a later century sang the praises of the "joyful season" of armed conflict. "I love to see the press of shields," wrote the composer-knight Bertran de Born, "and the sight of shattered lances, pierced shields, shining helmets split and blows exchanged in battle." The comte de Foix, who ruled his redoubt in the Pyrenees as a quasi-independent state, wrote a sardonic spring song that sums up the spirit of regionalism that prevailed throughout the Middle Ages. The modern American poet Ezra Pound wrote a translation of it—the original is in Provençal—in one of his literary rambles through the poetry of twelfth-century France:

> Let no man lounge amid the flowers
> Without a stout club of some kind.
> Know ye the French are stiff in stour
> And sing not all they have in mind,
> So trust ye not in Carcason,
> In Genovese, nor in Gascon.

There were still kings of France, at least in name successors to the throne of Charlemagne, and the great dukes and counts—of Normandy, Brittany, Aquitaine, Gascony, and Toulouse—were nominally their vassals. But the royal domain of the French kings shrank to a diminutive piece of territory, the landlocked Ile de France, which embraced only Senlis, Paris, and Orléans. The Carolingian

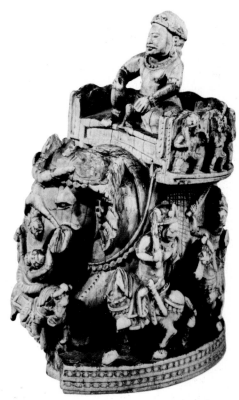

The ivory chess piece above, sculpted as an elephant in a caravan, probably commemorates the friendship of Charlemagne and Harun al-Rashid, the grand caliph of Baghdad. The caliph sent Charlemagne a live elephant, the first one the emperor had ever seen. It delighted him and cemented goodwill between the two empires.

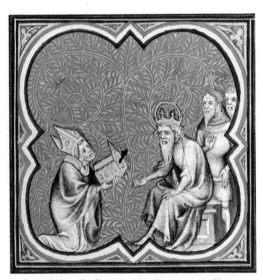

A bishop kneels before Charlemagne, offering a model of a church to the man whose patronage may have built the edifice. This emblem of the emperor's devotion to the Church and the one opposite are from the fourteenth-century French royal history, Grandes Chroniques de France.

line died out, and in 987 the powerbrokers of the day, those great dukes and counts of the provinces, elected one Hugues Capet as ruler of the diminished kingdom. The king's principal vassals controlled regions that were far wealthier and more extensive. Yet the Ile de France dominated the main rivers and trade routes of the north, and thanks to the strategic importance of Paris it served a succession of Capetians as a base for the reunification of France. The dynasty lasted, in fact, for as long as France had kings, though as the centuries passed the family tree of Capet produced its Valois and then its Bourbon branches.

For the five hundred years after Capetian rule began, the central theme of French history was the extension and consolidation of the royal domains. William, duke of Normandy, conquered England in 1066, and thereafter his descendants claimed half of France as their hereditary domain. But early in the thirteenth century, Philip Augustus (Philip II) broke the power of his rivals in England and seized Normandy, Anjou, Maine, Touraine, and the Auvergne. His son and grandson, Louis VIII and Louis IX, added most of Languedoc and Poitou. Philip the Fair (Philip IV) kept up the momentum by acquiring the city of Lyon and the duchy of Champagne. The Hundred Years' War, though it included an early, crushing French defeat at Crécy in 1346, gradually brought an end to the English kings' sovereignty over Gascony and Aquitaine. Calais was the one remaining English possession in France.

In 1453 the war petered out; it left France exhausted and depopulated but more firmly united than ever under the centralized government of the House of Valois, the younger branch of the Capetians. At the end of the fifteenth century, Louis XI acquired the duchy and countship of Burgundy (though the adjoining province of Franche-Comté, with the city of Besançon, was to remain Hapsburg territory for another two hundred years). At about the same time the duchy of Brittany came to the French crown, by marriage. Calais fell to the French in 1558.

There were to be still further acquisitions as the result of subsequent wars and treaties; indeed, it was not until the incorporation of

Nice, in 1860, that continental France received its precise present form. But by the year 1500, in the reign of Louis XII, the basic shape of France was virtually complete, and it became the first of the modern nation-states. Henceforth its rulers, from their seats of power in and around Paris, would be able to lavish enormous resources on the beautification of their palaces and châteaux. By the time Louis XIV completed his dream palace of Versailles in the mid-seventeenth century, only the grand moguls of distant India and the emperors of China could rival the magnificence of the French kings.

Despite an occasional setback during wars and insurrections, the history of the French monarchy can be charted as one continuous movement from the austerities of feudalism to the conspicuous consumption of the baroque era. The life of luxury is not as easy as it seems; it would take several generations of practice, from François I to Louis XIV, before everyone had got the hang of it. Still, the French monarchy had got off to an early lead in Europe at mastering the art of being rich and powerful.

This penchant for material splendor provided another of the great themes of French history: the burgeoning power of the French kings produced a corresponding upsurge in the magnificence of their standard of living. Having forced their nobles into submission and achieved a relatively stable mode of politics, they were able to amass their breathtaking collections of art objects, furniture, tapestries, ornamental armor, jewels, sculpture, paintings. Their court jewelers had always been capable of producing masterpieces, but the arts of interior decoration could begin to flourish only after the pleasure palace of the Renaissance replaced the castle of the Middle Ages.

But as soon as the French kings settled down, they were the first to create the means for palatial living. To Paris came the glovers, hosiers, milliners, coiffeurs, and corsetieres; the perfumers, cheese-mongers, and pastry cooks; the goldsmiths, drapers, *ornemanistes*, and tapestry weavers, who provided the essential logistical support for the king's pleasures. The whole world began to recognize the preeminence of France in the sumptuary arts and crafts. While other schools of cooking existed, it was French cuisine that they had to

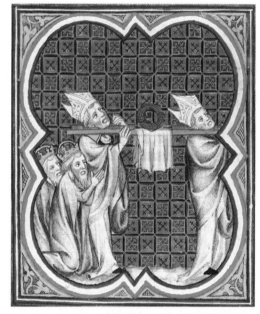

Two priests carry a religious relic—the object may be an ancient altarpiece—as Charlemagne and a prince fall to their knees before it. The emperor not only endowed many churches but also patronized ecclesiastical art and venerated religious icons.

measure up against. Other nations might produce perfumes, but they bore French names.

This agglomeration of specialists in things to delight the senses made it possible for the kings of France to become the envy of all Europe. Yet it was also the outcome of French history. Each additional territorial acquisition contributed some new and remarkable element to the repertoire of homegrown pleasures available to the French court. From the Jura region came *morilles*, the tastiest mushrooms in the world; from recalcitrant Brittany, splendid lobsters and oysters from an as yet unpolluted sea. Roquefort-sur-Soulzon provided a unique species of moldy cheese; the duchy of Champagne a certain kind of effervescent wine; and the town of Cognac, on the Charente (the birthplace of François I), produced a decoction of grape that struck the palate as neither too sweet nor too dry.

There were lace makers in Alençon, tapestry weavers in Aubusson, and silk spinners in Lyon. Strasbourg was famous for its goose-liver pâté, Marseille for its bouillabaisse, and Béarn, in Gascony, for the cream sauce that ennobled the *filet de boeuf*; from the flowering fields of Grasse, in the Alpes-Maritimes, came the fragrances that made life tolerable at a crowded court before the invention of the weekly bath.

Other courts tried to imitate the French, but only France possessed the material and human resources that enabled its kings to live as privileged representatives of their people rather than as pampered specimens of a different species, like the czars. At least from the Renaissance onward, the king himself served as the presiding spirit of this dazzling way of life. As the focal point of every artist's ambition, he was the lodestone that drew the treasures to his court; it was his image that was mirrored in the golden cups and silver ewers. In France the royal road to splendor begins, of course, with the finely crafted treasures associated with the reign of Charlemagne. But even in these early medieval emblems of power, the theme of magnificence is already sounded, and like the notes of Roland's horn it will reverberate down through the centuries of this many-splendored realm.

THE HEART OF FRANCE

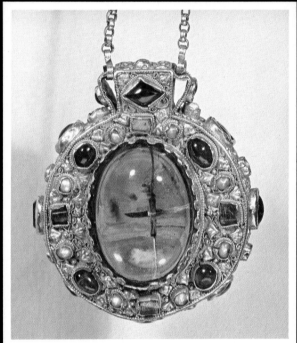

The Talisman of Charlemagne—a pendant of blue glass set in gold filigree—is said to hold a relic of the holy cross. The emperor wore the amulet to his grave.

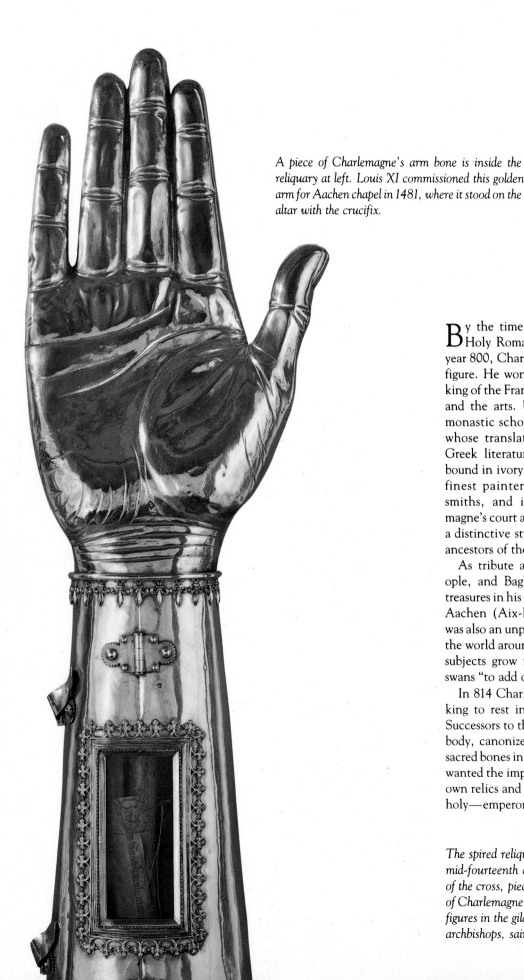

A piece of Charlemagne's arm bone is inside the reliquary at left. Louis XI commissioned this golden arm for Aachen chapel in 1481, where it stood on the altar with the crucifix.

By the time he accepted the crown of the Holy Roman Empire on Christmas in the year 800, Charlemagne was already a legendary figure. He won his glory as the all-conquering king of the Franks and as a true lover of learning and the arts. Under the emperor's patronage monastic schools thrived, attracting scholars whose translations of biblical, Roman, and Greek literature, beautifully illustrated, were bound in ivory and sapphire-studded gold. The finest painters, sculptors, architects, goldsmiths, and ivory carvers came to Charlemagne's court and churches, where they created a distinctive style called Carolingian, after the ancestors of the imperial dynasty.

As tribute arrived from Rome, Constantinople, and Baghdad, Charlemagne placed the treasures in his magnificent palace and chapel at Aachen (Aix-la-Chapelle). Yet Charlemagne was also an unpretentious man who delighted in the world around him: he even decreed that his subjects grow flowers and raise peacocks and swans "to add ornament to our lives."

In 814 Charlemagne's archbishops laid their king to rest in the octagonal Aachen chapel. Successors to the Frankish throne exhumed the body, canonized Charlemagne, and placed his sacred bones in reliquaries. Afterward, men who wanted the imprimatur of his power forged their own relics and regalia of the mighty—and now holy—emperor.

The spired reliquary opposite, commissioned in the mid-fourteenth century, presumably houses slivers of the cross, pieces of the crown of thorns, splinters of Charlemagne's bones, and three of his teeth. The figures in the gilded sculpture include Charlemagne, archbishops, saints, angels, and Christ.

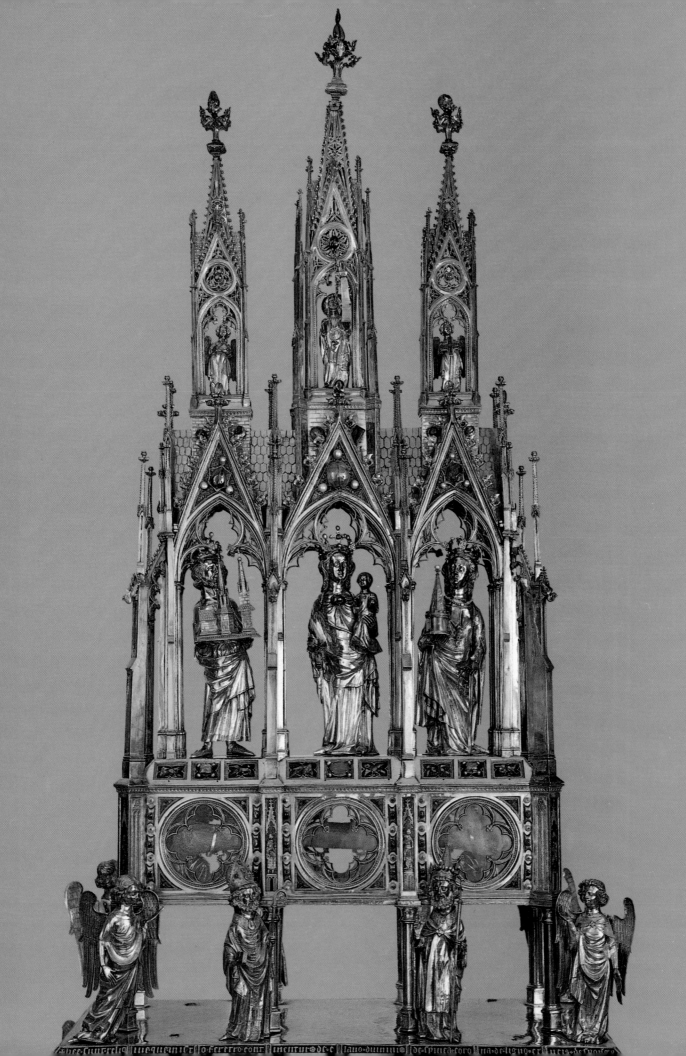

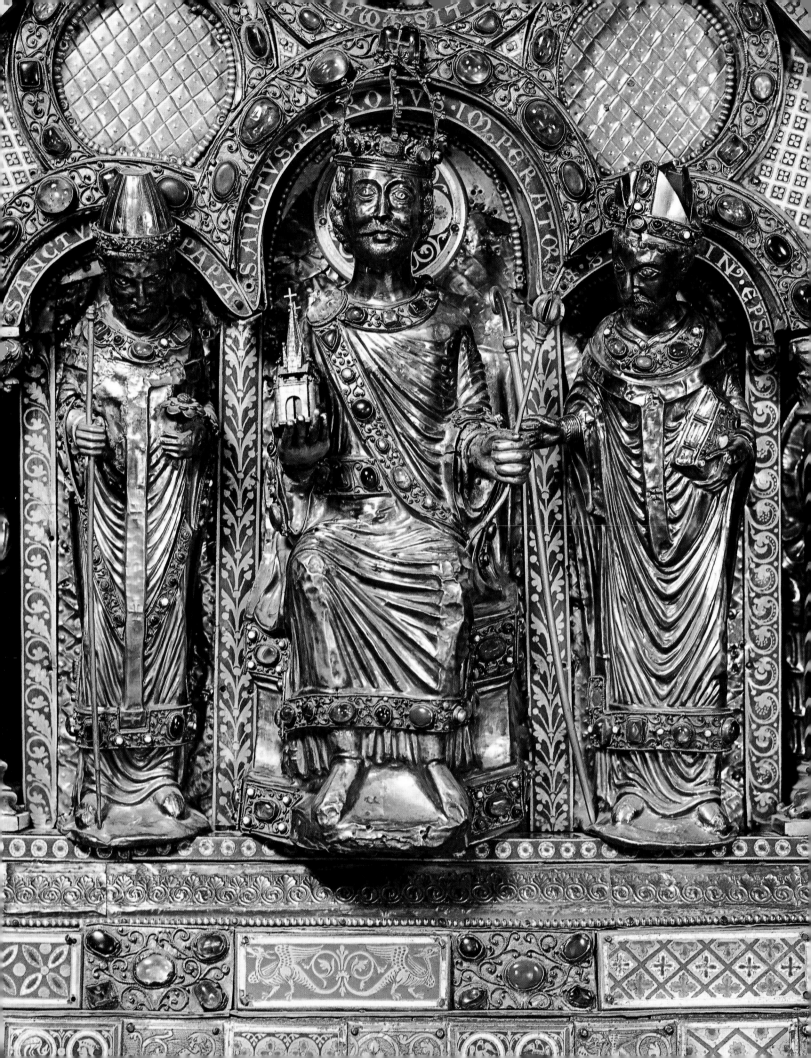

CHARLEMAGNE'S GILDED RELIQUARY

Two unknown twelfth-century sculptors made the silver gilt casket above (and in detail opposite and overleaf) to hold Charlemagne's leg bones. The reliquary, studded with jewels, is in the shape of a cathedral. Its images link the power of the emperor—and his successors, in their thrones along the side—with that of the Church. In the detail opposite, Charlemagne, enthroned between a pope and a bishop, holds a model of his eight-sided chapel at Aachen, where the emperor located his capital in 794.

OVERLEAF: *Charlemagne and his men surround the renegade Spanish town of Pamplona, as the emperor himself begins to tear down its walls. The relief of gilded tin, a detail from the roof panels of the reliquary above, records a minor eighth-century Frankish military campaign to bring the town under Charlemagne's rule.*

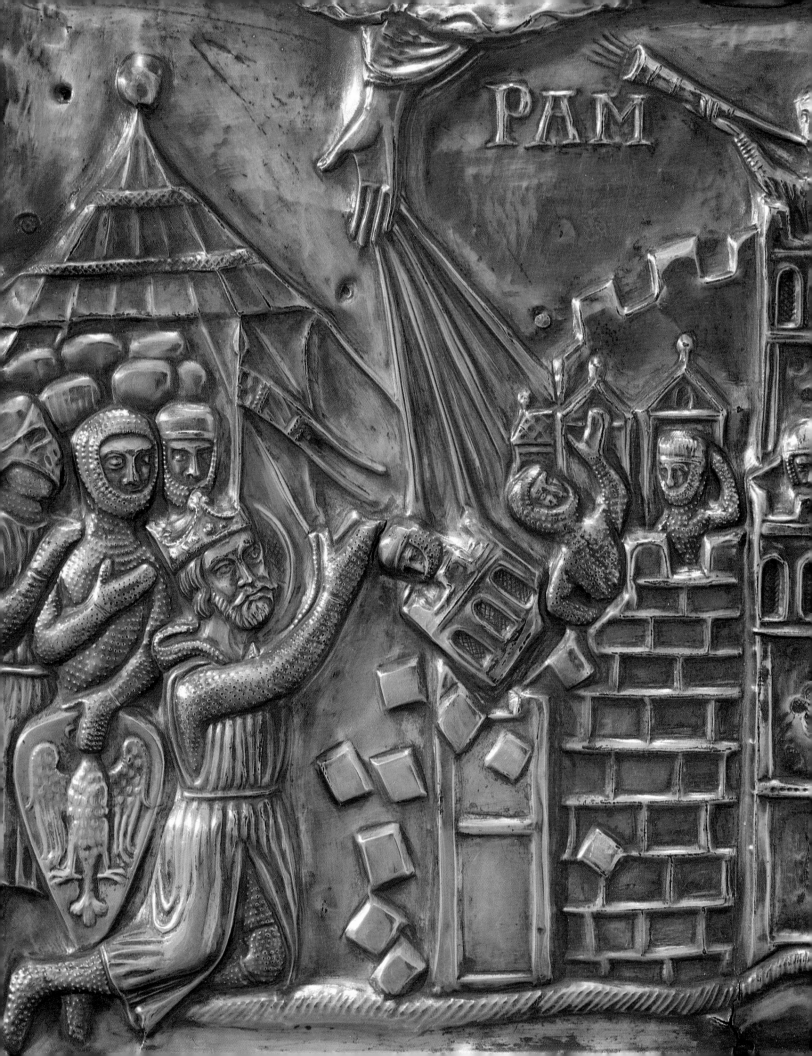

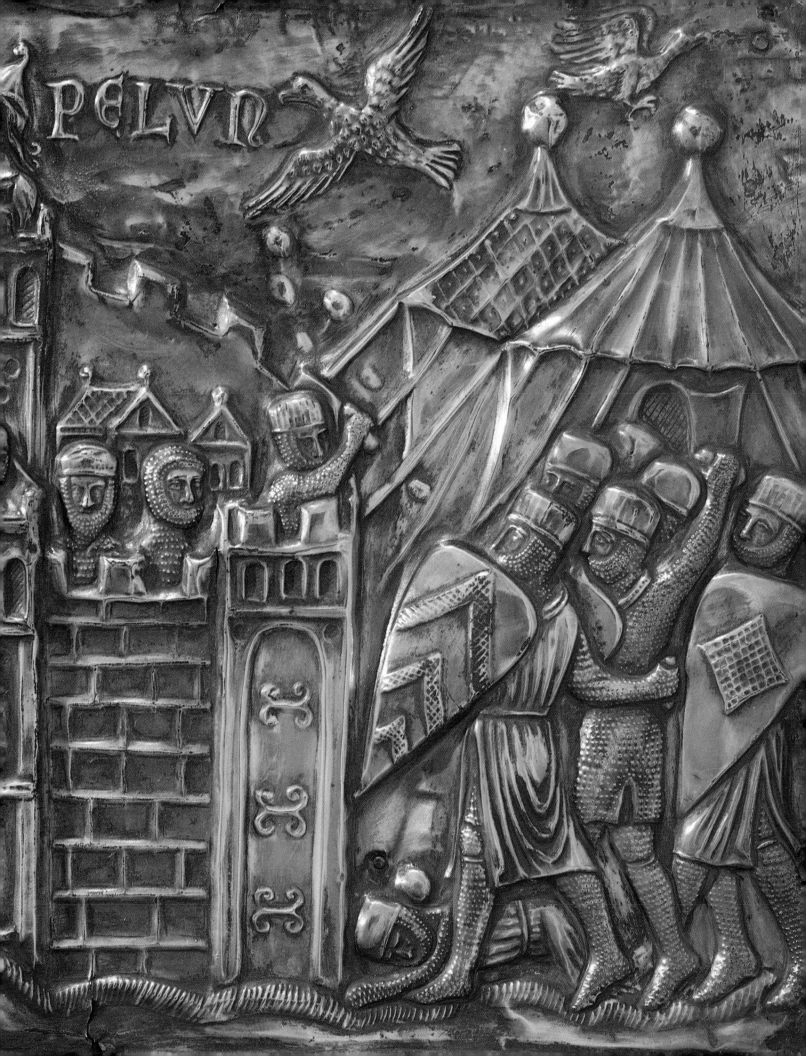

PELVΠ

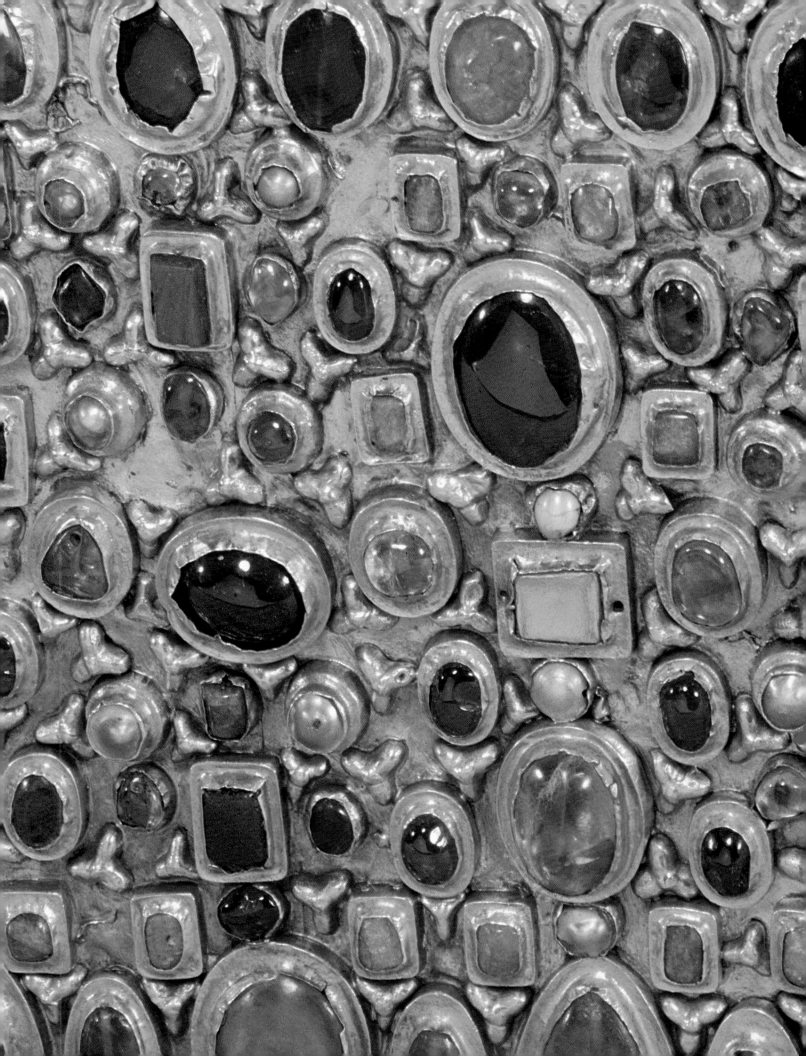

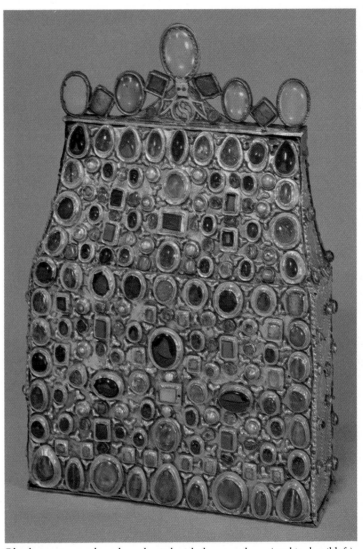

Charlemagne may have been buried with the case above (and in detail left), a ninth-century reliquary. The goldsmith who made the case first carved it from wood, gilded it, then encrusted the gold with stones and pearls.

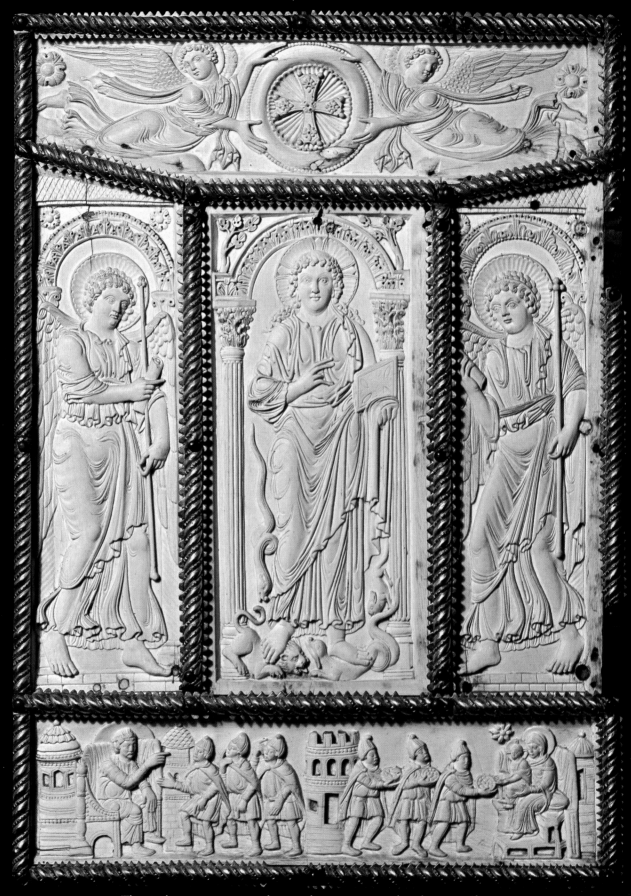

The ninth-century ivories, above and opposite, carved at the imperial monastery at Lorsch, Germany, under the patronage of Charlemagne, were the front and back covers for the gospels of Matthew, Mark, Luke, and John.

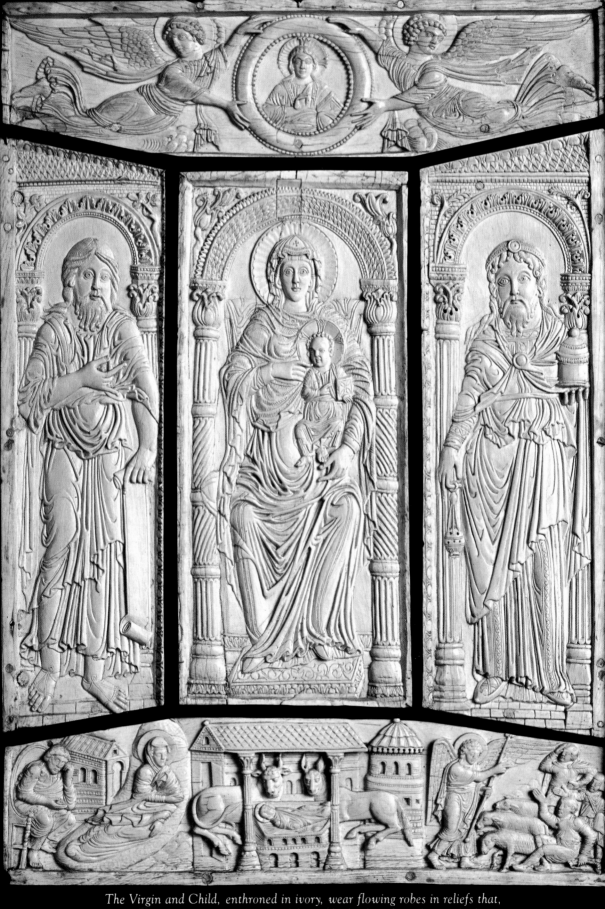

The Virgin and Child, enthroned in ivory, wear flowing robes in reliefs that, together with the ones opposite, celebrate the birth and teachings of Christ. Both gospel covers are composed of five intricately carved panels.

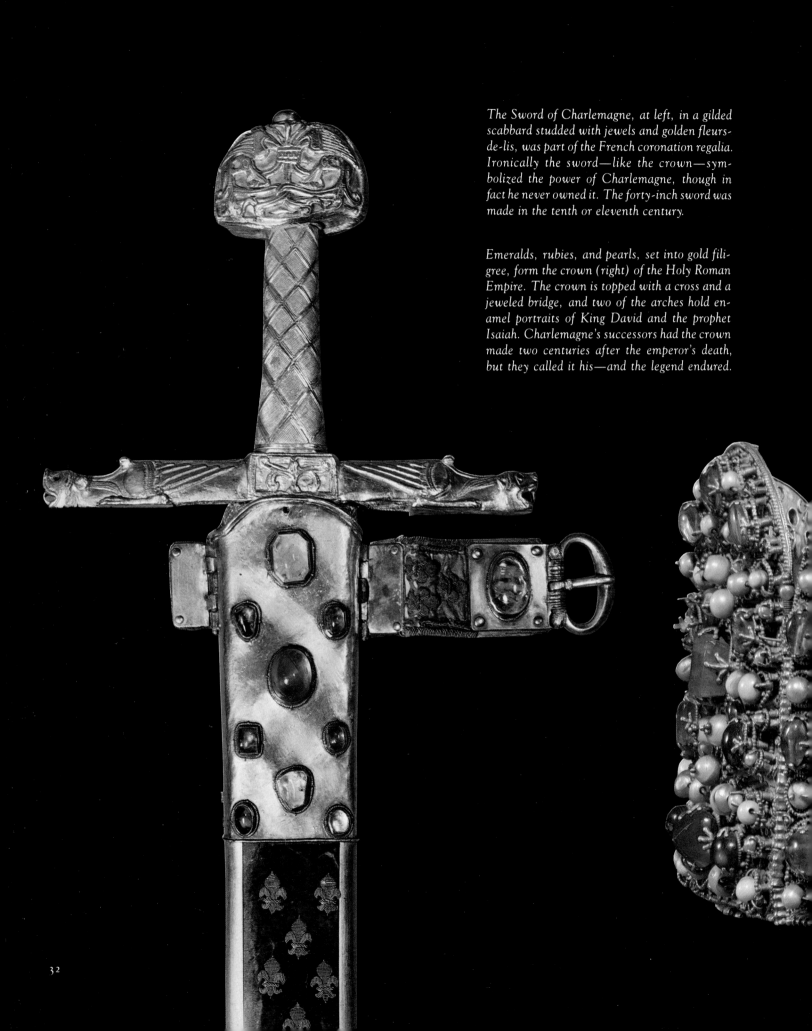

The Sword of Charlemagne, at left, in a gilded scabbard studded with jewels and golden fleurs-de-lis, was part of the French coronation regalia. Ironically the sword—like the crown—symbolized the power of Charlemagne, though in fact he never owned it. The forty-inch sword was made in the tenth or eleventh century.

Emeralds, rubies, and pearls, set into gold filigree, form the crown (right) of the Holy Roman Empire. The crown is topped with a cross and a jeweled bridge, and two of the arches hold enamel portraits of King David and the prophet Isaiah. Charlemagne's successors had the crown made two centuries after the emperor's death, but they called it his—and the legend endured.

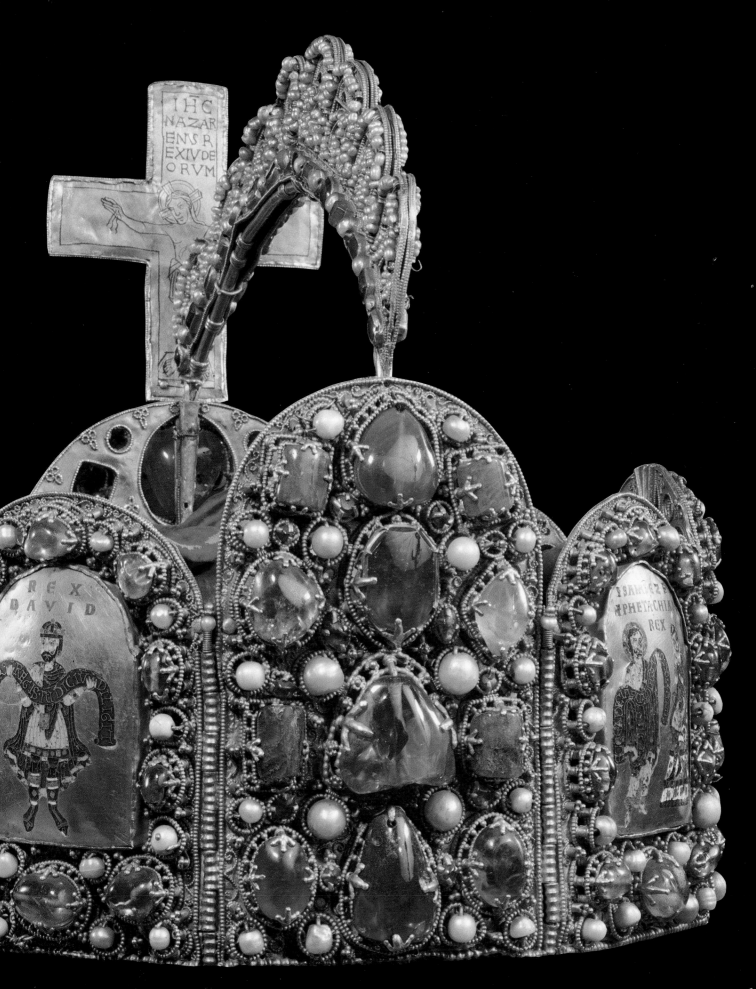

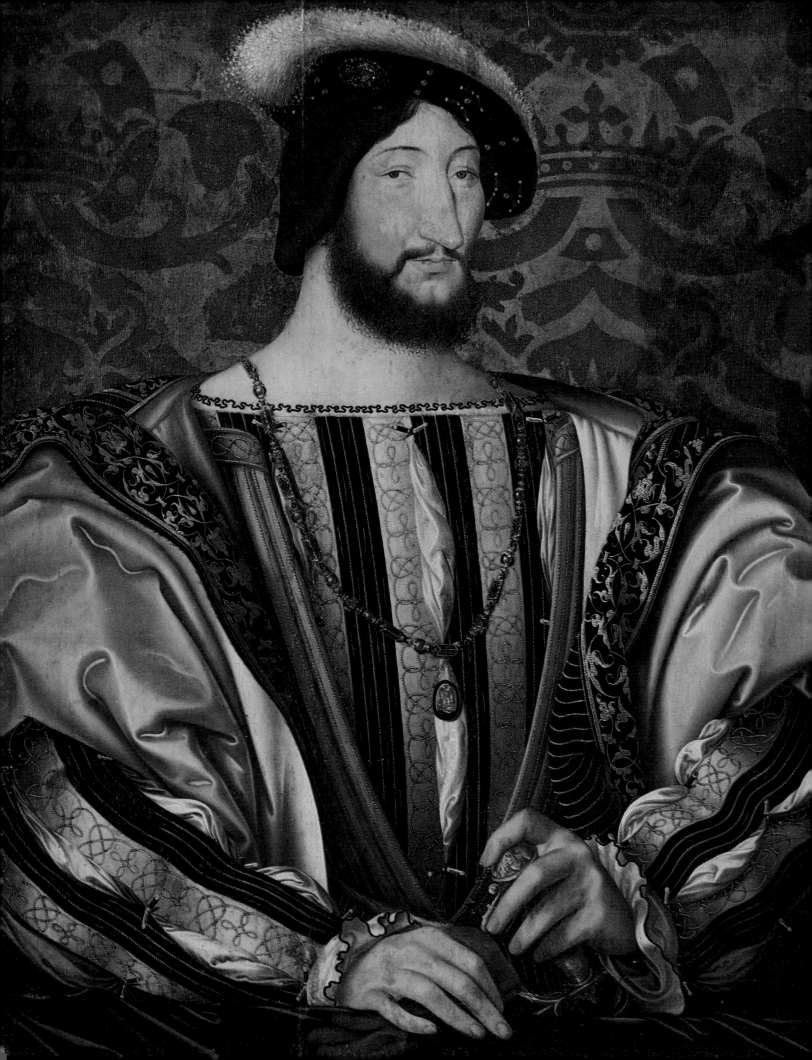

II

FRANÇOIS I

THE MODEL
RENAISSANCE MONARCH

With François I the treasures of the kings of France began to attain supreme importance as symbols of royal power; indeed, importance almost as instruments of national policy, expressed in gold and precious stones. In an age of great monarch-collectors and connoisseurs, none could play the game with such panache as François, who liked to make his grand entrances on horseback, dressed in cloth of gold covered with diamonds—a prince of the Renaissance par excellence.

When the twenty-year-old François succeeded to the throne of France on New Year's Day, 1515, he inherited a monarchy that was well on the way to becoming absolute. The great nobles were no longer in a position to defy the king, who now maintained his authority by means of a standing army and a class of new men—bureaucrats and advisers—answerable only to the crown. As a result he had at his disposal far more massive resources than his predecessors, enabling the French court to attain a level of opulence previously known only in the Mediterranean world.

Here portrayed by Jean Clouet, François I strikes a haughty pose—the image of a monarch who reigned by the phrase, "for such is our pleasure."

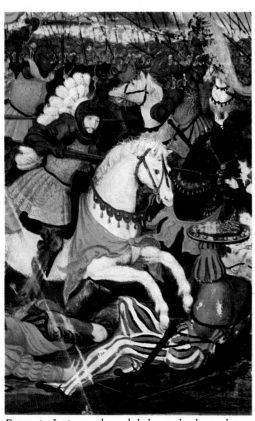

François I, in a plumed helmet, leads a charge against Swiss pikemen in the battle of Marignano in 1515. The king fought side by side with his men throughout the two-day battle, which won the duchy of Milan for France.

The times were propitious for change: in Italy the artists of the Renaissance had rediscovered the glories of classical Rome and were creating a sumptuous new style based on the splendors of the ancient world. Over the course of his reign, François, himself partly of Italian descent, imported the Italian Renaissance wholesale, erecting the first of the grandiose French palaces whose rooms are decorated from floor to ceiling with sculptures, paintings, tapestries. The gloomy Gothic of the royal châteaux on the Loire—Blois, for example, or Amboise, where François spent his boyhood—were still stamped with the siege mentality of the Middle Ages. They soon gave way to the airy elegance of the palace at Fontainebleau. It was a symbolic innovation that set an example for the whole of France. François I, writes a recent biographer, Desmond Seward, "transformed the cultural life of France to a degree unparalleled at any time in her history."

François was born a count, not a king—comte d' Angoulême—but a dearth of crown princes made him heir presumptive to his cousin Louis XII, and his ambitious mother, Louise de Savoy, saw to it that he was well prepared for the responsibilities of kingship. In *Pantagruel* François Rabelais, the great comic writer of the period, gives a tongue-in-cheek account of the rather too well-rounded education of this prince: he spent his days studying "the pleasant history of ancient prowess...geography, astronomy and music; how to sing musically so as to please the throat...and how to play the lute, clavichord, harp, flute." He practiced penmanship, riding, jumping, swimming in deep water, and he "climbed trees like a cat," according to Rabelais; he read ancient manuscripts, played chess, and learned Latin, Italian, and Spanish. As one of his boyhood companions later recalled, "No prince ever had more pastimes than did my said Lord or was better instructed by the provision of my Lady his mother."

François grew to imposing manhood, six feet tall, broad-shouldered and skilled in fencing, jousting, and executing the arts of war. The Italian diplomat Baldassare Castiglione, whose *Courtier* made him an arbiter of Renaissance manners, described the young prince

as handsome of person and visage, and "in his countenance so great a majesty, accompanied nevertheless by a certain lovely courtesy...." To reinforce his claims to the throne, François married the daughter of Louis XII, Claude de France, an unprepossessing fifteen year old, "very small and strangely fat," who had a pronounced squint and walked with a limp. No matter: her role was to bear royal children; romantic enthusiasms could easily be satisfied elsewhere.

At twenty-one, newly crowned and thirsting for action, François took his army into Lombardy in the north of Italy to claim his tenuous right to the duchy of Milan. Like Hannibal he crossed the Alps with heavy equipment: three thousand armored knights, twelve thousand horses, thirty thousand foot soldiers, twelve heavy guns, and three hundred fieldpieces. At Marignano, near Milan, he routed an army of Swiss pikemen, professional soldiers who had been regarded as invincible. To commemorate his victory in the proper Renaissance style he had a medal struck bearing his portrait in profile under a plumed hat, with the inscription, "François I, King of the French and Tamer of the Swiss."

But his conquest of Milan created more problems than it solved, since it brought him into direct conflict with the Hapsburg emperor of Austria and Spain, Charles V. Henceforth he was to squander his resources in a succession of disastrous wars and imbroglios with his powerful rival, who ruled over a vast aggregate of territories, which included Spain, large parts of Italy, the Netherlands, and the duchy of Burgundy.

François needed allies against the Hapsburgs; he hoped to forge an alliance with Henry VIII, the English king who still styled himself "king of France" because the English still held the enclave of Calais. To gain Henry's friendship François staged the most spectacular political happening of the century, a summit conference that came to be called the Field of the Cloth of Gold, which took place in June 1520, at Val d'Or, where French territory adjoined Calais. François made his headquarters at Ardres, in a huge pavilion entirely covered in cloth of gold; nearby were four hundred tents housing the flower of French chivalry in gold, silver, and silk.

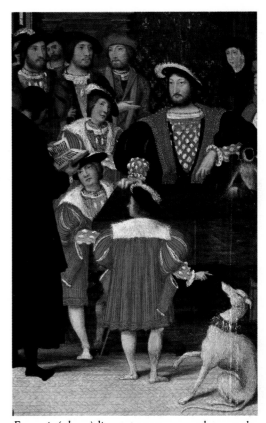

François (above) listens as a savant reads a translation of a first-century-B.C. Greek manuscript. The king generously supported education; he founded the Collège de France and invited scholars into his personal library of three thousand books.

When he rode out to meet his English counterpart, François wore cloth of gold studded with pearls, diamonds, and other precious stones; his black velvet hat was decorated with magnificent white plumes, his horse caparisoned in gold. With him, also in gold and sparkling jewels, were his brother-in-law, the king of Navarre, and dukes, counts, cardinals, and bishops—the privileged officers of the royal household. Some of the poorer noblemen in attendance had mortgaged their estates in order to dress themselves for this great contest of appearances.

On the English side was the red-bearded Henry Tudor, only three years older than François but already a trifle too stout for fashionable tastes. Though he came from a parvenu house among the royal families of Europe, he was conscious of being the courted party at this rendezvous, and he could afford to underplay his part. He rode onto the field on a bay jingling with golden bells, dressed merely in silver embroidered with jewels; his black hat sported black plumes. With him was his lord chancellor Cardinal Wolsey in crimson-figured velvet on a mule caparisoned in red and gold, and an escort of other great notables. Both monarchs were preceded by their constables, holding aloft the glittering swords of state.

For two weeks there were jousts, banquets, and processions amid continual dancing and music making. Many and copious were the toasts drunk by the *"bons amis, français et anglais,"* and there was an exchange of royal gifts: Henry gave François a collar of rubies. François gave Henry an elaborate bracelet in return. Yet despite mutual assurances of respect and even affection, François never succeeded in winning Henry as an ally. François would have done better to have saved the vast sums he lavished on the diplomacy of conspicuous luxury. When he went to war with Charles V three years later, it was the lack of ready money that defeated him, for he was short of troops and could not hire the Swiss mercenaries he needed to buttress the small expeditionary force that he led into Italy.

At Pavia, in February 1525, the French army was annihilated; François and his surviving captains were taken prisoner. "All is lost

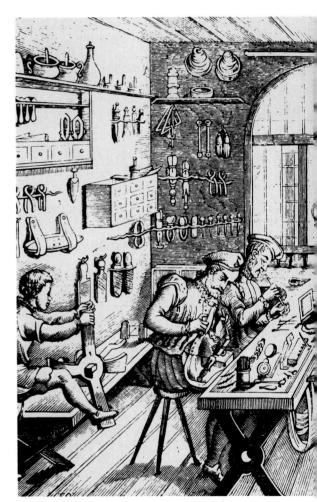

The sixteenth-century artist Etienne Delaune, who designed the armor and shield on pages 56–61, engraved this view of a Parisian goldsmith's shop. Artisans, from the left, stretch gold wire on a wheel, hammer decorations into an object, chisel a die, and mark a design on a piece of metal. The man at right is heating gold in a furnace.

save honor," he is supposed to have said when the battle was over; his actual words, in the letter he wrote to his mother after the defeat, are only slightly less melodramatic: "Of all things, nothing remains to me but my honor and my life. . . ." Charles had him locked up in a tower of the Alcázar in Madrid until he would agree to a peace treaty ceding the duchy of Burgundy, Toulouse, and Provence.

François refused at first and coined an elegant epigram to express his determination: *le corps vaincu, le coeur reste vainqueur*—"though the body be conquered, the heart remains the victor." In the end, after a severe illness, he agreed to the treaty that bought him his freedom, only to repudiate it once he was back in Paris, arguing that promises made under duress have no validity. He had, however, been forced to send Charles his two sons as hostages, and when the two monarchs finally came to terms, he was obliged to ransom the boys for four and a half tons of gold.

Added to the other costs of the war, this ransom nearly bankrupted the French exchequer, and François was forced to raise taxes to levels that were considered ruinous at the time. (They hardly seem excessive by modern standards: landowners were obliged to pay twenty-five percent of their annual income, and there was a forty percent tax on revenues of monasteries and other church institutions, which functioned much like modern corporations.) But despite his straitened circumstances, his career as a patron of the arts could now begin in earnest. Some kings have the reputation of having lost at the peace table what they gained on the battlefield. With François it was just the opposite: he regained, as a patron of the arts, the prestige he had lost by his military ineptitude.

The passion for Renaissance art and architecture that he had brought with him from Italy led him to abandon his châteaux in the Loire valley and to create a new royal residence at Fontainebleau, then two days' journey from Paris. It had been a simple hunting lodge; with the help of a phalanx of Italian and French artists, he turned it into a pleasure palace whose splendor astounded his contemporaries. "What a building is Fontainebleau," wrote one of them, "where, out of a wilderness, there has been made the finest house in

TEXT CONTINUED ON PAGE 46

THE ROYAL SALT AND PEPPER

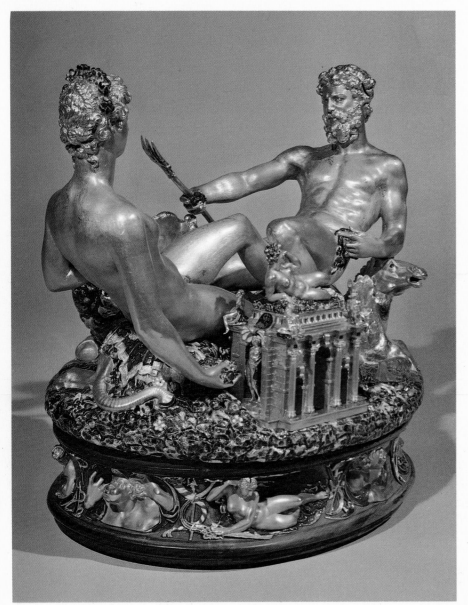

The two main figures on Benvenuto Cellini's saltcellar, fashioned of hammered and cast gold, are Neptune, lord of the sea, and a voluptuous woman representing the earth. Cellini fitted ivory balls into the ebony base so that François could roll the cellar across his table.

Benvenuto Cellini burst upon the French court in 1540—a sculptor and goldsmith of genius, a hot-tempered swordsman, and a consummate flatterer. In order to bring Cellini to his court, François first had to extract him from prison, where Pope Paul III had confined him on charges of stealing papal jewels. Acting for François a cardinal secured Cellini's release by pleading his case when the pope was drunk, according to the sculptor's wonderfully bombastic autobiography.

François enthusiastically welcomed Cellini and placed a castle in Paris at his disposal for his home and studio. There Cellini worked on a bronze ornament for a doorway at Fontainebleau (see page 49) and a saltcellar (left), which François commissioned because he was so delighted by a basin and jug Cellini had given him on his arrival in France.

Cellini's friendship with François—the king called him *mon ami* and often visited his studio—annoyed the king's mistress, the duchesse d'Etampes, who constantly connived against the artist. She cajoled the king into letting one of her associates move into part of Cellini's castle; but the irascible Italian fired blanks from his musket at the man's lodgings and threw the terrified intruder into the street.

Despite the intrigues of Madame d'Etampes and other courtiers, Cellini completed several major works for François, most notably the famous saltcellar on these pages. Though Cellini often boasts and exaggerates in his autobiography, there is no reason to question his description of the ecstatic reaction of his patron on first seeing the saltcellar—"he uttered a loud cry of astonishment, and could not satiate his eyes with gazing at it."

Cellini designed the miniature Greek temple opposite to hold pepper. He equipped the temple with a hinged lid, atop which reclines a lovely nude.

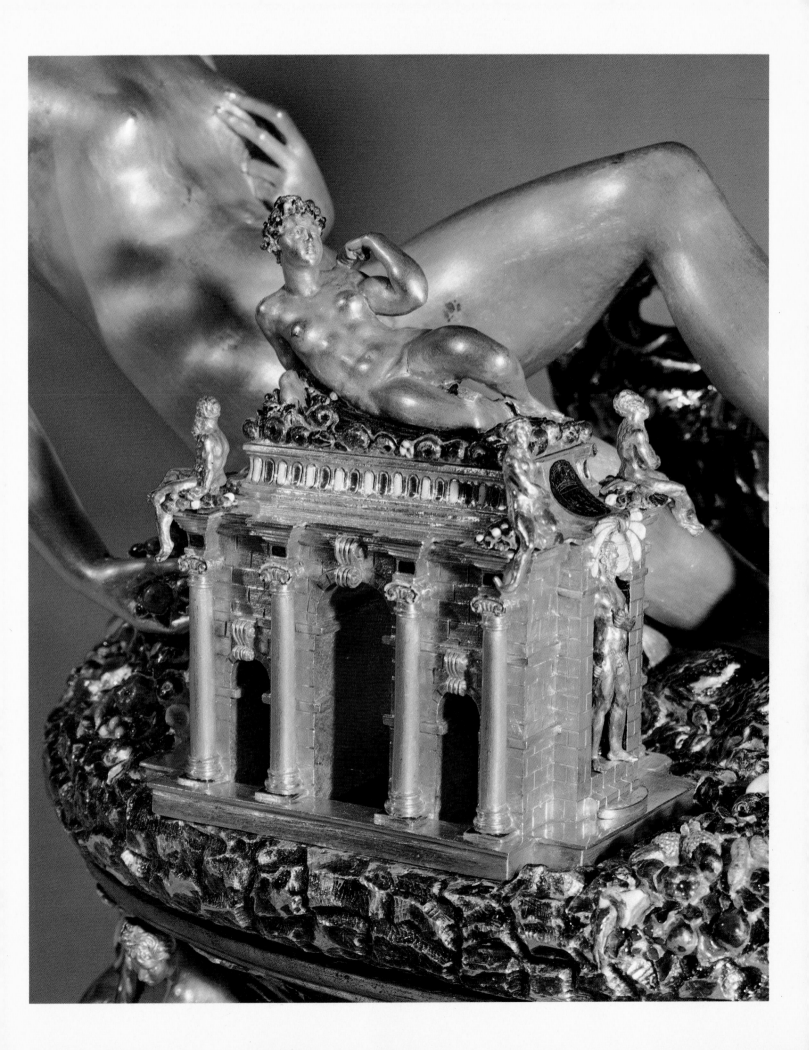

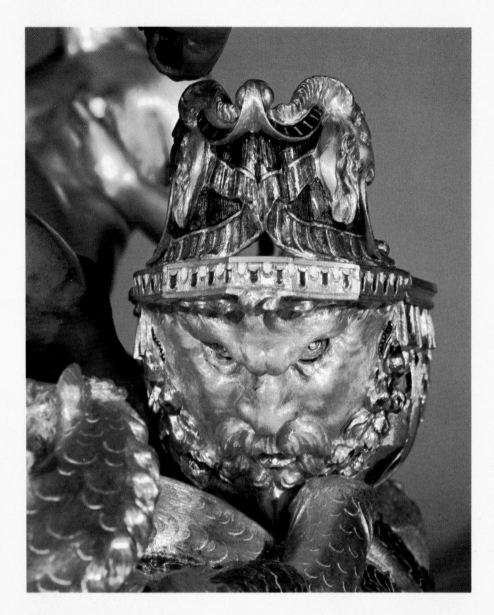

Cellini decorated the saltcellar of François I with a rich variety of symbolic figures in gold and enamel. The subsidiary figures amplify the main allegory of the piece—salt comes from the sea and pepper from the earth. Sea horses, opposite, carry Neptune over undulating waves of enamel. At left the scowling face of a sea god adorns the basin that holds the salt. As a final decorative touch, Cellini put four nudes around the base of the cellar. Three appear below.

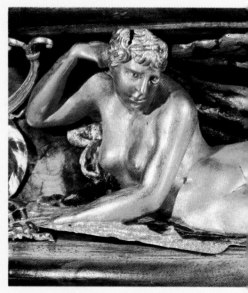

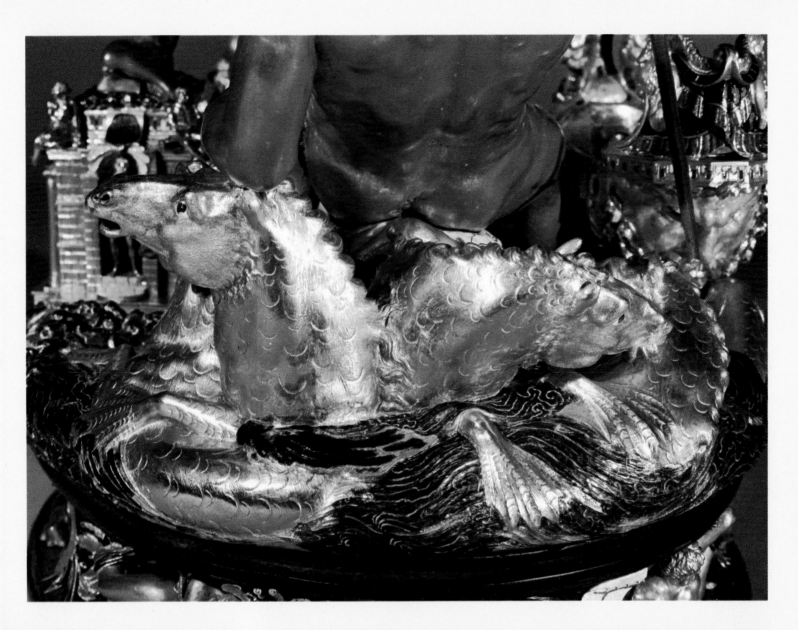

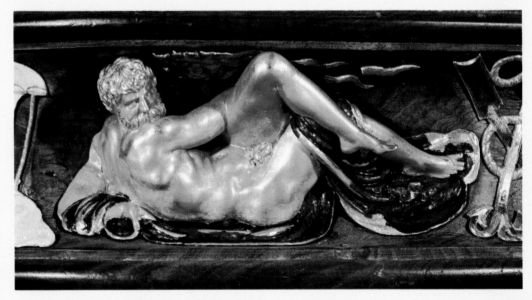

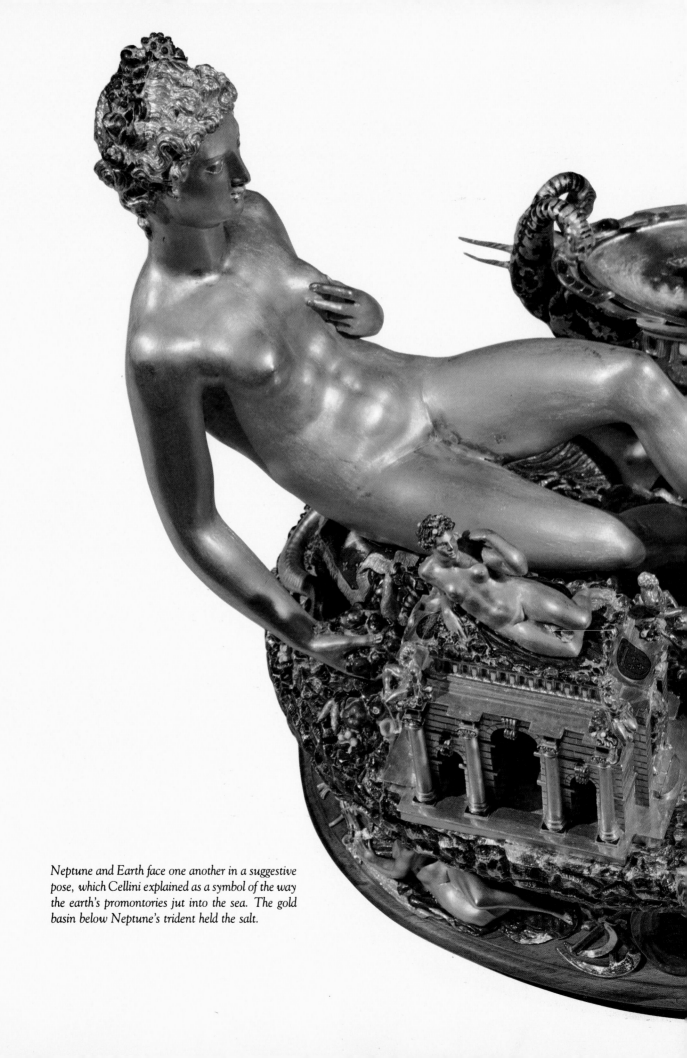

Neptune and Earth face one another in a suggestive pose, which Cellini explained as a symbol of the way the earth's promontories jut into the sea. The gold basin below Neptune's trident held the salt.

44

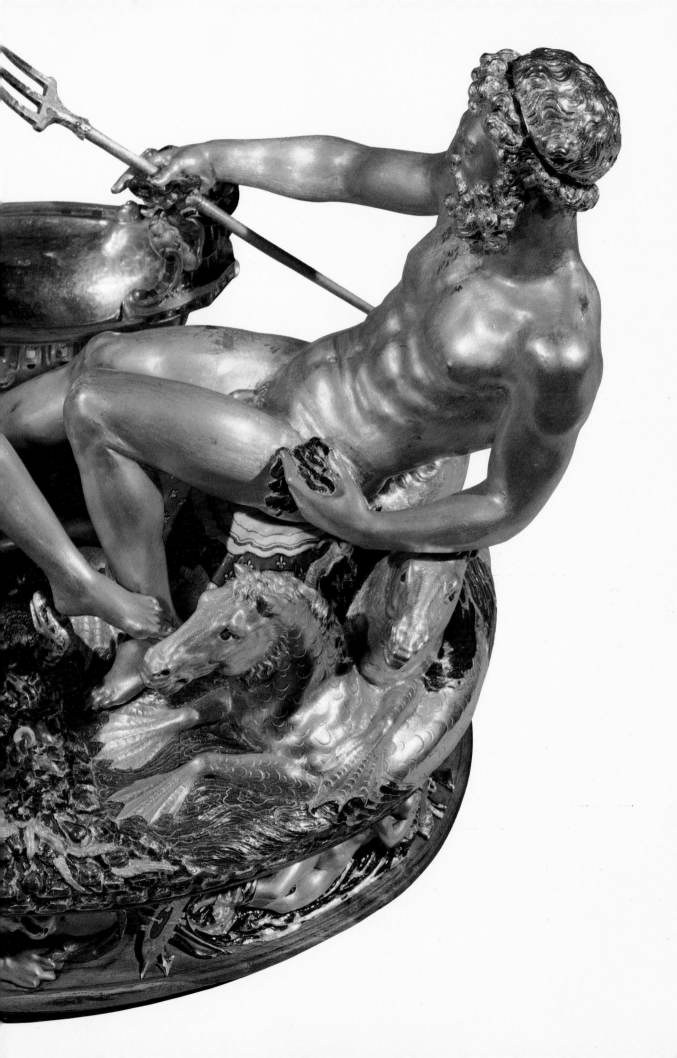

TEXT CONTINUED FROM PAGE 39

Christendom... so rich and fair a building"

François filled his new palace with a hoard of treasures: gold and silver plate; cups, bowls, and ewers of crystal, sardonyx, jade, and lapis lazuli; vases and saltcellars, caskets and reliquaries. Hundreds of enamels were produced for the king's pleasure, chiefly by the celebrated enamelists at Limoges. And when he became impatient with having to import tapestries from Flanders, he established a tapestry workshop at Fontainebleau, the first of the *manufactures royales*, specialty workshops that François and his successors would set up to produce the finest in wall hangings, carpets, porcelains, and other luxuries that royalty required. His Cabinet of Rings was filled with jewels and cameos; his Cabinet of Curiosities contained antique vases, statuettes, and coins.

One of the marvels of Fontainebleau was the Gallery of Ulysses, decorated with twelve mythological frescoes, framed by a bewildering profusion of stucco cupids and caryatids, baskets of fruit, sphinxes, masks, and salamanders. They were created for him by the Italian Mannerists, members of a school of flamboyant Florentine artists whose bent was toward the theatrical. Transplanted to France these artists became known as the School of Fontainebleau; its leaders were Francesco Primaticcio, from Mantua, and the red-headed Giovanni Battista di Jacopo, whom the Italians called Il Rosso Fiorentino and the French Maître Roux. Il Rosso painted the vivid allegories in which François appears as Achilles and other heroes of pagan mythology.

Still earlier François had invited the aged Leonardo da Vinci to become "First Painter, Engineer and Architect to the King." Leonardo spent the last three years of his life at Amboise, painting very little but making sketches and designing royal festivities. He had brought some of his earlier paintings with him, however, and François was not disappointed by the selection—it included the *Mona Lisa*, a masterpiece destined to remain ever after in French hands.

In 1540 François brought Benvenuto Cellini to Paris as goldsmith and sculptor to the court. This famous Florentine artist and adven-

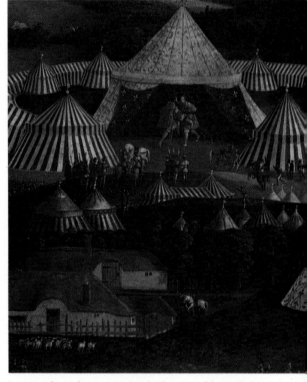

In a pavilion about sixty feet high covered by a cloth of gold (at top in the painting above), François I meets with Henry VIII in 1520. Shakespeare wrote later that the French "all in gold, like the heathen gods/Shone down the English."

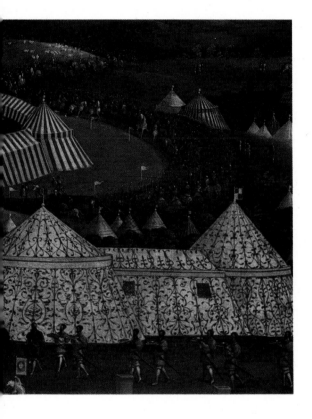

turer had been in jail: he had been charged with stealing papal jewels. His first commission was to prepare twelve silver statues of gods and goddesses, which were to stand around the king's table as candelabra. He and his workmen were installed in the castle of Le Petit Nesle—just across the Seine from the Louvre—which François had recently transformed from a medieval fortress into a royal residence. Before long the king paid him a visit to see how things were going, an event that the goldsmith recorded in his memoirs:

The first thing he saw on coming into the great hall was myself with a huge plate of silver in my hand, which I was beating for the body of my Jupiter; one of my men was finishing the head, another the legs; and it is easy to imagine what a din we made between us. It happened that a little French lad was working at my side, who had just been guilty of some trifling blunder. I gave the lad a kick, and, as my good luck would have it, caught him with my foot exactly in the fork between his legs, and sent him spinning several yards so that he came stumbling up against the King precisely at the moment when his Majesty arrived. The King was vastly amused, but I felt covered with confusion.

One thing that emerges from Cellini's *Memoirs*: he may have been one of the great artists of the Renaissance, but he was not an easy employer to work for in an age when the minimum wage consisted mainly of cuffs and blows. He recruited his assistants from among the Italian, French, and German journeymen who crowded the workshops of Paris, and, as he says, "I took the best I could find, and changed them often, retaining only those who knew their business well. These select craftsmen I worked to the bone with perpetual labor."

Cellini produced several masterpieces for François, including the magnificent gold saltcellar in which the allegorical figures of Sea and Earth sit with their legs interlaced (see pages 40 to 45). All went well for Cellini until he ran afoul of the king's mistress, Anne de Pisseleu. She was beautiful, erudite, and proud, the daughter of a knight, and François had found her an unconcerned husband and created her duchesse d'Etampes. Queen Claude had died in 1524; François then married Eleanor of Austria, the sister of his rival Charles V. It was a

shrewd political move, but his real affections were reserved for the blond duchesse.

Anne d'Etampes took a dislike to Cellini and tried to discredit him when he brought the first of his silver candelabra to Fontainebleau. François, for his part, was overjoyed by the sight of Cellini's ingenious piece of applied art—Jupiter holding aloft a thunderbolt with a wax torch concealed in it. But the duchesse dismissed it as a piece of "modern trumpery," and declared that the gauze veil covering the figure's loins had been placed there to conceal its faults. Cellini writes in his memoirs that he had, in fact, veiled the statue's loins "with a view of augmenting its majesty." As the duchesse spoke, he lifted this veil from beneath, "uncovering the handsome genital members of the god; then tore the veil to pieces with vexation. She imagined that I had disclosed those parts of the statue to insult her." Cellini knew that his relationship to François was becoming untenable. Soon he was back in Florence, creating the great statue of Perseus, which capped his life's work.

The art that the Italians brought to France was symbolic of profound changes in the world of ideas: Renaissance humanism displaced the mysticism of the Middle Ages; a new spirit of critical inquiry made itself felt in science, scholarship, and religion. The first tremors of the Reformation were felt during François's reign; under his successors France was plunged into a long and bloody series of civil wars between Protestants, or Huguenots, and Catholics, which devastated the countryside and destroyed the tenuous prosperity of the cities. Such court jewelers as survived were kept busy turning out propaganda pieces for one side or the other. One superb Limoges enamel, "The Triumph of the Eucharist and of the Catholic Faith," for example, shows Antoinette de Bourbon, duchesse de Guise, riding in a golden cart over the bodies of various Protestant leaders.

In 1593, after thirty-eight years of civil wars, the contending factions resolved their differences and rallied behind "the good king," Henri IV of Navarre—a Protestant turned Catholic and a pragmatist in the new Renaissance style. *"Paris vaut bien une messe,"* he is reported to have said; "Paris is well worth a mass." He was a

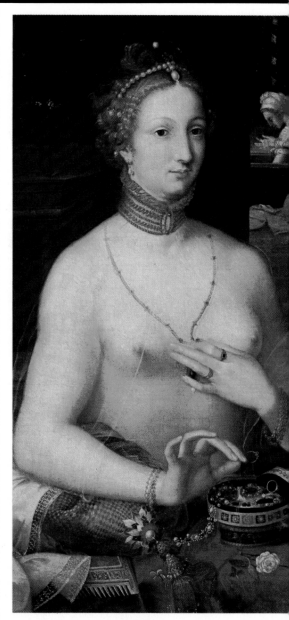

Diane de Poitiers, portrayed here at her toilette, reputedly preserved her great beauty by drinking a potion containing gold and by bathing in asses' milk.

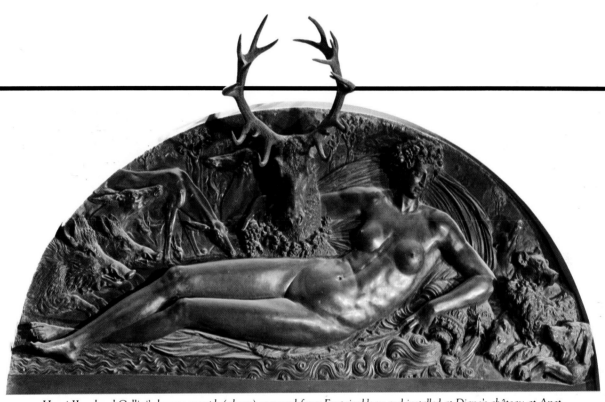

Henri II ordered Cellini's bronze nymph (above) removed from Fontainebleau and installed at Diane's château at Anet.

A LEGENDARY BEAUTY

As for the king, he continues to submit himself more and more to Silvius, to whom he makes himself a slave," wrote the Spanish ambassador to the court of Henri II, the son and successor of François I. Silvius, a code word, refers to the king's mistress Diane de Poitiers, who indeed had Henri under her spell. Henri was but a boy when he first met Diane. She was a widow and twenty years older than Henri, but slim and athletic, the practitioner of a stern regimen that began each day with a gallop on horseback. She always dressed in white and black—colors that flattered her and set off the crown jewels that Henri gave her to wear.

When Henri ascended the throne, he gave Diane the château of Chenonceaux and transformed it into a luxurious showplace, decorated throughout with the emblem of his love for Diane—their intertwined initials *H* and *D*. The queen, Cathérine de Médicis, who had none of Diane's beauty, stoically bore the king's indifference. For her part Diane had a warm affection for the queen and risked her own life to nurse Catherine when she suffered from scarlet fever.

After Henri's death Catherine banished Diane from the court; but Diane retained a château near Paris, her wealth, and her looks. Just before she died in 1566, at the age of sixty-seven, a courtier wrote of her that her beauty could still stir even a heart of stone.

On July 1, 1559, at a joust that Queen Cathérine had tried vainly to stop, Henri II was fatally wounded (above). His opponent failed to drop his splintered lance, which pierced Henri's visor and penetrated his brain. He died ten days later.

warrior, a drinker, and a womanizer of legendary appetite. He became immensely popular, not only for his courage and his kindness, but because he put French industry and agriculture back on sound footing. He enlarged Fontainebleau and the Louvre, built parks, bridges, public squares in Paris; he subsidized the manufacture of silk and glassware; he built roads and canals. Under Henri IV the monarchy regained its splendor, partly because he married, as his second wife, Marie de Médicis, a woman with a flair for palatial living. At the christening of their eldest son, the future Louis XIII, an eyewitness recorded, "the luxury and magnificence of the princesses and ladies were so great that the spectators could hardly bear the glitter of the gold, the pure whiteness of the silver, and the brilliance of the pearls and jewels which covered their dresses." But Queen Marie outshone everyone, "for she had two thousand pearls and three thousand diamonds sewn onto her robe."

Marie, whose life was to furnish the subject of a great cycle of allegorical paintings by the Flemish master Peter Paul Rubens, was the first to recognize the administrative genius of cardinal de Richelieu, the prime minister who guided France through the most turbulent years of the seventeenth century. Richelieu remained in office for eighteen years; his death, in 1642, preceded that of Louis XIII by less than a year. Once again France was ravaged by a Catholic campaign against the Huguenots, at La Rochelle and in Languedoc. Yet the monarchy withstood all assaults and became stronger than ever. Art and industry flourished under Richelieu's patronage; new treasures poured into the strong room of the Louvre. But all was not politics and high seriousness. While his ministers looked after the affairs of state, Louis XIII made Paris the center of the ballet world. He himself was a superb dancer who specialized in character roles: comic soldiers, peasants, carnival musicians. One of the highlights of the 1626 carnival season in Paris was the king's appearance, at five o'clock on the morning of Ash Wednesday, in a ballet presented at the Hôtel de Ville before an audience of townspeople who had been waiting for thirteen hours for the privilege of seeing their sovereign perform one of his most famous roles.

STEEL JEWELS
FOR KINGS

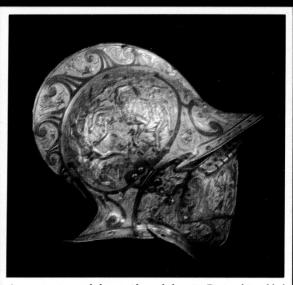

A masterpiece of the royal workshop in Paris, this gilded and richly embossed helmet belonged to Henri II, who wore it on ceremonial occasions.

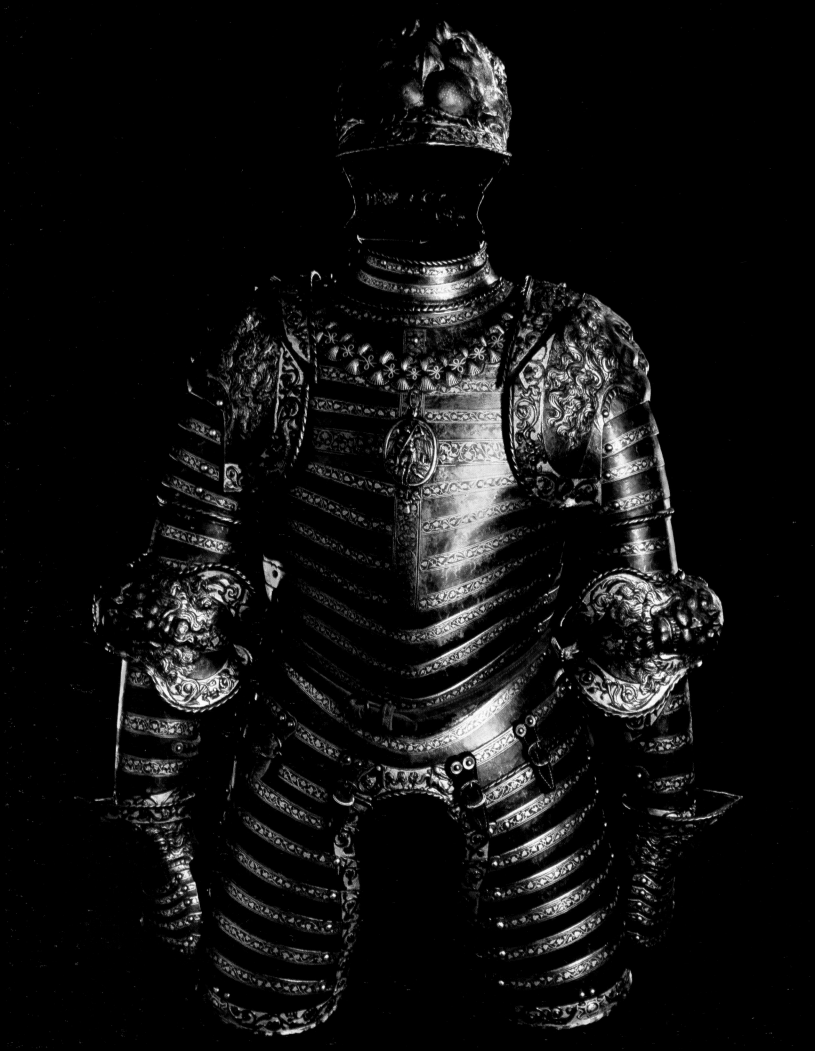

Armor was the ultimate in manly jewelry—a rich adornment covering the entire body with harmoniously curving lines and sumptuous decorations. The kings of France rated their armorers on a par with the greatest artists, for they considered an armorer to be no mere blacksmith, but a sculptor. Indeed, François I's steel helmet on pages 54–55, fashioned by Philippo de Negroli, is one of the most beautiful sculptures ever wrought in metal. The Holy Roman Emperor Charles V, rival of François, paid more for a suit of armor than for a painting by the Italian master Titian.

The art of making armor reached its zenith in the era of François I and his successors Henri II and Charles IX. Ironically the military need for armor was waning at that time, with the increasing use of firearms and artillery that could shatter protective metal. Knights, of course, resisted the change as best they could. When German knights captured a musket-bearing infantryman in battle, they sometimes cut off the man's hands and blinded him in punishment for waging war in so unchivalrous a fashion.

Though armor was becoming obsolete on the battlefield, nobles still required it for the joust—a mock battle, but still a dangerous one, in which two horsemen leveled wooden lances at each other and charged. The object was to unseat one's opponent, or at least to win points for a good performance from judges on the sidelines.

The armor shown here cost too much to be risked in a joust, and the protruding ornaments would have caught a lance thrust instead of deflecting it. Rather, the kings wore this armor when they viewed jousts, or in parades and in the pageants held when a sovereign visited a town. Astride a prancing horse, aglitter in gilded or polished steel armor, the king awed his subjects as he passed through a town on his way to a feast or a pageant.

Several pieces of armor on these pages have decorations based on Greek or Roman legends and history—a battle scene from the third-century-B.C. war waged by the African city of Carthage against Rome; the monstrous head of Medusa brandished by the Greek hero Perseus; and the famed lion's-head trophy of Heracles (opposite). Donning his armor the king clothed himself in myth, imagining himself the scourge of imperial Rome, or the comrade of Heracles.

A helmet shaped as the upturned head of a lion gives this suit its name—the Lion Armor—and was probably an allusion to the lion's head worn by Heracles in Greek legend. The famous Negroli armory of Milan made the suit, of steel with gold inlay, for François I. The medallion on the chest and the scallop-shell collar are the emblems of the knightly order of Saint Michael.

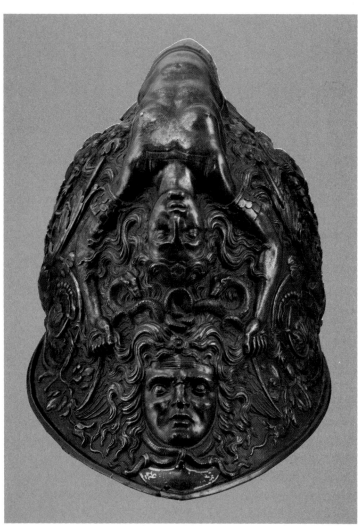

On the top of a parade helmet owned by François I, a mermaid (above) grasps the hair of Medusa—the hideous Gorgon of Greek mythology, whose head bristled with snakes and whose face turned men to stone. Philippo de Negroli hammered the lavish ornamentation (right) from cold steel.

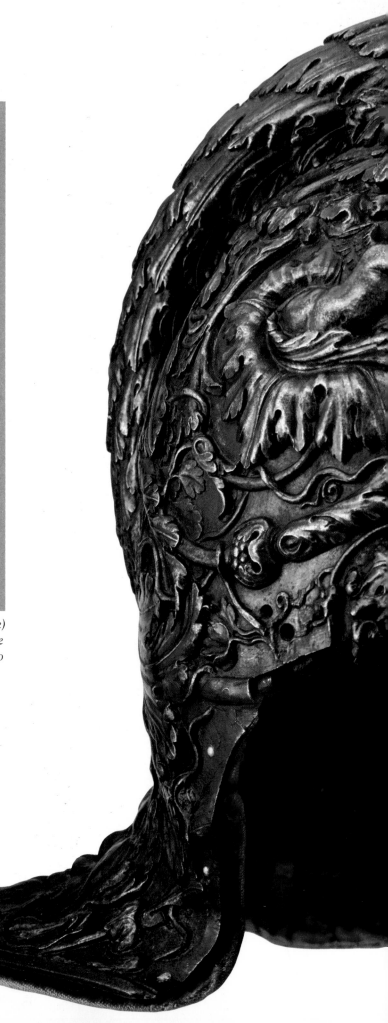

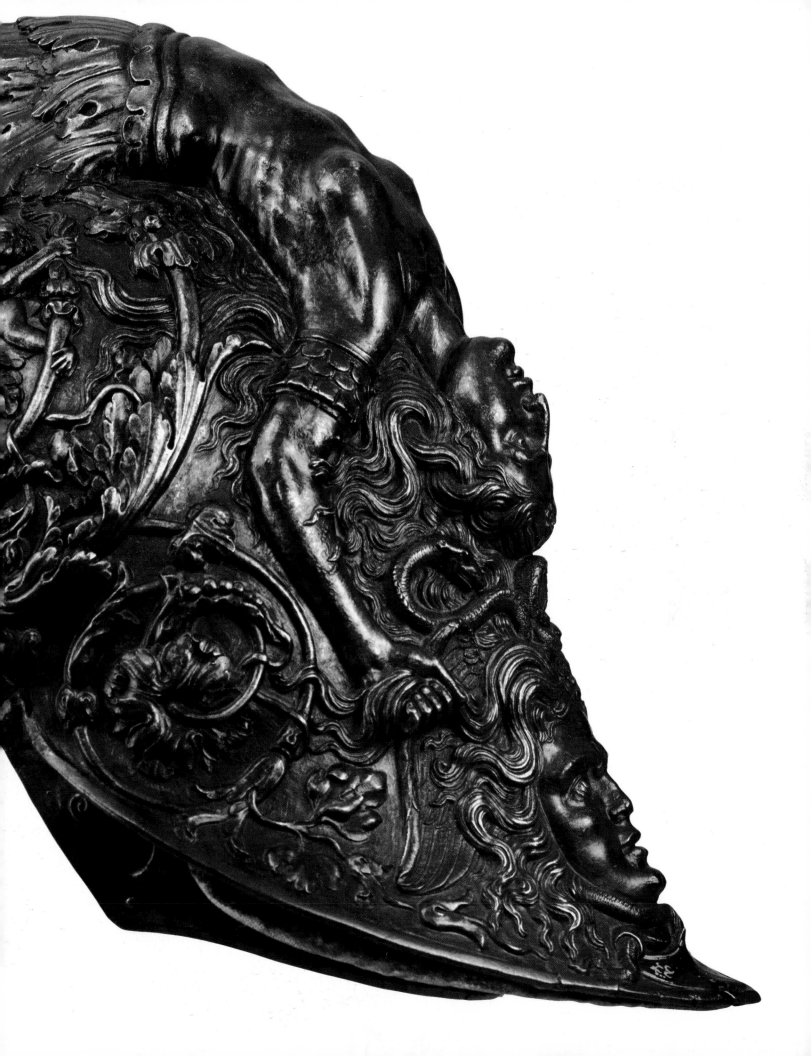

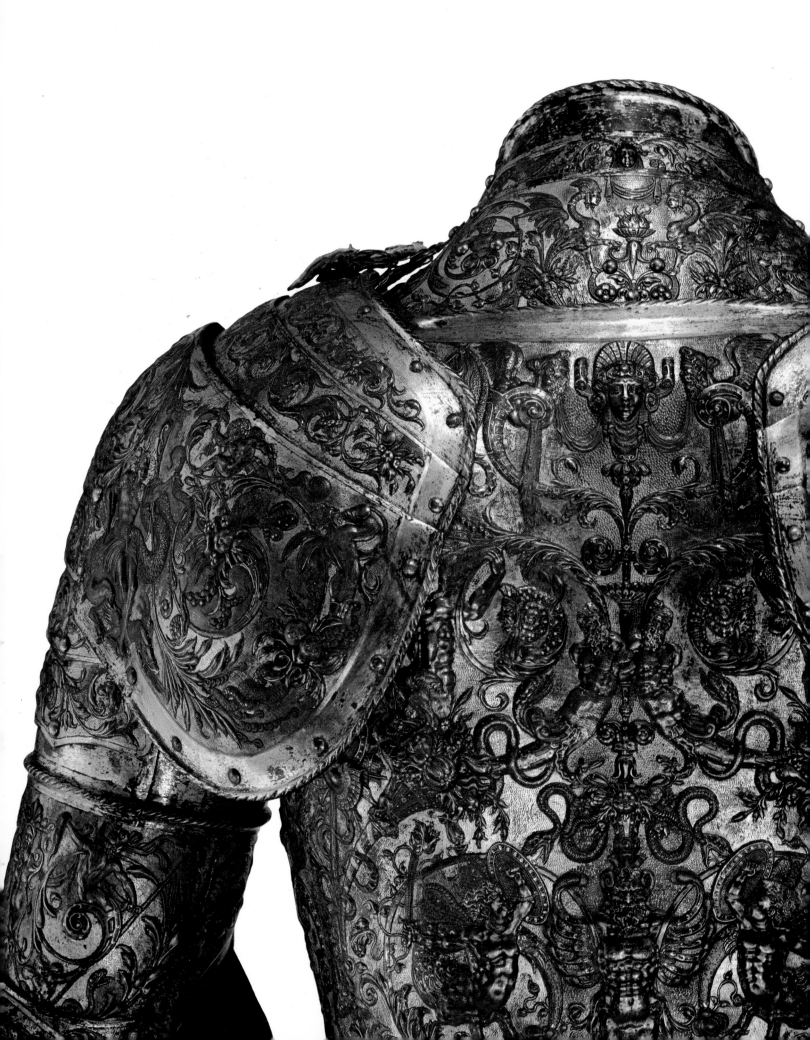

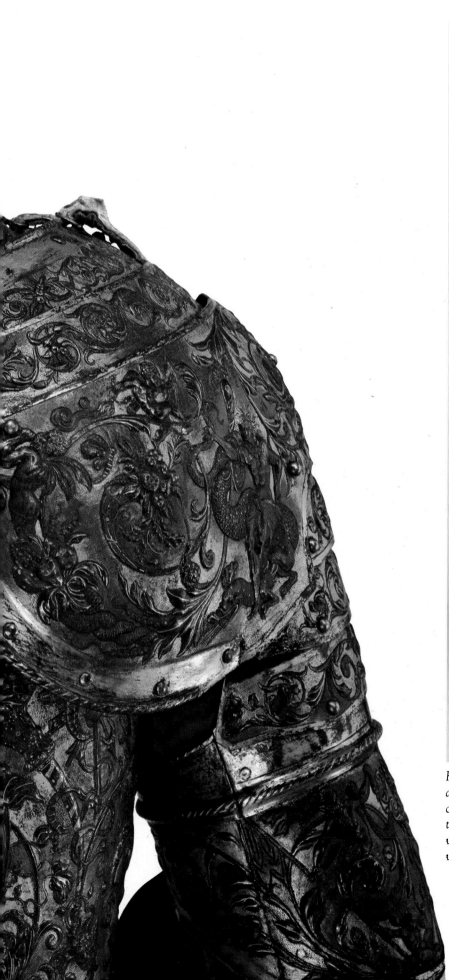

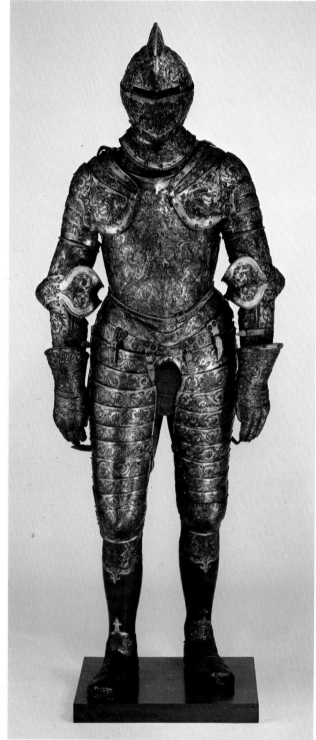

Henri II commissioned Etienne Delaune to design the suit of armor above for a ceremony in the 1550s. A host of fantastic creatures decorates the back of the armor, in detail, left. Between the shoulder plates seashells sprout heads and wings. At bottom winged swordsmen with plumed tails flank a bizarre bearded man with twelve insectlike arms.

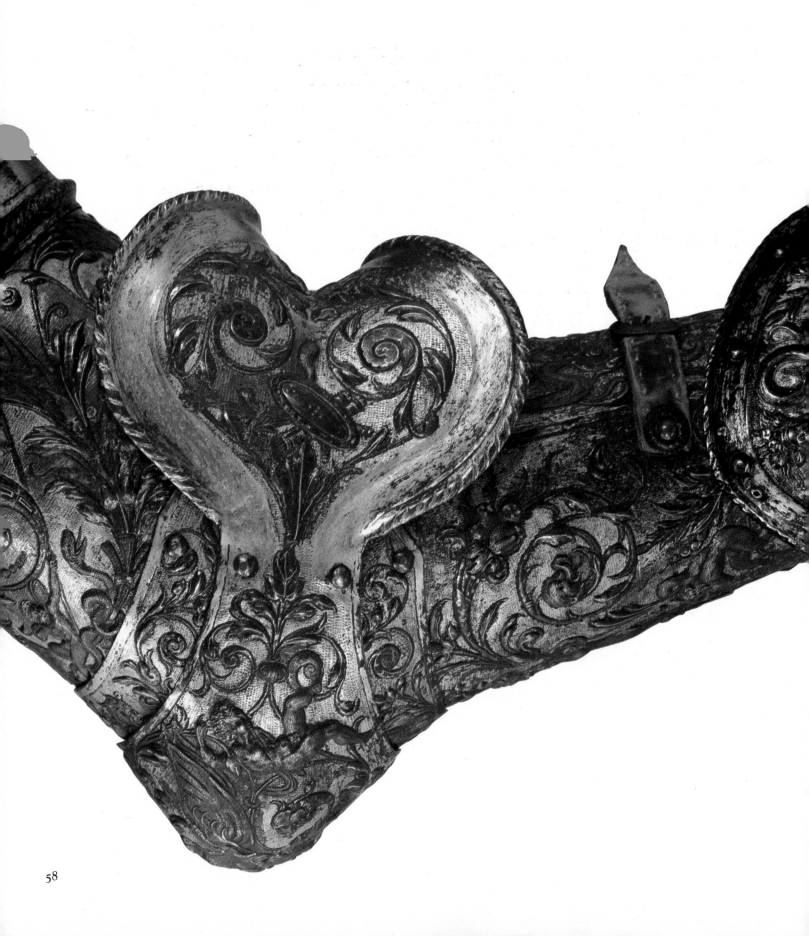

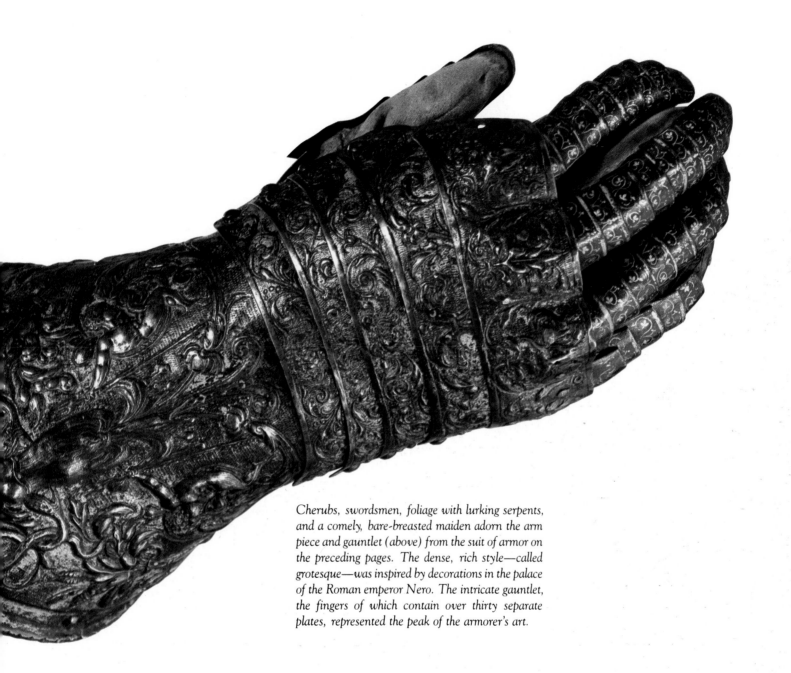

Cherubs, swordsmen, foliage with lurking serpents, and a comely, bare-breasted maiden adorn the arm piece and gauntlet (above) from the suit of armor on the preceding pages. The dense, rich style—called grotesque—was inspired by decorations in the palace of the Roman emperor Nero. The intricate gauntlet, the fingers of which contain over thirty separate plates, represented the peak of the armorer's art.

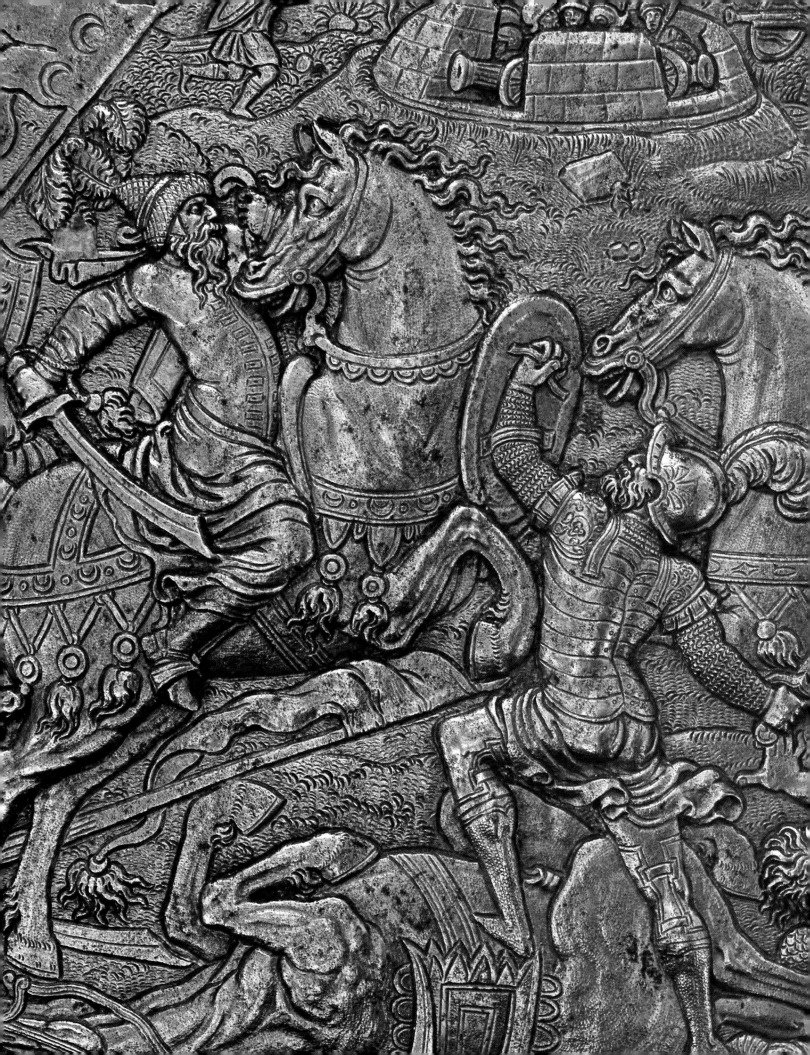

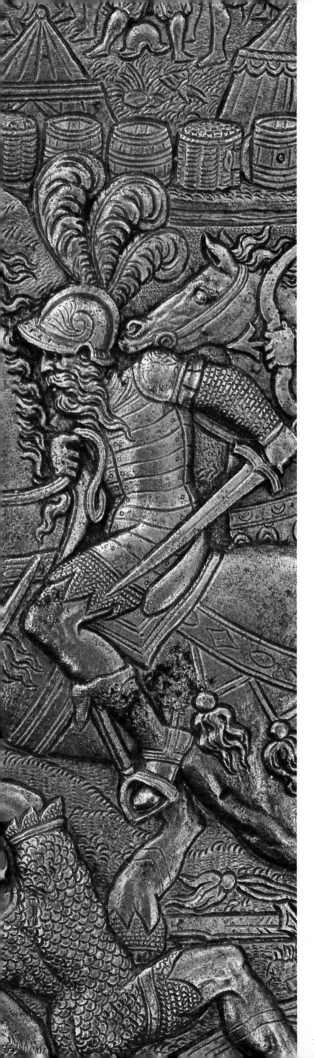

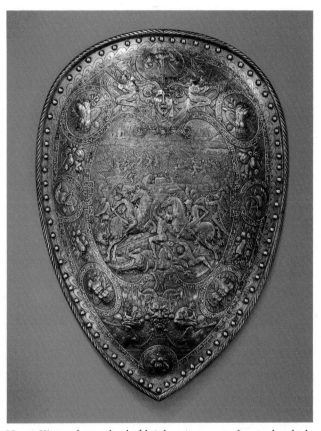

Henri II's steel parade shield (above), twenty-five inches high, commemorates the third-century-B.C. battle of Cannae, in which the Carthaginian general Hannibal annihilated a Roman army in southern Italy. The embossed ornamentation (detail, left) vividly portrays the ferocious hand-to-hand combat between the Romans (on the right) and Hannibal's Gallic auxiliaries.

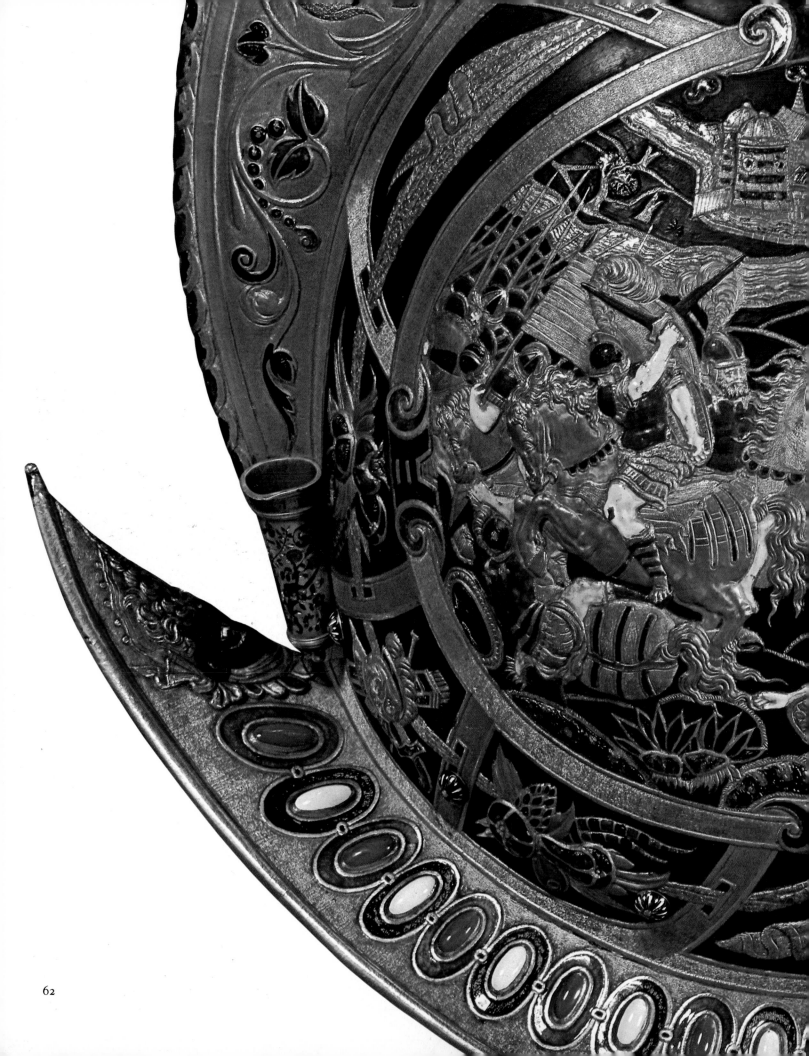

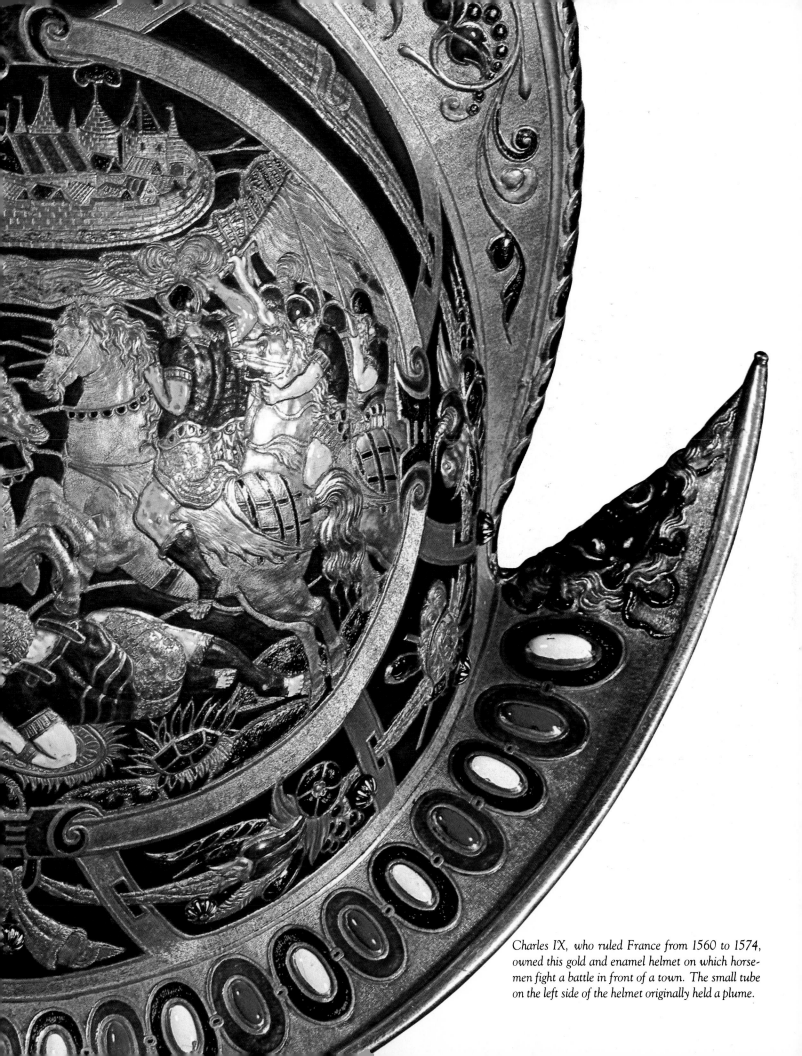

Charles IX, who ruled France from 1560 to 1574, owned this gold and enamel helmet on which horsemen fight a battle in front of a town. The small tube on the left side of the helmet originally held a plume.

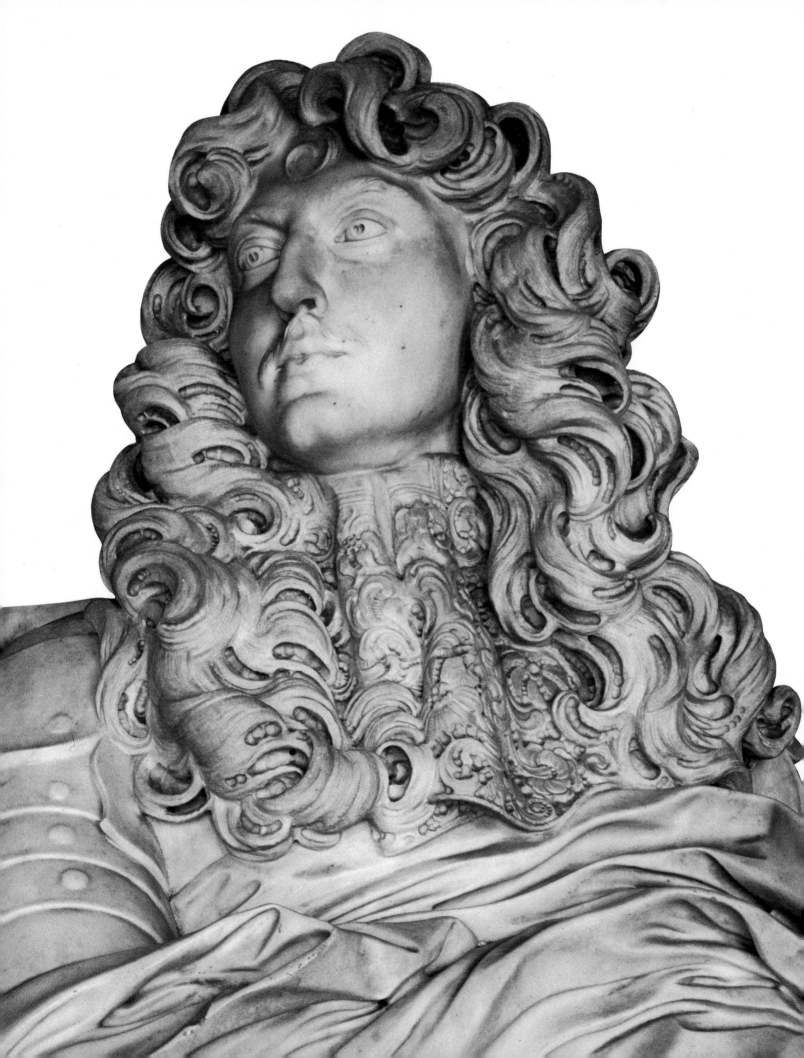

III

LOUIS XIV

THE POLITICS OF DISPLAY

All you have seen of the splendor of Solomon cannot compare with the pomp that surrounds the king," an officer in the French army wrote to a friend while accompanying Louis XIV to Flanders in 1670. The army, with its gorgeously attired regiments of foot and horse, was part of the aura of magnificence that surrounded the most powerful and long-lived of all the kings of France. In his mid-thirties, Louis amassed a peacetime army of 120,000 well-trained soldiers—a vast army by seventeenth-century standards, and one that transformed France into the foremost military power in Europe. The French grenadiers were armed with a new and terrifying weapon, the bayonet. For the first time in military history, moreover, almost the entire army was dressed in uniforms—light gray faced with red and other cheerful colors—in the interests of discipline and control as well as of fashion.

Yet Louis XIV was never a soldier-king like his predecessors François I or Henri IV. He left it to his field marshals to expose themselves to shot and shell. Reviewing dress parades was more to

The Italian sculptor Gianlorenzo Bernini unveiled this marble bust of Louis XIV in 1665. The king loved the portrait and displayed it prominently at Versailles.

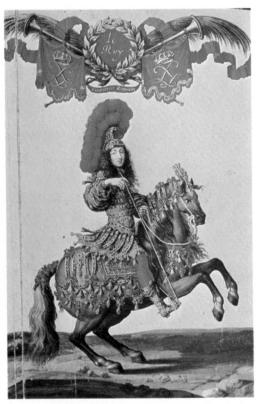

Cast as a Roman emperor, Louis XIV bestrides his horse in a pageant celebrating the birth of his first son, Louis, the grand dauphin, in 1662. The illustration above is from a book—bound in red leather, stamped with gold, and colored throughout—that the king published to commemorate the gala.

his liking, or witnessing the formal surrender of cities and towns that his army had besieged—ceremonial occasions to which he could invite the ladies of his court. It was the ballroom rather than the battlefield that really riveted his attention. His finest hours were those in which he led the great nobles of his realm in dancing court ballets, and when he took his part in the great equestrian spectacle known as *le carrousel,* a ballet on horseback which was descended from medieval jousting.

He was an expert dancer: for twenty years he took daily lessons from his ballet master, Pierre Beauchamps, and the result was a splendid carriage that proclaimed him a king even in this field of endeavor. "To the least gesture, his walk, his bearing, his whole countenance, all was measured, all seemly, noble, grand, majestic and withal very natural," wrote the duc de Saint-Simon, who inhabited the salons and the corridors of Versailles for three decades and set down most of what he saw and heard there.

Louis was only fifteen when for the first time he played the role of the Sun in the thirteen-hour *Ballet of the Night,* dressed in a golden costume with a sun symbol on his chest, light beams shining from his neck, wrists, and ankles, and a crown of sunbeams on his head. He gave a dazzling performance: henceforth he was to reign in life, as in ballet, as *le Roi Soleil,* the Sun King. "I chose to assume the form of the sun," he wrote later without a trace of false modesty, "because of the unique quality of the radiance that surrounds it; the light it imparts to other stars, which compose a kind of court; the fair and equal share that it gives to all the various climates of the world; the good it does in every place...and that constant, invariable course from which it never deviates or diverges—assuredly the most vivid and beautiful image of a great monarch."

The Sun King's father, Louis XIII, died when his son was only five years old, and the boy was left to face a difficult and dangerous decade. Many of the great nobles of France were in revolt against the regency headed by his mother, Anne of Austria, and her indispensable first minister, Cardinal Mazarin. An Italian diplomat of humble origins who had become a cardinal without ever having been a

priest, Mazarin devised a foreign policy for France that was unclut-
tered by nationalist preconceptions. He realized that above all else
France needed peace with her old rival, Spain, and to that end he
engineered the marriage of the young Louis XIV with his cousin, the
infanta Maria Theresa of Spain. France and Spain were at war while
the negotiations were conducted, but the wedding brought hos-
tilities to an end, at least for the better part of a decade. It did not, of
course, prevent Louis from falling in love with a succession of women
who were prettier, brighter, and more sensuous than his royal bride.

The elderly Mazarin lived until 1661, long enough to see his
foreign policy come to fruition and to indoctrinate the young king
in the arts of statecraft. Mazarin's success on the domestic front was
due, in large measure, to the efficiency of his devoted financial
secretary, Jean-Baptiste Colbert. Mazarin himself had not been
nearly so scrupulous as Colbert in conducting his own affairs and had
amassed a private fortune during his ministry. "Sire, to you I owe
everything," he told the king as he lay dying. "But I repay part of the
debt by leaving you Colbert." Indeed, Colbert was to prove
indispensable.

Louis, who was twenty-two when Mazarin died, decided that
there would be no more first ministers running the government on
the king's behalf. In the early years of his reign Louis had been
relatively poor, for less than half the taxes paid by the people actually
reached his treasury. The rest lined the pockets of his farmers-
general, financial contractors who purchased the right to collect
certain taxes. They ground the faces of the poor and amassed great
private fortunes. The foremost among them was the superintendent
of finance Nicolas Fouquet, who used his embezzled millions to build
a palace at Vaux-le-Vicomte, near Paris, which was decorated with a
magnificent collection of paintings, tapestries, sculptures, and ob-
jets d'art.

Shortly after Mazarin's death the arrogant Fouquet committed the
blunder of trying to impress his master the king by inviting him to
one of the most sumptuous fetes ever given in France—a party at
which six thousand guests were regaled with superb food, music,

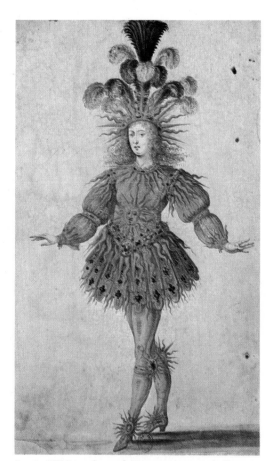

*Louis XIV performed in many court ballets as
Apollo, the Greek god who drove the chariot of the
Sun. Both a patron and a student of dance, the mon-
arch chose roles in palace entertainments that glori-
fied his identity as the Sun King.*

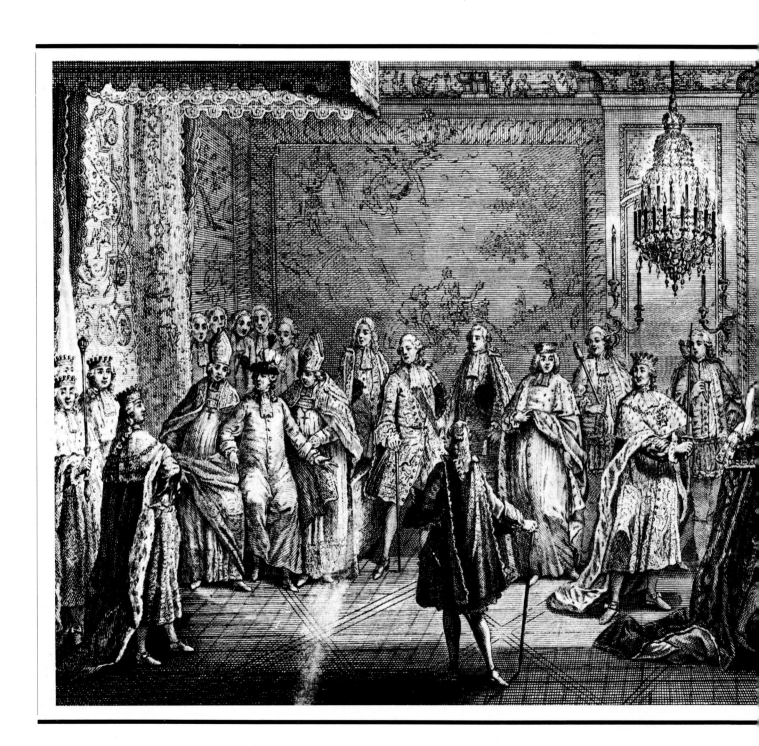

THE SUN ALSO RISES

From the moment he awoke, Louis XIV was on display. Audiences of course watched as he performed the duties of state, and courtiers mobbed his receptions and balls, but Louis also made unprecedented spectacles of his meals, garden strolls, and dressing (as at left in *le grand lever*, the royal morning ritual of Louis and his successors). Louis XIV's day began at eight o'clock, when the first valet of the bedchamber bolted from his cot beside the monarchial bed to rouse his master and summon doctors to tend to the king, as well as masseurs to give him an invigorating rub. In his dressing gown and sleeping wig, the king permitted certain nobles, family members, clergy, and ministers to watch him eat a breakfast of bread and wine.

Before his swarm of witnesses, the king commenced dressing. Favorite servants and courtiers presented garments to him according to exacting etiquette: while the first valet of the bedchamber helped the king into the right sleeve of his shirt, the first valet of the wardrobe assisted only with the left. And so it followed with velvet britches, brocaded coat, silk stockings, golden-buckled shoes, wig, and plumed hat, until, accepting his lace handkerchief, Louis was ready to face the day. The king's evening retirement provided yet another opportunity for an ambitious courtier to rise: to hold a candle as Louis undressed for bed was one of the highest honors bestowed at Versailles.

In this eighteenth-century engraving, elegant courtiers, members of the clergy, and state officials jockey for position around the king (seated at far left in his nightshirt and hat) as he begins his day.

theater, and fireworks. Louis, though duly impressed, also became furiously jealous; his own rather obsolete palaces had nothing to compare with this majestic building, its spacious gardens, and its opulent decor. Three weeks later he arrested Fouquet, charged him with treason and misappropriation of funds, and ultimately had him sentenced to life imprisonment.

Now Louis summoned his principal advisers and informed them that there would be a new way of doing things: "It is time for me to govern my own affairs. You will assist me with your advice when I ask for it." The number of ministries was reduced from twenty-four to three. He made Colbert, the controller-general of finance, his chief administrator. Colbert supervised the collection of taxes and everything that touched on economics. Under his aegis the industries and commerce of France began to rival those of England and Holland. He formed new trading companies for the exploitation of French colonies in India and the West Indies; he put French shipyards to work building scores of frigates and merchantmen, both essential to the development of an overseas empire that was to provide important new sources of wealth for traders and manufacturers.

But the most important changes took place on home ground. For the first time since the Reformation, continental France was able to develop its economy free from the trauma of civil war. Because of Colbert's reforms the roads were open and free of brigandage; Colbert abolished internal tariffs and local excise taxes so that goods could move freely throughout the country; he built the vital canal of Languedoc, which connected the Atlantic to the Mediterranean and facilitated the shipment of inland cargoes.

Through Colbert and his inspectors, the king intensified his control of every aspect of government, down to the municipal level. Unlike his predecessors he worked six to eight hours a day running the affairs of France—"informed about everything," as he put it, "listening to the least of my subjects, knowing at any time the numbers and quantity of my troops and the state of my strongholds, unceasingly giving my instructions upon every requirement, dealing directly with ministers from abroad, receiving and reading dis-

patches, making some replies myself, regulating the income and expenditure of my State and keeping my affairs secret as no other man has before me." The country he governed had grown in population as well as wealth; with nineteen million inhabitants by 1660 it was now the most populous nation in Europe.

And the misdeeds of Fouquet had still another momentous consequence. In its beauty and splendor, Vaux-le-Vicomte established most of the precedents for the king's own dream palace, Versailles, which was to duplicate its achievements, but on a far grander scale. Fouquet's architect Louis Le Vau, his landscape architect André Le Nôtre, his painter-designer Charles Le Brun, and even his playwright Molière, were all co-opted into the king's household and richly rewarded for their services to the crown. Henceforth the glories they created were reserved for Louis, and no one else ever made the mistake of trying to upstage the king of France.

In 1661, shortly after his visit to Vaux-le-Vicomte, Louis began to reconstruct his father's small hunting château and gardens at Versailles, eleven miles southwest of Paris—a project that took more than forty years to complete. It was to be the largest, most magnificent palace that Europe had ever known, the outward, physical manifestation of the Grand Monarque's incomparable power and *gloire*. It could have been built only after the creation of a centralized government capable of mobilizing the entire resources of the nation on behalf of the monarchy. At Versailles Louis's restless imagination created a style of palatial living that eclipsed anything his predecessors might have dreamed of; in the century that had elapsed since François I, the stylistic emphasis of court life had moved from grandeur to extravagance. Soon the palace and its contents had caused an aesthetic revolution throughout Europe, and mini-Versailles began to appear at Potsdam, Vienna, Aranjuez, Schwetzingen, and St. Petersburg, among others—obliging their builders to import French architects, upholsterers, and cabinetmakers; later on they would require French dancing masters, chefs, and governesses.

Louis knew very well what he was doing when he created this

Louis XIV, in red, visits the Gobelins, the great factory in Paris where craftsmen, working under the direction of Louis's official painter, Charles Le Brun, made royal tapestries and furnishings. This visit to the workshops—on October 15, 1667—is from a tapestry based on a Le Brun painting.

isolated capital away from the pressures and uncertainties of mob-ridden Paris. By drawing the great nobles to his court he prevented them from making trouble for him in the provinces. At Versailles they had no choice but to become courtiers, committed to the king's service by the demands of fashion and protocol. "One is puny at court," one of them wrote, "and however proud one may be, one has to realize it. But the complaint is general, and even the great are small." Before Versailles many of these dukes and counts had led independent lives as lords of their own domain; now they represented no danger (and little help) to the crown, wasting their lives at costume balls and at the gaming tables. The worst punishment they could imagine was to be banished from Versailles—condemned to boredom and insignificance on their own estates.

Louis spent sixty-five million livres building the palace that became the cynosure of all Europe. (It did not bankrupt the nation, but by comparison a peasant's house at the time cost about twenty livres to construct.) Louis had the knack of working harmoniously with the most gifted architects, designers, and master craftsmen: he expressed his wishes; they elaborated his ideas. Originally the landscape around Versailles had been unprepossessing; "the saddest, the most unattractive of places," as the duc de Saint-Simon put it, "without views, any woods or streams, nothing but shifting sand and swamps." All the more reason for Louis to rearrange nature and create an environment worthy of the Sun King: he felt the need to leave his stamp on everything he touched.

Beauty and order were the central themes of his reign, and to achieve his vision of orderliness he was prepared to live for more than twenty years amid the clutter and confusion of the biggest construction site in Europe. Colbert, counting the costs, had every right to wring his hands over his master's extravagance: "His Majesty has laid down that everybody to whom he gives apartments should be provided with furniture. He is having everybody fed and all the rooms equipped even down to firewood and candles, which has never been the practice in royal houses." In 1682, when Louis officially moved his government to the still-unfinished palace, two

TEXT CONTINUED ON PAGE 76

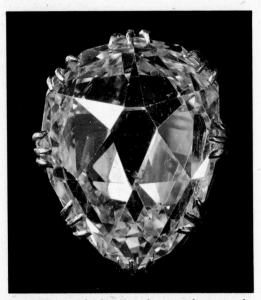

Louis XIV was the first French monarch to wear the Sancy Diamond (above), a fifty-five-carat stone given to him by his father's prime minister, Cardinal Mazarin. The Sancy was one of the first diamonds to be cut into symmetrical facets.

APOLLO'S GALLERY

Though Louis XIV determinedly moved his court and government from Paris, he did leave behind some of his most prized possessions in the Gallery of Apollo at the Louvre, which was still a palace. The gallery had been destroyed by fire, but in 1661 Louis hired his Versailles designers Louis Le Vau and Charles Le Brun to recreate it as the grand repository of his possessions, a few of which are on these pages. This treasury of the French crown reveals Louis XIV as a patron of the fine arts, a keeper of historical relics—and a lover of diamonds, gold, crystal, and other beautiful and expensive things.

In his typical fashion, Louis spared no expense on the gallery, sending buyers throughout Europe and to the Orient and the Americas to find gems, most of which he lavishly mounted in gold. Vases, statuettes, inkstands, mirrors, ewers, and other objects in the collection—all of them made of rare stone and precious metals—were enriched with gilding, enamel, and jewels. If Louis could not find the treasure he was looking for, he commissioned what he fancied from his own artists. Though the splendor of the Sun King emanated from the palace at Versailles, his extravagant taste was now on permanent display in Paris.

Classical columns and an elaborate pediment of highly polished agate frame the seventeenth-century crystal mirror opposite, which Louis XIV bought for his Gallery of Apollo. Cameos, miniature busts, large emeralds, and enameled gold surround the looking glass.

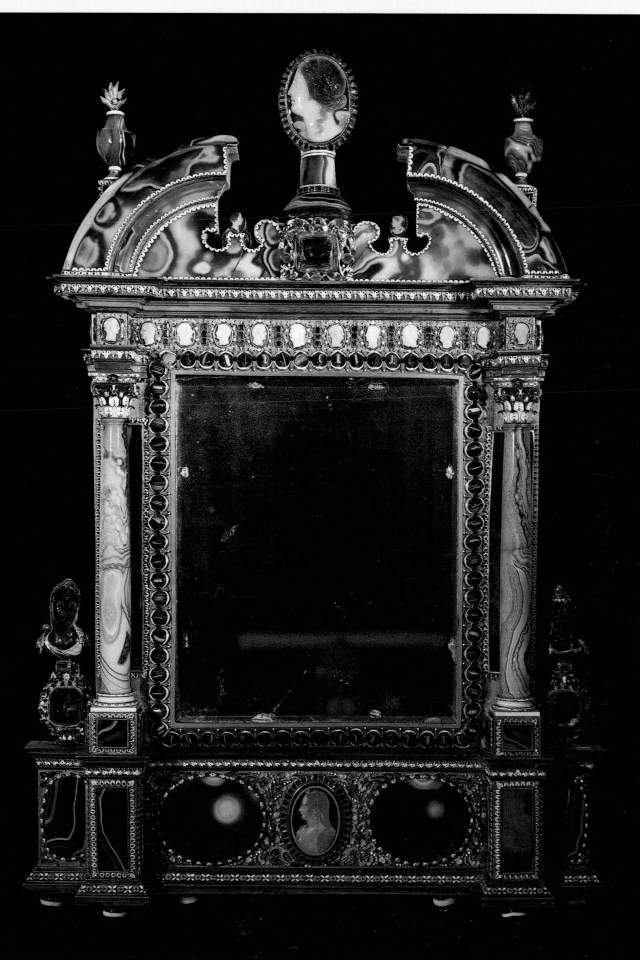

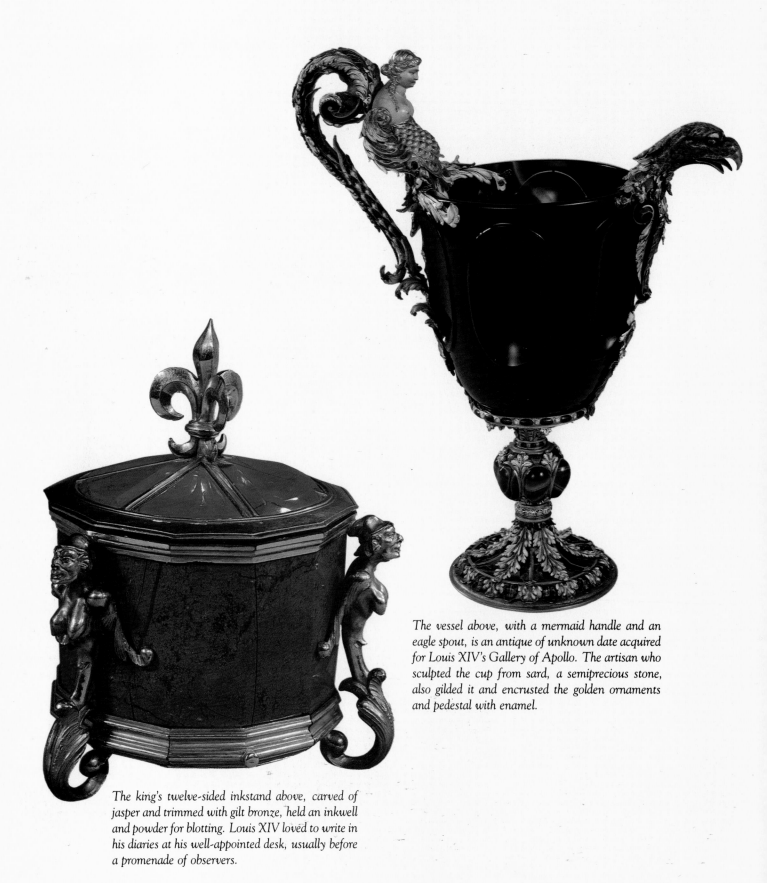

The vessel above, with a mermaid handle and an eagle spout, is an antique of unknown date acquired for Louis XIV's Gallery of Apollo. The artisan who sculpted the cup from sard, a semiprecious stone, also gilded it and encrusted the golden ornaments and pedestal with enamel.

The king's twelve-sided inkstand above, carved of jasper and trimmed with gilt bronze, held an inkwell and powder for blotting. Louis XIV loved to write in his diaries at his well-appointed desk, usually before a promenade of observers.

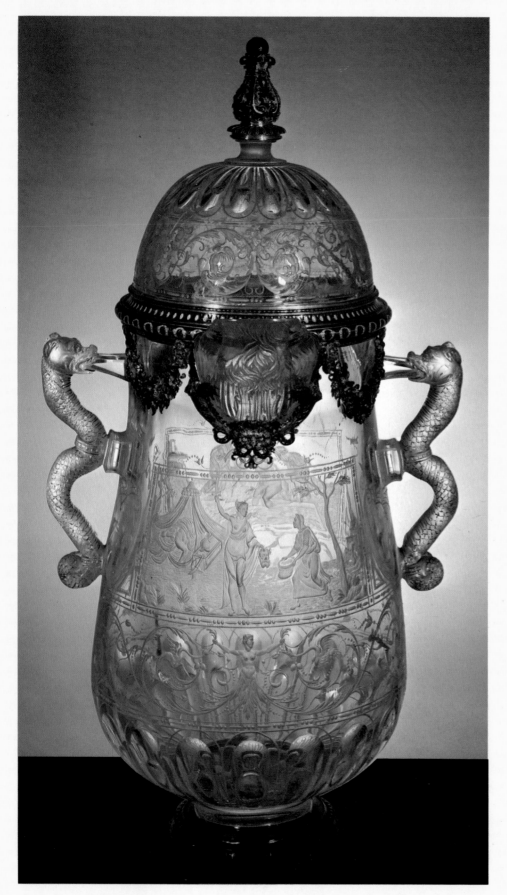

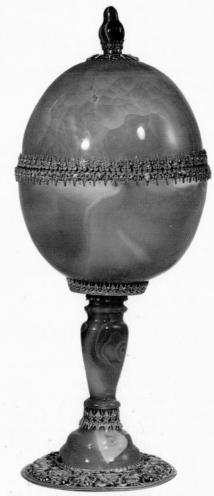

The egg-shaped, stemmed cup above, carved from agate stone, is actually a covered dish that a royal jeweler made for Louis XIV. Rings of gold and enamel decorate the cup's pedestal (also of agate), seam, and top piece.

The serpent-handled crystal vase at left, rimmed and capped with enameled gold, bears etchings illustrating the legends of biblical heroines Judith and Susannah. The vessel was probably made in the middle of the sixteenth century in Milan.

TEXT CONTINUED FROM PAGE 71

thousand servants were employed in the kitchen, pantry, and wine cellars just to feed this agglomeration of hungry mouths.

With his royal landscape architect Le Nôtre, Louis turned the most unattractive of swamps into the world's most spectacular gardens—formal, symmetrical, and constantly decked out in new plants and flowers. He had four hundred gardeners, who were prepared to change the tulips in a terrace two or three times a day if the occasion warranted. No less important to the development of Versailles was the superintendent of buildings, Charles Le Brun, an artist of great versatility. He painted royal portraits, decorated the ceiling of the Hall of Mirrors (see pages 96–107), designed furniture, tapestries, vases, candlesticks—even a door knob—and supervised every detail of the palace interiors. He set up the Manufacture des Gobelins in Paris for the sole purpose of furnishing the royal palaces. Under his direction it produced furniture, tapestries, mosaics, sculpture, and masterpieces of the goldsmith's and silversmith's art.

An army of craftsmen labored for the greater glory of the monarch in workshops and factories throughout northern France. Paying them involved what Colbert described as "spending which is so extraordinary that it must surely be unprecedented." In addition Versailles had to be paid for in more than money. Two hundred twenty-seven workmen died in construction accidents during the building of the palace, and some of its most beautiful appointments—the Hall of Mirrors is a striking example—entailed tremendous hardships for the workers who created them.

France produced virtually no mirrors when Louis took over the government; 300,000 livres' worth of mirrors were imported every year from Venice, which enjoyed a monopoly on mirror-making technology. In defiance of a Venetian law that prohibited anyone, on pain of death, from taking the secrets of mirror making to a foreign country, Colbert had twenty Venetian glassmakers brought to Paris. He set up a royal mirror workshop in the Faubourg Saint-Antoine, and soon French mirrors were superior in quality to those of Venice. But the factory exacted a terrible toll from those who worked there. The rooms were sealed tight against fresh air, which

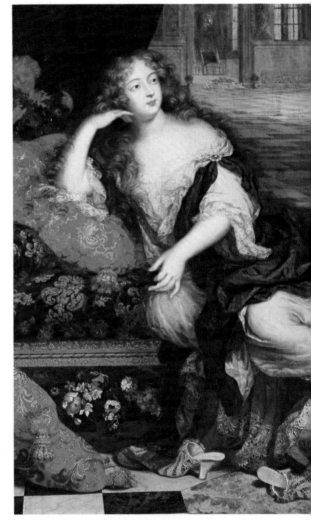

Madame de Montespan, one of several mistresses of Louis XIV, reclines on her bed in this seventeenth-century painting. Madame de Montespan was a great wit and, according to her enemies, a practitioner of black magic: she won the king's heart after consulting a sorceress.

could have caused stripes in the mercury backing. After a few months men and women laborers came down with mercury poisoning—"Soon all their limbs are seized by a constant trembling. . . ." Thanks to them Louis's architect Jules Hardouin-Mansart was able to create the Galerie des Glaces.

Some of the smallest objects at court were, of course, the most expensive. As Colbert's tax revenues began to pour in, Louis filled the royal vault with jewels worth millions of livres, among them the brilliant, sixty-seven-carat, blue stone now known as the Hope Diamond (cut down to forty-five carats); the fifty-five-carat, pear-shaped Grand Sancy Diamond, bequeathed to the king by Mazarin; the *Diamant Hortensia;* and many other gems: between 1665 and 1668 alone he spent more than two million livres on precious stones.

When Louis appeared in court ballets and festival processions, these jewels would sparkle on his costume and on the horse he was riding. He loved moving in their refracted light not only because they proclaimed his power but also because, despite his mastery of the world of solid objects, he was even more fascinated by movement, glitter, and change. His passion for splendor in motion dominated his politics, aesthetics, and choice of a succession of imposing and powerful mistresses—though the rhythms, of course, had to be suitably dignified.

Under Louis the fete, the processional, and the horseback ballet reached their apogee, for all of them were a kind of public theater designed to impress his subjects with the aura of majesty. At the fete *Les Plaisirs de l'Ile Enchantée,* held at Versailles in May 1664, for example, the king made his formal entry into the grounds of the unfinished château accompanied by six hundred noblemen of his court, preceded by heralds, pages, and equerries carrying shields and signs with poems written on them in golden letters. Louis rode through the triumphal arches especially built for this spectacle in a coat glittering with diamonds. He was accompanied by an immense chariot of the Sun, followed by the Four Ages (of gold, silver, bronze, and iron), the Signs of the Zodiac, the Four Seasons, and the Hours. This great parade of living symbols and metaphors was his way of

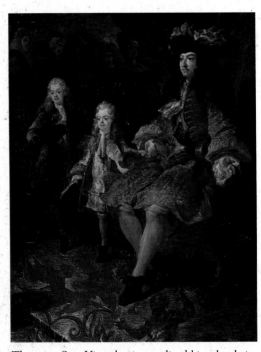

The aging Sun King, having outlived his other heirs, brought his great-grandson—the future Louis XV— to his throne, to introduce the boy to his court. Antoine Coypel, an artist at Versailles, made this painting in 1715—the year of the king's death.

showing the world the place he had reserved for himself in history. Later that day there was a banquet illuminated by four thousand torches, at which the food was served by retainers dressed as fauns, dryads, and forest nymphs. The entertainment went on for seven days. In such an environment no one could say for certain where reality ended and fantasy began.

His court had become a perpetual theater, and to help with the staging Louis employed the greatest costume designer of his time, Jean Bérain, who ran the department known as the *Menus Plaisirs* (in England the man who occupied that position was known as master of the king's revels). Bérain created sets and costumes for the court opera, ballets, and theatrical performances, and directed the choreography of the carrousels. In these spectacles the whole genius of Louis's reign—and its weaknesses—revealed themselves. The chariots and costumes, floats and disguises conjured up a brilliant world of make-believe that served to obscure the harsher realities of the nation itself.

In time Louis himself became intoxicated by his image as the all-powerful Roi Soleil, and his pursuit of still further glories led him into ruinous military adventures that dissipated the nation's resources and drained the exchequer. He went to war against England and the Low Countries. One English victory, in 1704 at Blenheim, left thirty thousand dead or wounded Frenchmen. These wars, rather than his edifice complex, accounted for the fact that at his death he left a national debt estimated at three billion livres, enough to have built forty or fifty Versailles. On his deathbed in 1715, after a reign of seventy-two years, he cautioned the five-year-old dauphin, his great-grandson, against repeating his errors. "Soon you will be king of a great kingdom. . . ." he told the boy. "Try to remain at peace with your neighbors. I have loved war too much. Do not copy me in that, or in my overspending. Take advice in everything; try to find out the best course and always follow it. Lighten your people's burden as soon as possible, and do what I have had the misfortune not to do myself." Had his advice been followed, there might still be a ruling house of France, as there is of England.

A PALACE FOR
THE SUN

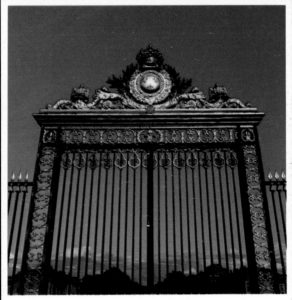

The gilded gates of Versailles, topped with royal emblems,
open onto the magnificent palace, fountains, and gardens
envied by Europe's mightiest kings.

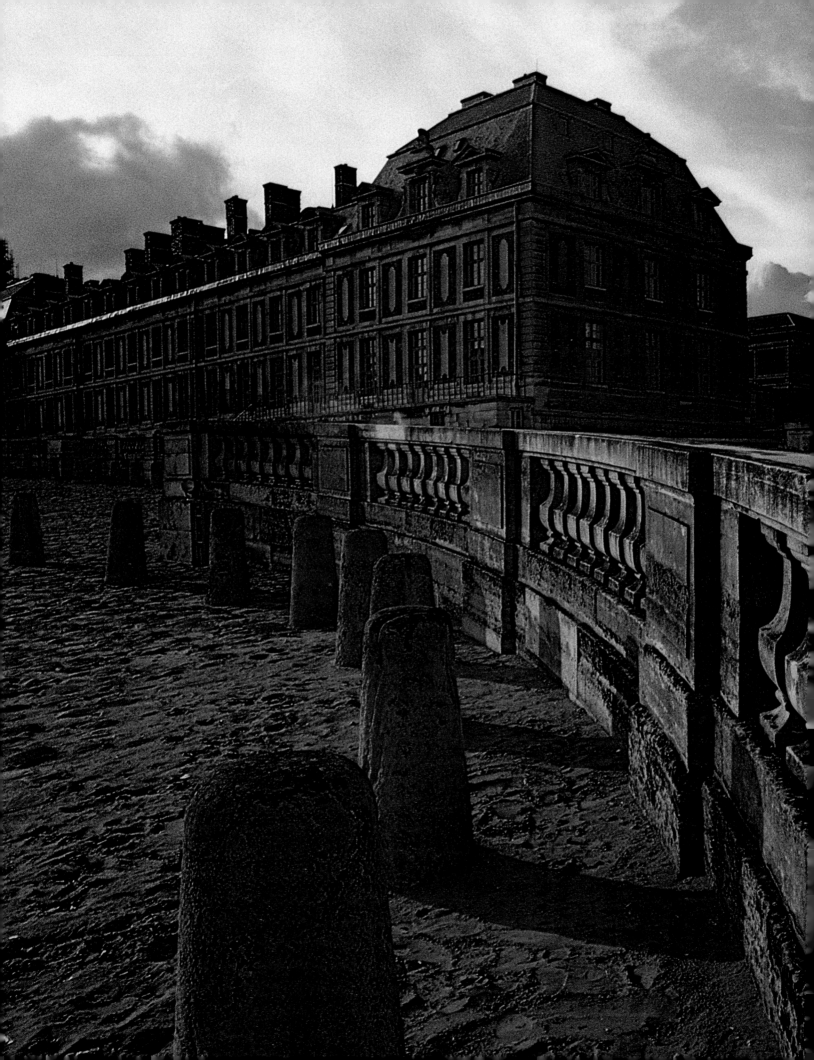

In 1677, when Louis XIV moved his entire court and government from Paris to Versailles, all the king's retinue, even his bishops and family, vied for a place in the immense château. Over a period of fifty years, thousands of workers transformed what had once been Louis XIII's hunting lodge into the greatest palace of Europe—"a place," in the words of one of the many diarists at Versailles, "to show what a great king can do when he spares nothing to satisfy his wishes." Having commissioned architects Louis Le Vau and Jules Hardouin-Mansart and artist Charles Le Brun to design it, Louis spent such a fortune on the palace that he had to destroy the financial records to avert a national scandal over his extravagance. No matter that many of the apartments at Versailles were cramped and drab: ten thousand people considered it an honor to live there, their lives governed by etiquette and protocol that at times seemed insane: for example, the king forbade knocking upon doors at Versailles, decreeing that one should scratch at them with the nail of the little finger, a rule requiring great attention to manicure.

Beyond the palace's rooms, many filled with masterpieces, were Louis's gardens, which the landscape architect André Le Nôtre created as a classical setting for sculpture and fountains celebrating the Sun King. Gardeners tended acres of trees, shrubs, and flowers; a team managed the numerous fountains so that they played as the king strolled past, one magnificent spray of water following another as Louis moved about. The king loved his immaculate grounds, statuaries, and dancing fountains, and he loved sharing the view with those he esteemed. To walk with Louis in his gardens was the ultimate ambition in many a courtier's life.

As he set out on his afternoon walk, Louis XIV might pass the Wing of Northern Ministers, left, which faces the largest courtyard at Versailles. The second royal architect, Hardouin-Mansart, added the building to the palace complex.

OVERLEAF: *Heading toward his gardens, Louis passed the three-story facade of his palace's southern wing, the quarters of his dukes. High above the perfectly coned shrubbery are eight statues representing the arts and sciences.*

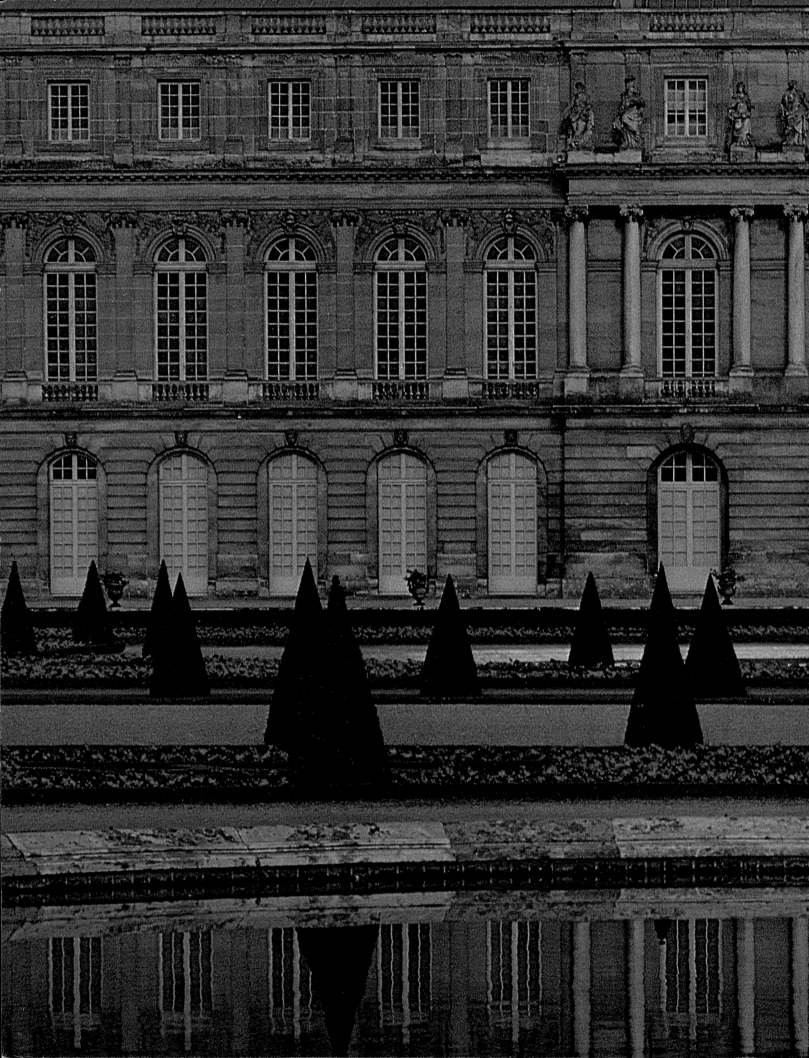

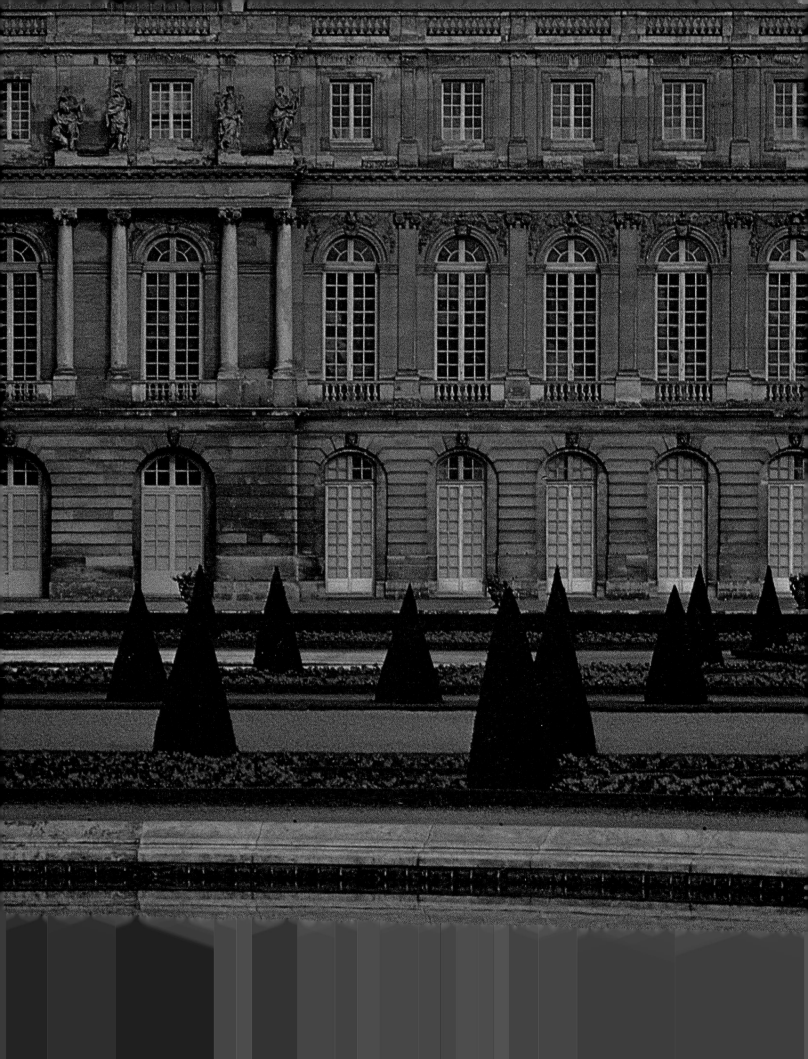

Louis XIV sometimes ordered entire flower beds to be replanted as often as three times a day so that he could enjoy new colors and fragrances on each visit to his gardens. (Particularly fond of tulips, the king imported over a million bulbs every year from Holland.) Louis's gardens—their precise, geometric patterns reflecting a masterly shaping of nature—defined the ideal of seventeenth-century French landscape architecture. No plant grew wild, and nothing about the gardens was unplanned: the fleurs-de-lis topiary of the greenery, in detail above, is as carefully sculpted as the marble urns at right. This is the Parterre de la Reine, or the "Queen's Terrace."

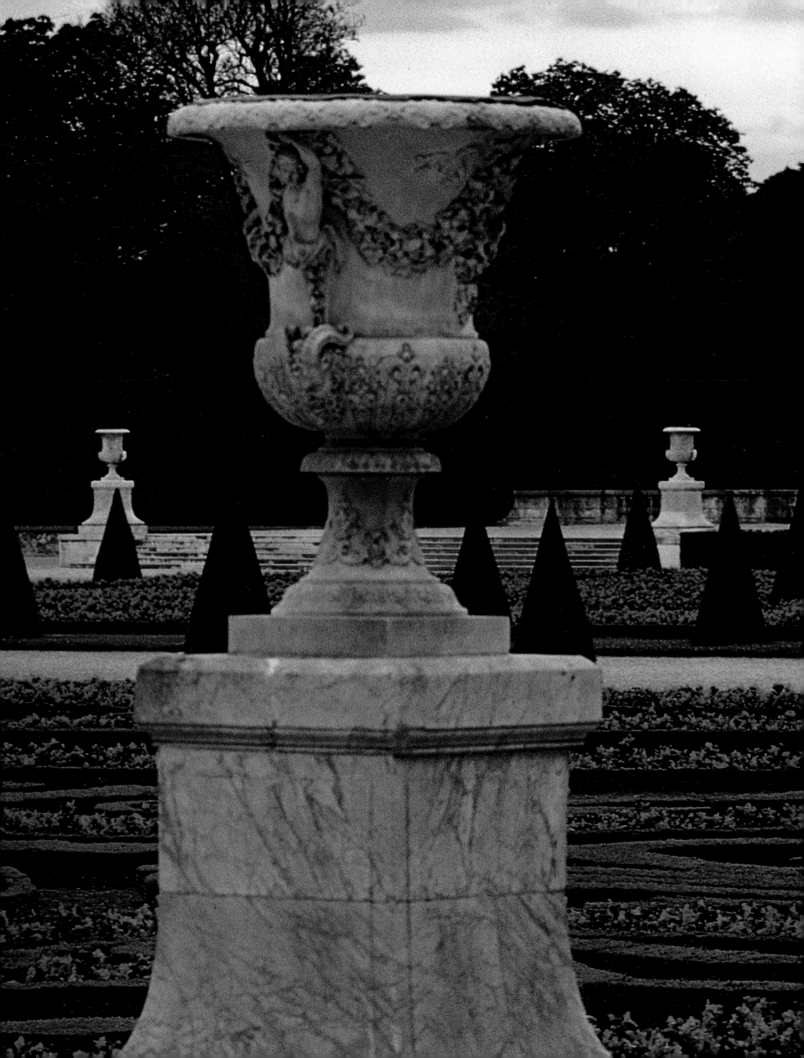

Jean Cornu, a sculptor at Versailles, studded the plaza above with marble urns. This was one of the king's favorite garden spots.

His palace behind him, Louis entered his garden on the pathway opposite, which skirts a verdant lawn and is lined with marble statuaries of mythological figures. The sculpture on the left is a barbarian prisoner, and the woman across the hedge is Venus, goddess of love.

Apollo embarks on his mission to drive the sun chariot across the sky, in this once-gilded fountain sculpture that Louis XIV especially admired.

The Fountain of Spring, opposite, is illuminated by light filtering through trees that Louis imported to Versailles from the forests of France. The fountain sculpture—which a court artist cast of lead—is one of four in the gardens representing the seasons.

OVERLEAF: The goddess Latona stands amid jets of water in this detail of a sculpture by Balthazar and Gaspard Marsy. Latona, the mother of Apollo, may have reminded the king of his own mother, Anne of Austria—for he often lingered at this fountain.

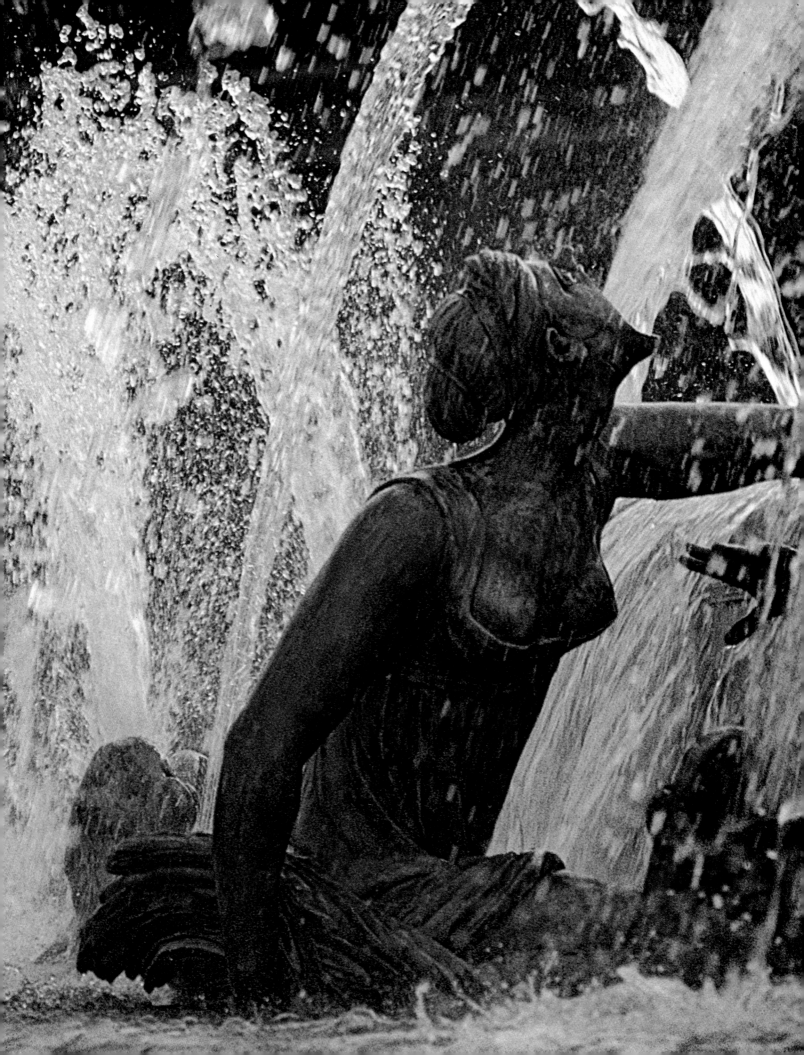

Louis XIV walked past this statue, an allegorical figure for flora, as he followed a path into an alcove.

Stopping to admire another of his great marble urns—the one opposite rests on a pedestal surrounded by flowers—the king might sit on a bench until the heat of day had passed. Louis had many stone benches placed throughout his gardens so that he and his guests could pause wherever they liked.

The king emerged from his gardens here at this reflecting pool ringed with bronzes symbolizing the rivers of France: the foreground statue above

represents the Garonne. Looking back at the sun setting over his vast gardens, Louis might then turn toward his shimmering palace.

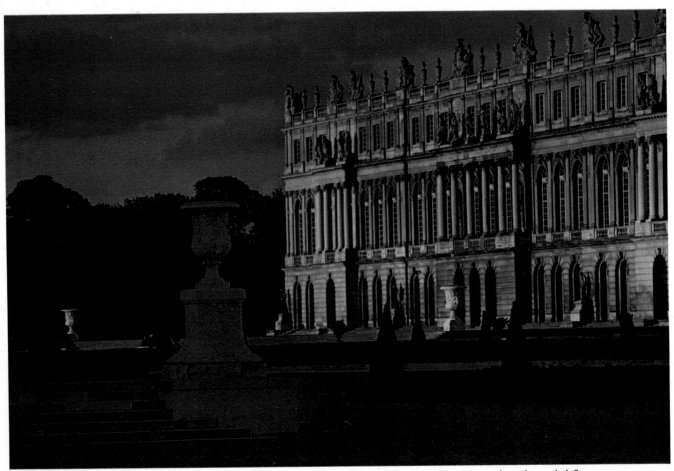

Windows in the western facade of the palace face the gardens at Versailles. The Hall of Mirrors is on the colonnaded floor.

Aglow with the sunset, the great arched windows of the Hall of Mirrors hide the opulence within. Fine food and wine usually awaited the king and his party as they entered the hall from the gardens.

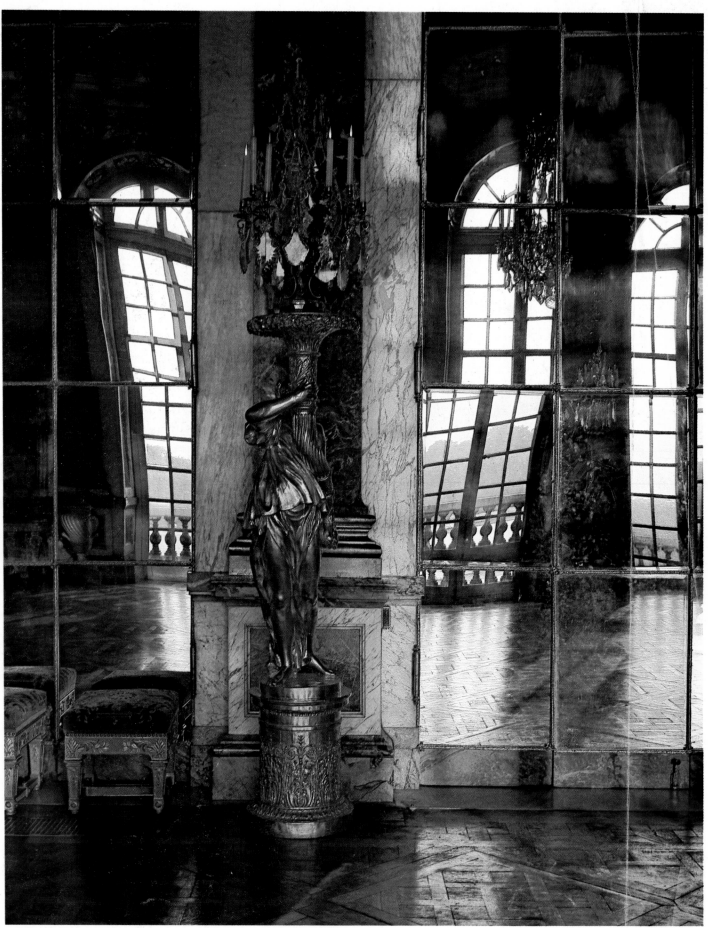

Mirrors reflect the richness of crystal, gold, marble—and the light from royal gardens—in the great ballroom of Versailles.

In a gilt relief at Versailles Heracles, wearing his lion skin, symbolizes the strength of Louis XIV.

The Hall of Mirrors is the glory of Versailles, the stage for Louis XIV's grand costume balls, royal wedding parties, and formal receptions for dignitaries and ambassadors from Europe as well as such lands as Persia, Siam, and Turkey. Jules Hardouin-Mansart designed the hall, building it on top of what had originally been a huge terrace (240 feet long) looking west toward the setting sun and the gardens. Charles Le Brun painted the vaulted, forty-foot ceiling celebrating the military victories of Louis XIV. So much solid silver furniture filled the red marble hall that it formed part of the country's monetary reserves.

During the day the Hall of Mirrors, flooded with light from seventeen arched windows, was the palace crossroads where nobles and courtiers, decked out in the latest fashions, spangling with jewels and often caught in traffic jams of sedan chairs, waited to catch sight of the king. Three thousand candles illuminated the hall by night.

The splendor of the room and the glitter of its crowds were magnified in the beautiful mirrors. Louis employed only the best artists and craftsmen and imported master glassmen from Venice who were recognized as the finest in Europe. The Hall of Mirrors, its opulence heightened in the reflecting wall, was the ultimate stage for the Sun King's very public life.

←—FOLDOUT

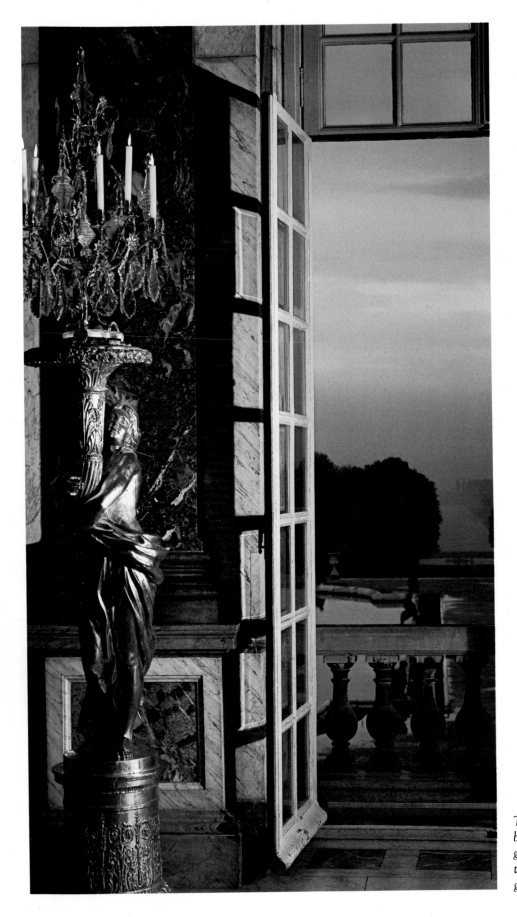

The glass doors of the Hall of Mirrors open onto a balcony where the king could escape the crush of guests, breathe fresh air, and view his dancing fountains. The crystal chandelier left, held aloft by a gilded goddess, is one of twenty-four in the hall.

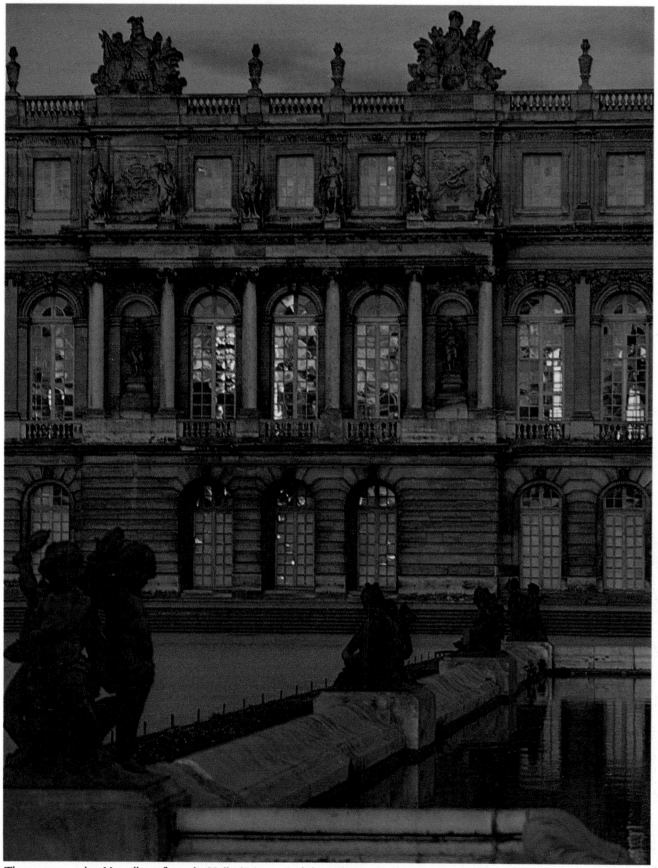

The western pool at Versailles reflects the Hall of Mirrors and the sculptures on the palace exterior.

OVERLEAF: *The palace is in full evening splendor. The fountains, statuaries, and gardens complete the majesty of what one seventeenth-century visitor to Versailles described in her diary as "the little house of the greatest king on earth."*

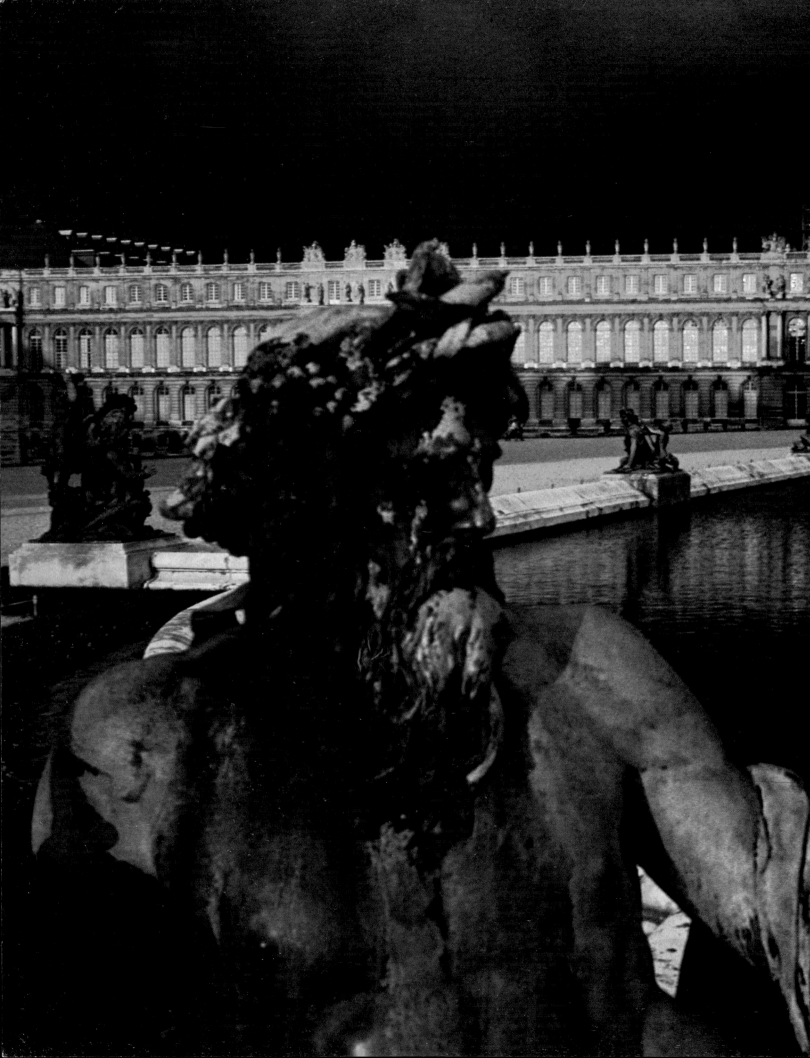

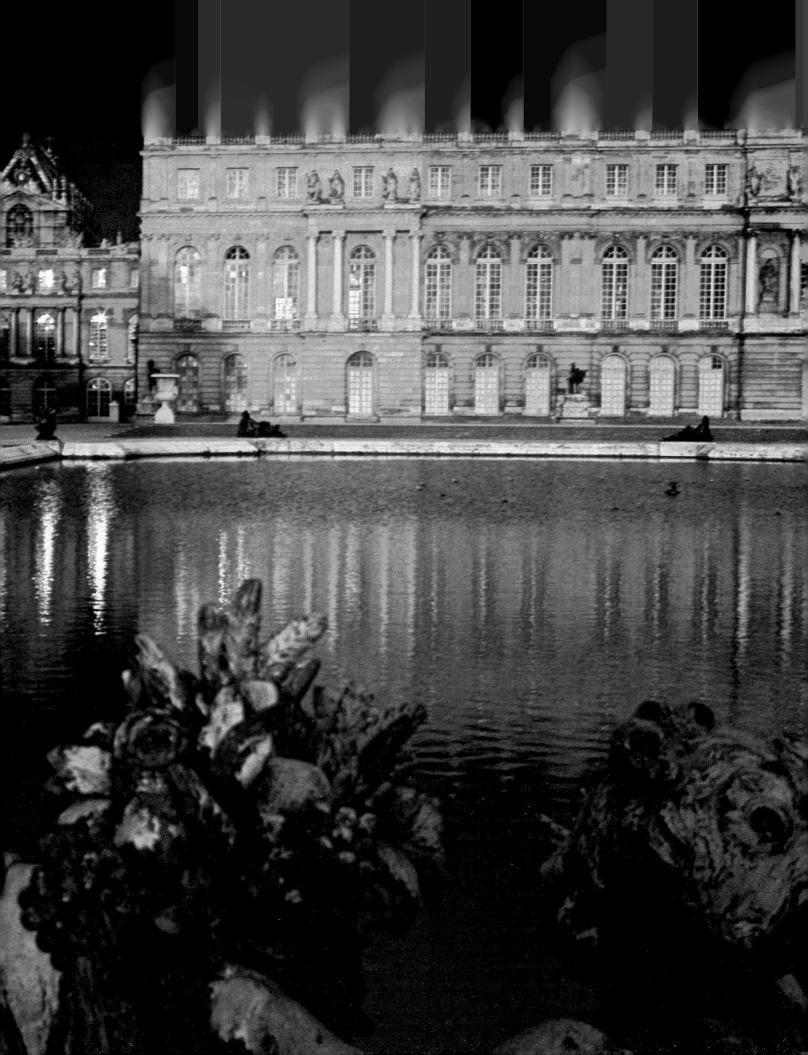

IV

LOUIS XV

A TALENT FOR PLEASURE

Like his great-grandfather the Grand Monarque, Louis XV succeeded to the throne at the age of five. Neither his parents nor his siblings were still alive; they had all succumbed to the medical and surgical ineptitude of the court physician, Dr. Fagon, who specialized in lethal bleedings and purgatives. While Louis XV grew to manhood, France was governed by his grand-uncle the regent, Philippe d'Orléans. Since the country was bankrupt, the conscientious regent chose to abandon Versailles for seven years. "After we had left the town of Versailles and ceased to regard it as our usual residence," he noted, "the majority of the merchants, artisans, workmen, and others, who were dependent upon our court and our councils, having left, the city was deserted overnight."

The regent preferred to govern France from the Palais Royal in Paris, near the Tuileries palace, where the young king was being educated. Philippe did his best to carry out some of the reforms that had been long overdue under the old king. "The Regency," wrote the nineteenth-century historian Jules Michelet, "is a whole century

In this grandiose portrait by Hyacinthe Rigaud, chief painter at court, Louis XV wears his coronation robes and wields the gilded scepter of Charlemagne.

compressed into eight years." It was, at any rate, a period of economic change and social revolution that prepared the way for what Michelet called the ultimate "triumph of the middle classes" at the end of the century. New methods of financing the government were introduced, the groundwork was laid for a system of free education, and the means of communication were vastly improved. The regent tried also to introduce a semblance of representative government in the form of state councils headed by important nobles, but they had become too accustomed to the indolent existence of courtiers to shoulder the burdens of government.

Though the regent made heroic efforts to economize and to balance the budget, even he could not forego the chance to acquire what was incomparably the finest diamond ever seen in Europe, the Pitt Diamond, later known as the *Régent*. It had been brought from India by Thomas ("Diamond") Pitt, governor of the British East India Company's trading post at Madras. He claimed to have bought the jewel from an Indian dealer. Gossip from other quarters, however, suggested that the diamond had originally been stolen from a temple. The regent probably paid 4.3 million gold francs (135,000 pounds sterling) for the diamond, though accounts vary: it was, at any rate, sufficient to raise Pitt's family to a position of wealth and influence in England. His grandson William Pitt became "the Great Commoner" of eighteenth-century British politics and the spokesman in Parliament for the American colonies against the crown.

Originally the stone had weighed 410 carats; cutting reduced it to slightly more than 135 carats—still one of the largest and most brilliant diamonds in the world. The duc de Saint-Simon, the chronicler of Versailles, who was involved in the purchase negotiations, noted that the regent had been obliged to consider the honor of the French monarchy in this affair: "He could not pass up the opportunity to obtain such a priceless stone." Since the privy purse was empty at the time, the regent paid forty thousand livres on account and secured the rest by depositing a hoard of smaller crown jewels as collateral. He had every reason to be satisfied with his purchase. When Louis XV was crowned on October 25, 1722, at the

Abandoning all thoughts of restraint, noblemen gorge on chilled wine and freshly shucked oysters, casting empty bottles and shells across the floor. This painting hung in Louis's private rooms.

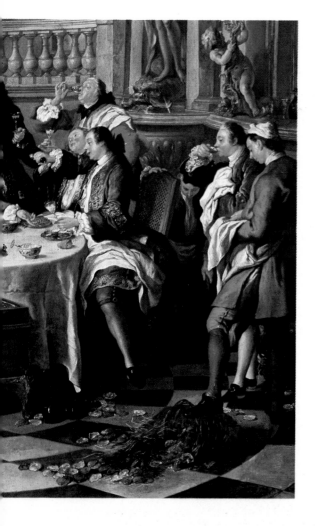

age of twelve, the Regent Diamond shone as the brightest jewel in his state crown—though the great Sancy Diamond surmounted the crown as the center of a gleaming fleur-de-lis of diamonds.

The regent died not long after Louis was crowned. At the beginning of his reign, Louis hoped to benefit from his great-grandfather's example, but his advisers soon discovered that he lacked the energy and determination of his predecessor.

But for twenty years Louis allowed the government of France to remain in the hands of his prime ministers. The first of these, the duc de Bourbon, held the office for four years. As a child of eleven, Louis had been betrothed to a Spanish Bourbon princess. She came to live at the French court when she was only five years old. Before long, however, the prime minister repudiated the king's engagement and sent the princess home unceremoniously. Then, for sundry reasons of his own, he arranged the king's marriage to Maria Leszczynska, daughter of the former king of Poland, who happened at the time to be living in penurious exile in France. Marie proved to be a serious though not very seductive woman, and she was seven years older than Louis: he was fifteen when they married. Eventually she bore him ten children, and Louis became genuinely attached to her. Yet he was ever on the lookout for more stimulating feminine companionship.

Meanwhile in 1726 Louis decided to replace the duc de Bourbon with his former tutor, Cardinal Fleury, who was seventy-three when he took office. For more than a decade, Fleury steered a cautiously conservative course in foreign affairs, and not until the War of the Austrian Succession, which broke out in 1740, did France again become embroiled in a major European conflict. Europe split over who was to have the throne of Austria—Maria Theresa of the House of Hapsburg or Charles Albert, a Bavarian prince. France was allied with Prussia, Spain, and Bavaria against Maria Theresa. Prussia soon withdrew, leaving France without strong allies, and England came into the war on the Austrian side. Early in 1743 the French took a disastrous defeat in Bohemia, and just as Louis's army was forced to evacuate Prague, Cardinal Fleury, aged ninety, died in office.

Now, if ever, it was time for the king to take over the government, and at that critical moment Louis XV attempted to emulate Louis XIV by becoming his own first minister. He was thirty-three and still an immensely popular figure. "The king is loved by his people in spite of the fact that he has never done anything for them," noted his new minister of war, the marquis d'Argenson. "This shows that the French are more inclined to love their ruler than the people of any nation; this loyalty is part of their character—in their king they are prepared to take the thought for the deed."

After Louis began to run the government, the war continued to go against the French, and the Austrians invaded Alsace. Louis had undertaken to go to war in person, with a view to invading the Austrian Netherlands. Instead he rushed to Alsace, where his presence did much to stiffen morale among the French troops. But suddenly he was taken ill with a high fever, and his army withdrew in defeat. The whole of France heard of the danger and showed its concern. The churches everywhere were filled with people offering prayers for his recovery. He was saved, finally, by a strong dose of emetic, and when he rose from his sick bed, he found that he had acquired the flattering title, *Louis le bien-aimé*—"Louis the well loved."

He went on to take part in a short but decisive campaign against the Anglo-Dutch army, which ended with a famous French victory at Fontenoy, Belgium—a classic set piece battle, stage-managed by the redoubtable maréchal de Saxe, the most famous general of the age. At Fontenoy the British brigade of guards and the French royal guard met face-to-face in battle formation. The captain of the Grenadier Guard advanced in front of the line and formally saluted the French. His opposite number on the French side, the comte d'Auteroches, came out to meet him. "Monsieur, have your men fire," shouted the British captain; but the French officer was not to be outdone: "No, Monsieur, you have the *honneur*!"

Louis bravely stood his ground at the height of the battle while members of the Regiment du Roi died all around him. But he detested warfare and afterward did everything possible to conclude a

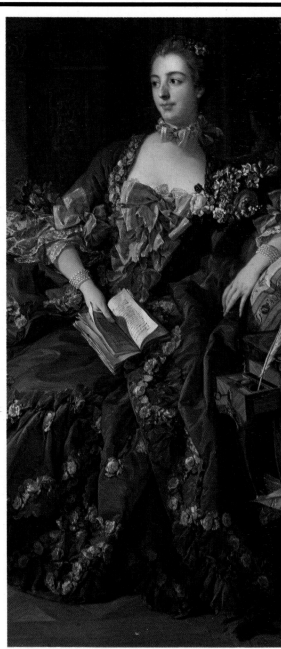

MADAME DE POMPADOUR

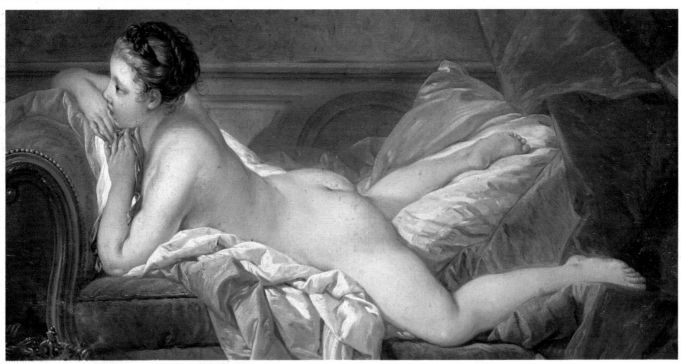

LOUISE O'MURPHY

A MISTRESS FOR ALL SEASONS

Because a fortune-teller predicted that she would one day be the king's mistress, her nickname from early childhood was Reinette, "little queen." Jeanne-Antoinette Poisson, born in 1721 to prosperous bourgeois parents, learned to sing, dance, draw, and play the harpsichord. She married well and presided over her own salon, where she charmed the literary men of the day. But she had her eye on the highest prize, and on February 25, 1745, when she contrived to dance with the king at a masked ball, she captured him. He made her the marquise de Pompadour: a queen without a crown.

Her portrait, opposite, by François Boucher, one of her favorite painters, glows with the elegant worldliness she possessed. She and Louis remained lovers for only a few years, though she seems not to have minded. She helped set up a private brothel for him, where she kept pretty women such as Louise O'Murphy, above, also portrayed here by Boucher. But no one replaced Madame de Pompadour in his affections. For twenty years she ruled his taste in art. She bought and built a series of châteaux, and redecorated at Versailles, selecting all the talented architects, painters, and cabinetmakers of France. When she died at forty-three of tuberculosis, Louis was bereft not merely of a mistress but of his unofficial minister of culture—a post never filled so brilliantly again.

speedy peace. Not until 1748 was the treaty finally signed at Aix-la-Chapelle, but Louis never appeared on a battlefield again. Understandably life at Versailles was infinitely more to his liking, even though the monarchy continued to be plagued with social and economic problems that he could hardly bring himself to face.

Despite the innovations made under the Regency, the French government was still badly in need of reform. Most peasants and artisans lived in conditions of extreme poverty; the disenfranchised middle classes were becoming restive; the intelligentsia were creating a whole new world of ideas—the Age of Reason—that was to demolish the philosophical premises of the *ancien régime*, the age-old rule of despots. Political dissatisfactions were intensified by the flagrant contrast between the poverty of working-class Paris and the extravagance of royal Versailles, to which the court returned after Louis's coronation. The king gave every sign of sympathizing with the poor, but went on spending vast amounts of money: in a single representative year, 1751, the royal household cost sixty-nine million livres, almost a quarter of the government's total revenue.

Once again the French monarchy underwent a profound change of style: henceforth the emphasis was to be on pleasure rather than grandeur. Louis had been carefully brought up, and he had once been a thoughtful and considerate young man, but the sybaritic society at court utterly corrupted him. "It was at the suppers with his entourage," reported the duc de Richelieu, "that the king began to lose the good qualities that were his by nature." He gradually abandoned the pomp and ceremonial of Louis XIV in favor of more intimate and sensuous occupations: the age of Louis XV became the age of pleasure par excellence. The classic age gave way to the elegant rococo of *le style Louis XV.*

The term rococo derives from the fanciful *rocaille* rockwork and shell designs that formed such a vital element of the style. It had its sources in the grottoes and gardens of Versailles and in the ornamental rockwork that the Chinese depicted on porcelain vases. Fine works of art from China were being imported in ever-increasing numbers, but the dominant French motif stemmed from the fluted

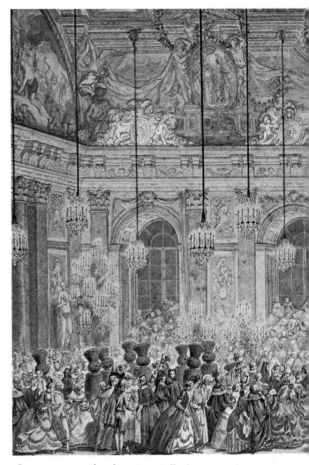

Guests swamp the glittering Hall of Mirrors during the masked ball held in 1745 to mark the marriage of the dauphin, the king's oldest son. Costumes range from Turks in vast headdresses (at right) to peasant girls; eight courtiers (at left), one of whom may be the king, are dressed as yew trees.

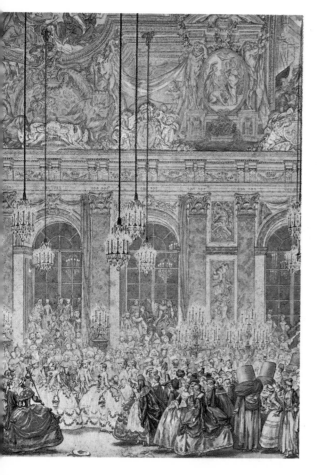

curves of the exotic seashells that were brought to France from the distant shores of Africa, Asia, and the West Indies. At mid-century one successful Parisian art dealer advertised his establishment on Notre Dame bridge as selling "all kinds of hardware both tasteful and new, jewels, mirrors, cabinet-pictures, pagodas, lacquer and porcelain from Japan, shells and other natural history objects, pebbles, agate, and generally all merchandise both strange and curious."

It was not an accident, of course, that shell forms should have assumed such importance in everything having to do with the court of Louis XV: fortunes were being made in trade with the overseas colonies whose beaches produced the shells that were so avidly collected and copied. Besides, the seashell was the mythological vehicle of Aphrodite, the goddess of love who rose from the waves on an Aegean half shell: this Aphrodite was the patron goddess of the age, just as rococo, in the words of one historian, represented "the quintessence of French femininity."

Soon there was hardly an object at Versailles without its sinuous echo of the seashell: the curved commodes with their scrollwork drawer pulls, the soup tureens with their shell-shaped handles, the knives and forks, andirons and candelabra, wrought-iron balcony railings; the silver buckles sewn on courtiers' shoes and the diamond brooches worn on décolletages, which, in their turn, seemed to mimic the interplay of waves and seashells.

At court there was a constant coming and going of the most beautiful women in the realm. The list of Louis's mistresses is headed by four daughters of the marquis de Nesle, each prettier than the last—Madame de Mailly, the duchesse de Lauraguais, the marquise de Vintimille, and the marquise de La Tournelle. The marquise de La Tournelle was the youngest but also the most determined: she insisted that the king make her a duchess, and he was happy enough to oblige.

When she died unexpectedly at a very young age, the king acquired, at last, an officially acknowledged *maîtresse en titre*. Her status was almost as high as the queen's, and the post had hitherto been reserved strictly for the old noblesse. But Madame d'Etioles,

TEXT CONTINUED ON PAGE 122

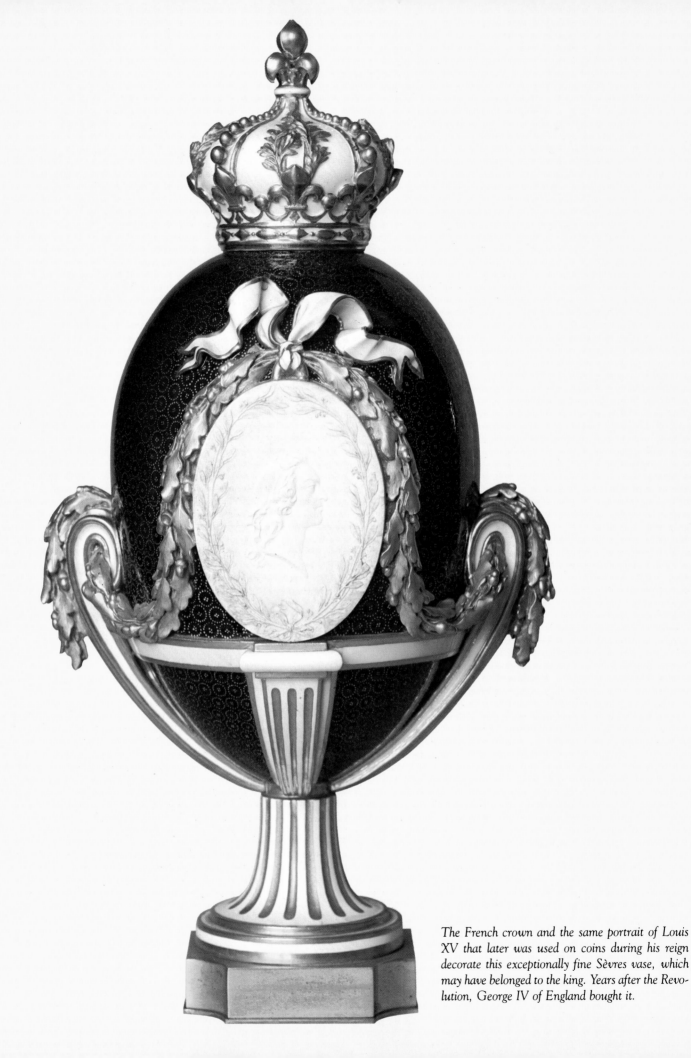

The French crown and the same portrait of Louis XV that later was used on coins during his reign decorate this exceptionally fine Sèvres vase, which may have belonged to the king. Years after the Revolution, George IV of England bought it.

The L's of the king's monogram are entwined on the sides of this flower vase. The floral spray inside the left lip masks cracks, which frequently occurred in the firing of such thin forms.

A PASSION FOR PERFECTION

Sèvres porcelain has an extraordinary translucency, a brilliance of color, and great richness in its decorative details, such as the gilding and the miniature scenes on most of the pieces. These three elements enthralled its admirers, among whom were Louis XV and Madame de Pompadour.

Both took an avid interest in the making of this pottery from its beginnings in the 1730s, and Louis later appointed himself the sole proprietor of the factory. Pompadour arranged for the best goldsmiths and portraitists to design and work on the decorative details. Ironically, because France lacked kaolin, a clay used to make hard paste that can be fired in a kiln at great heat, the earliest Sèvres wares were made of soft paste and fired more slowly. This produced the unique, creamy texture for which Sèvres is famous.

To please his mistress Louis moved the entire factory from Vincennes, its original home, to Sèvres, a small town nearer Versailles. In addition to their managerial roles, Louis and Pompadour were both avid customers—most of the pieces on these pages belonged to them. So too were members of the court—once a year, anyway. At every New Year's sale, Louis himself took the part of salesman.

Louis's daughter Adélaïde may have been the owner of this extravagant Sèvres inkstand. The terrestrial globe, left, holds the ink; the celestial globe holds sand to sprinkle through the pierced stars to dry the ink. The crown is a bell to summon a maid.

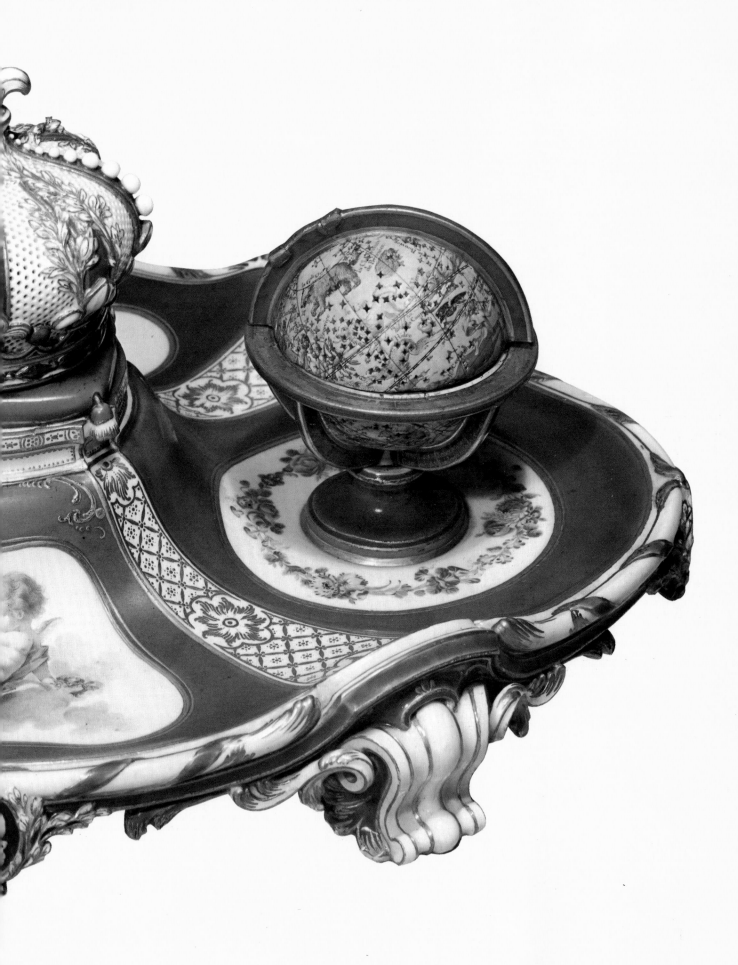

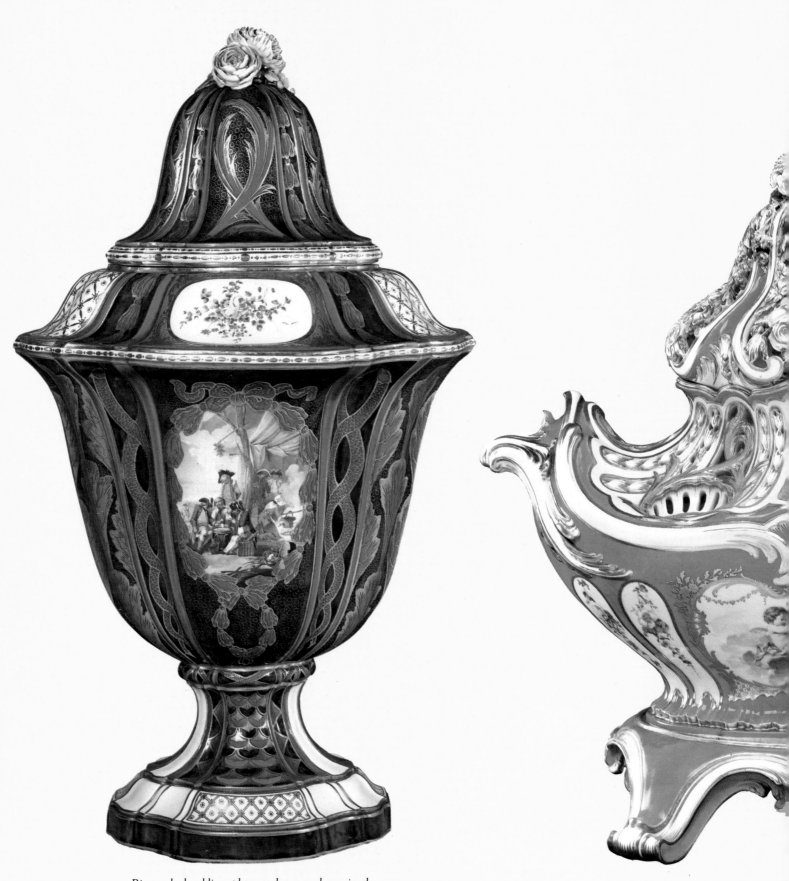

Bivouacked soldiers play cards on a drum in the precisely detailed scene on this vase. According to the 1759 sales records, Louis himself may have bought the piece.

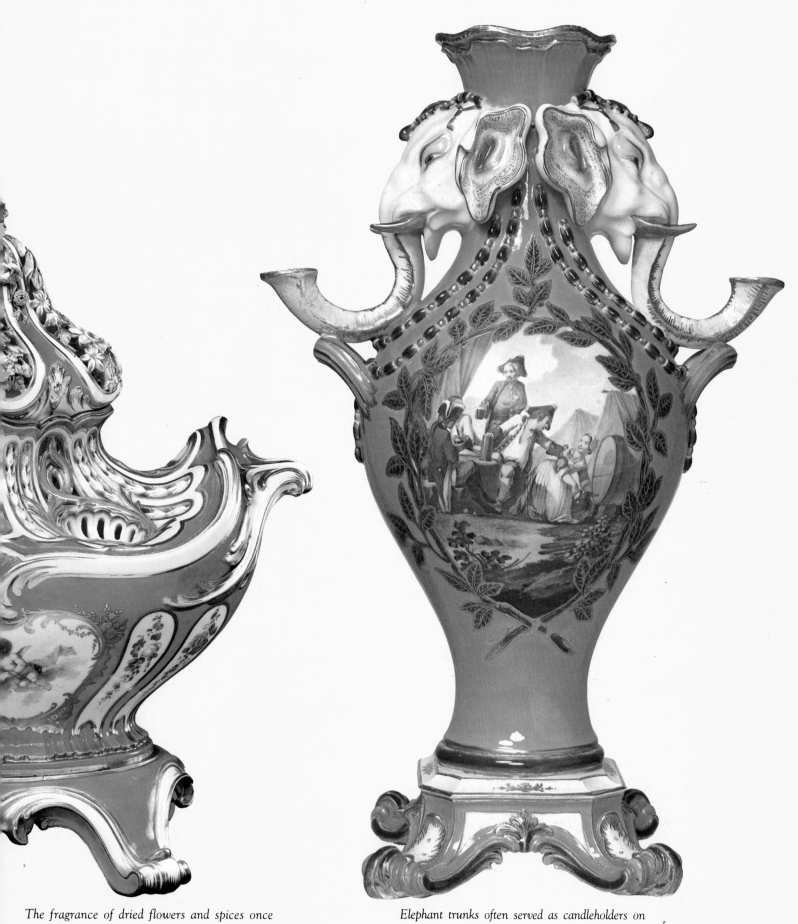

The fragrance of dried flowers and spices once wafted through the pierced lid of this potpourri vase, probably once Madame de Pompadour's. It is gondola-shaped and painted with cherubs.

Elephant trunks often served as candleholders on Sèvres vases. This one, on a rose ground, also has a detailed painting of soldiers at play—drinking and flirting with a camp follower.

TEXT CONTINUED FROM PAGE 115

formerly Jeanne-Antoinette Poisson, soon to be marquise de Pompadour, was one of the most remarkable women of her age. She had been adopted by a banker and educated as a member of the haute bourgeoisie: for a time she had been the leading hostess in the social circle formed by the financiers of Paris. Since these farmers-general and merchant bankers, rather than the landed nobility, provided most of the money for the royal exchequer, the king rightly chose a woman from that circle to help him spend it—though of course he had to make her a marquise.

The die-hard traditionalists were shocked by the elevation of this parvenu, but unbiased observers could only approve of the king's choice. "Not a man alive but would have had her for his mistress if he could," wrote the comte Dufort de Cheverny in his memoirs. "Tall, though not too tall; beautiful figure, round face with regular features; wonderful complexion, hands, and arms; eyes not so very big, but the brightest, wittiest, and most sparkling I ever saw. Everything about her was rounded, including all her gestures. She absolutely extinguished all the other women at court, although some were very beautiful."

Louis tried to be a conscientious ruler but he was bored by affairs of state; at the council table he "opened his mouth, said little, and thought not at all," according to the comte d'Argenson. He enjoyed hunting, dabbled in architecture, and played at raising chickens. Madame de Pompadour took over the management of this malleable man and, indirectly, of the government: soon most of the important state offices were filled with her appointees. At the same time she organized the king's life in such a way that he could devote his life to pleasure. She had a bandbox theater built into one of the galleries at Versailles where she and groups of talented amateurs could perform private theatricals for Louis and a dozen intimates. She also brought in professionals to divert the king with plays, operas, and ballets.

To show his gratitude he gave her a series of houses and châteaux in which to exercise her undoubted talents as an interior decorator. At Sèvres, the village below Bellevue, the king had the royal china factory installed at a cost of more than a million livres, and she saw

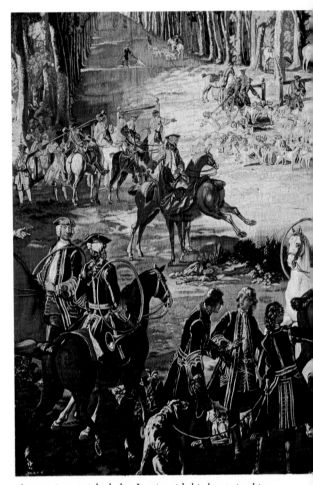

A courtier at right helps Louis with his boots in this tapestry of a royal hunt. Hunting was Louis's outdoor passion; he went off for days at a time and slaughtered deer, birds, and other game. His courtiers joked that if he wasn't hunting, "the king does nothing today."

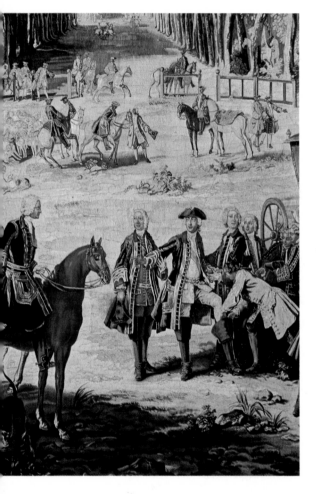

to it that this *manufacture* prospered both financially and artistically. At her behest the leading sculptors of the day—Jean Baptiste Pigalle and Etienne Maurice Falconet—produced the models for biscuit figures the luxury market sought. A whole new range of ground colors was invented by the factory's chemists, including the pale yellow *jaune jonquille,* the turquoise *bleu céleste,* and the delicate pink later christened *rose Pompadour.* Sèvres porcelain was to become the finest in Europe, and also the most expensive.

After her own sexual charms had palled, Madame de Pompadour found other women to provide them, though without relinquishing her place at the king's side: she had become the most indispensable of his advisers. The women she procured for him were anonymous for the most part and left no record of their encounters with the monarch. But posterity is fortunate in possessing an intimate account of Louis as a lover by an eyewitness—the chevalier d'Eon, who habitually dressed as a woman and managed to deceive the court as to his true sex. But although the chevalier dressed as a woman, his appetites were those of a man, and he claimed to have seduced Madame de Pompadour on an ottoman in one of the private apartments. Shortly afterward the king arrived and, seeing d'Eon in his women's clothes, decided that he must explore the possibilities of this lovely newcomer. The incident takes up several pages in the *Memoirs* of chevalier d'Eon:

"Don't be scared, my beauty," he said to me. "Don't be afraid of me." And the gallant monarch proceeded to stroke my cheeks with his soft, perfumed hand....The situation was difficult and my position embarrassing. His Majesty became scandalously enterprising and pressed on with the attack like a true king, unused to meeting resistance....I found myself right up against a certain ottoman which recently served me to such good purpose. As bold and more experienced than myself, Louis XV seized this opportunity in a flash and, without giving me time to finish my speech, placed me in the position where, some minutes earlier, I had placed the marquise de Pompadour. Flung down on my back without warning, I cried out and tried to get up, so as to enlighten the misguided monarch with a word. But it was too late. The King had already found what he was looking for, and, as it was not what he expected, his arms dropped to his sides and his mouth gaped open in stupefied astonishment.

Though the king was disappointed and annoyed, he conceived the idea of employing this convincingly disguised young man as his secret agent, to deliver a letter to the empress Elizabeth of Russia. Later, still dressed as a woman, he was sent to London to help the French ambassador negotiate terms for ending the Seven Years' War, the bitter conflict that involved almost every European power and had been fought in North America as well.

The war, and its attendant disasters, emptied the royal treasury and wreaked havoc among the lower classes, who no longer referred to their king as le bien-aimé. Still there was sufficient resilience in the French economy to absorb a further generation of misgovernment—and to allow the monarchy to amass a fresh collection of treasures. Under Louis XV the art of the jeweler and the goldsmith attained new heights of brilliance and technical refinement. The strong room in the Louvre received some superb objects: a Grand Cross of the Order of Saint-Esprit made entirely of diamonds, boutonnieres of diamonds, diamond vest buttons, hat buckles studded with diamonds, epaulettes for uniforms embossed with diamonds, pendants of pear-shaped diamonds.

More interesting as art were the seventy engravings in semiprecious stone that Madame de Pompadour commissioned from the jeweler Jacques Guay and left to the king—a portrait of Louis engraved in onyx, for example, and another in carnelian showing him as Apollo crowning the spirit of Painting and Sculpture, as well as one of the marquise's dog, Mimi, in agate.

Such baubles were designed for the momentary diversion of a handful of people condemned to spending their lives in a gilded cage and scarcely able to appreciate any one object amid their embarrassment of riches. But in a sense these diamonds and carnelians were time bombs ticking away in the treasury of the Garde-Meuble, and they were set to go off during the next generation, when there was to be a day of general reckoning. Louis must surely have known it and so did the intelligent Madame de Pompadour. To her is attributed—justly or not—the pithy prophecy that is also an epitaph for an epoch: *Après moi le déluge*, "After me, the deluge."

A MASTERPIECE
IN THE STUDY

A golden Apollo looks out from the top left corner of Louis
XV's desk. Behind Apollo, personification of the sun and a
favorite emblem of Louis XIV's, is a candelabrum.

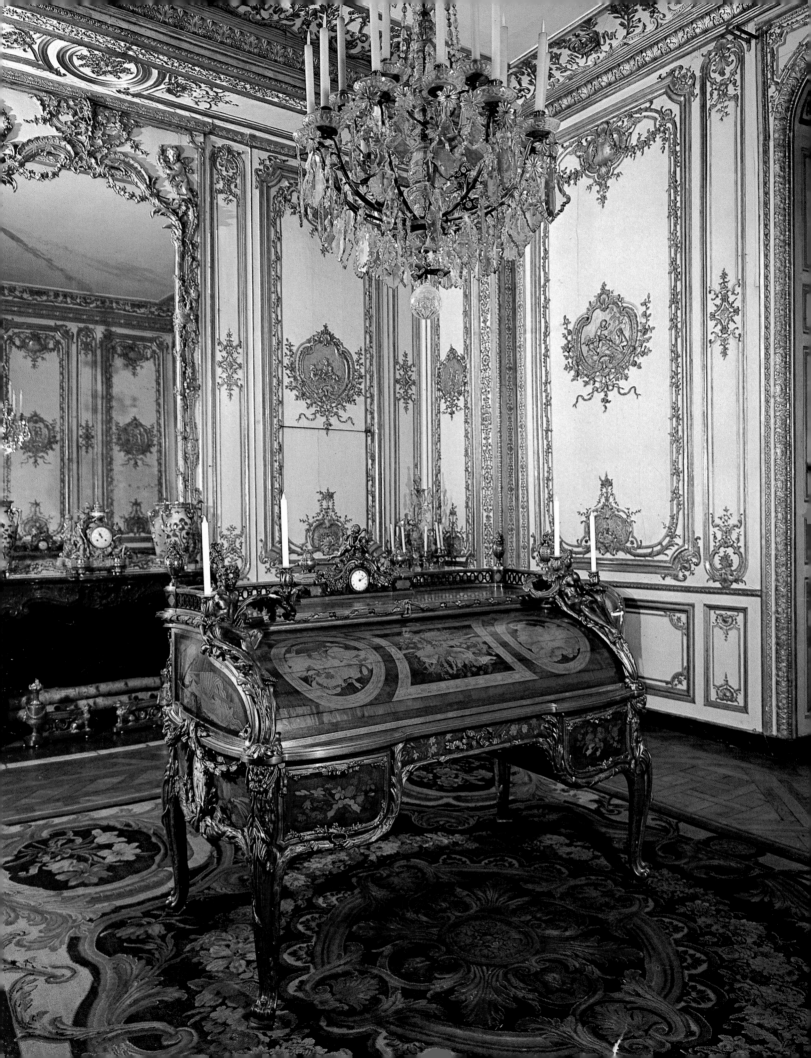

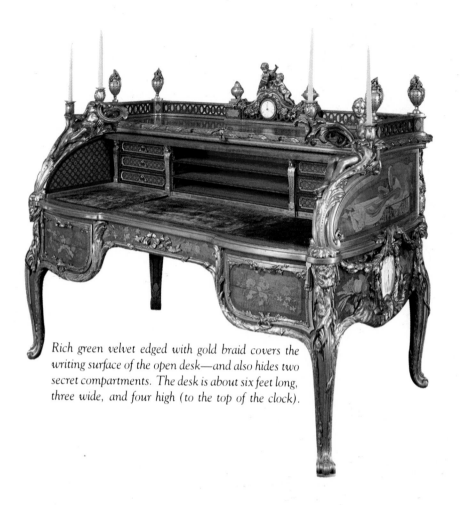

Rich green velvet edged with gold braid covers the writing surface of the open desk—and also hides two secret compartments. The desk is about six feet long, three wide, and four high (to the top of the clock).

Louis XV had several favorite rooms at Versailles. In a tiny kitchen, part of a warren of small chambers tucked away under the roof, he liked to make chocolate and marzipan and to bottle cherries. In the second-floor room, he brewed coffee for friends. But the room he loved best seems to have been his study, or *cabinet intérieur* (opposite). This room he ordered to be furnished with the best of everything—each item a masterpiece. The most extraordinary of all was his rolltop desk.

The desk took nine years to make and cost at least seventy thousand gold livres, almost as much as Louis's foreign minister earned per year. The desk also bankrupted the man assigned to make it, Louis's personal cabinetmaker, Jean-François Oeben. He began in 1760, first doing the mahogany work and then installing the

mechanism that unlocked the drawers and opened the top—all at the single turn of a key.

In 1765, not halfway done but destitute from the cost of the materials, Oeben died. His former pupil Jean-Henri Riesener took over. He supervised the inlaying of more than forty different types of wood and the adding of the gilt-bronze decorations. He also ensured the smooth operation of the locking mechanism.

Very probably Louis used his desk a great deal; he conducted much of his business in his study, including the signing of royal wedding contracts. Years later Riesener had to work on the desk again. The Revolutionary government ordered all Louis's monograms replaced with impersonal designs. They spared the desk itself, a treasure of French craftsmanship and the finest piece of furniture in Versailles.

Elaborate gilt-bronze decorations, including a clock, and elaborate marquetry with more than forty different kinds of wood, adorn the desk in Louis XV's study.

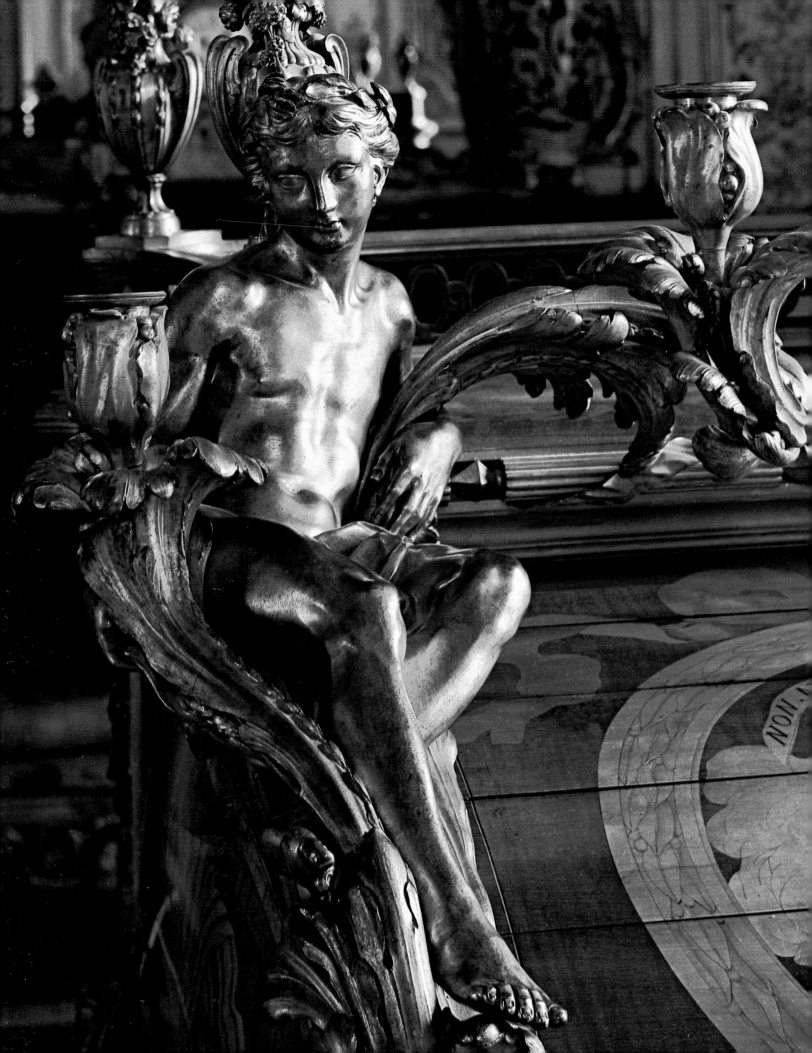

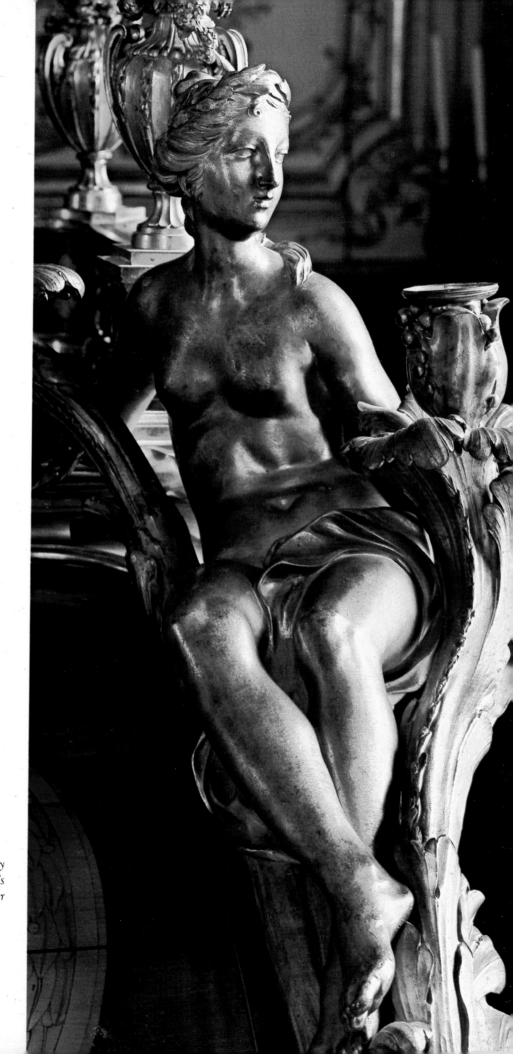

Apollo (opposite) and Calliope, muse of epic poetry and eloquence (right), perch at either end of Louis's desk. Both are made of gilt bronze, as are the other decorative features atop the desk.

Two gilt-bronze cherubs, representing the Arts and the Cardinal Virtues (justice, prudence, temperence, and fortitude),

romp over the clock in the middle of the desk top. The clock, which is double-faced, still keeps perfect time.

A celestial globe, a telescope, an astrolabe (a precursor of the sextant), books, and a hunting horn lie in a bed of flowers in the

central design of the desk's cover. This marquetry replaces the royal emblem that was ordered removed during the Revolution.

Lion skins—the symbol of Heracles, made of gilt bronze—swathe each leg of the desk, at left in detail. Opposite, the Three Graces appear on a panel at the side of the desk. Made of Sèvres porcelain, like the similar plaque at the other end, the panel was installed during the Revolution as a replacement for Louis's monogram.

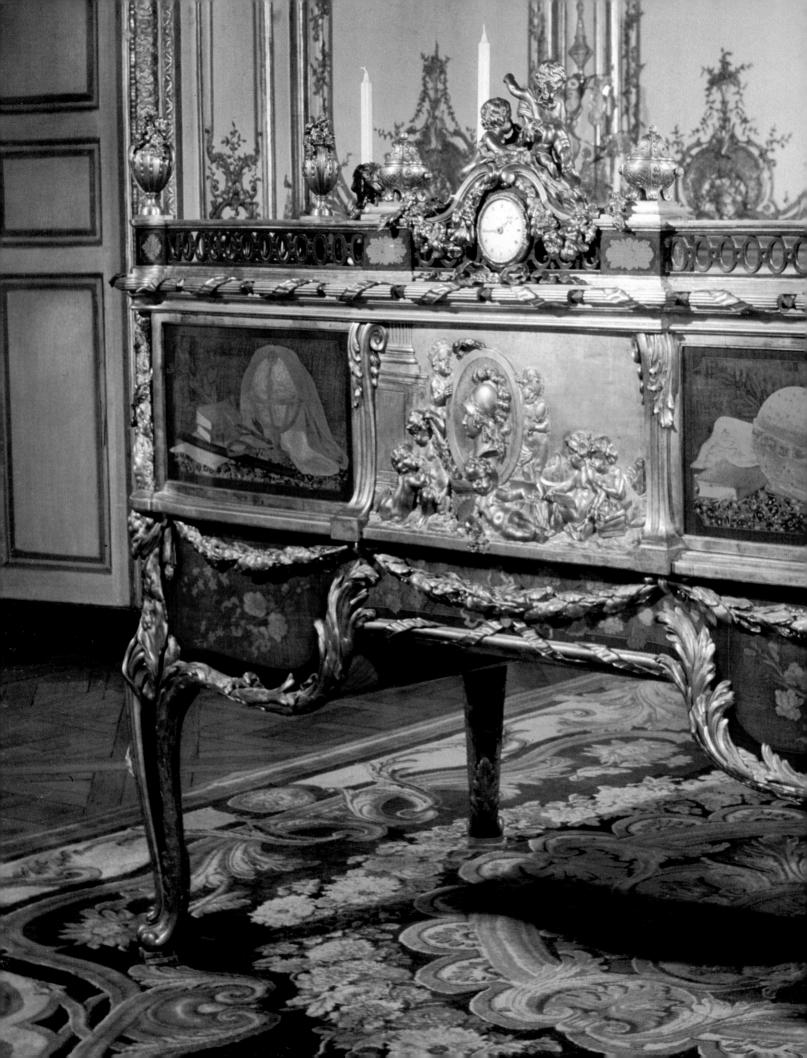

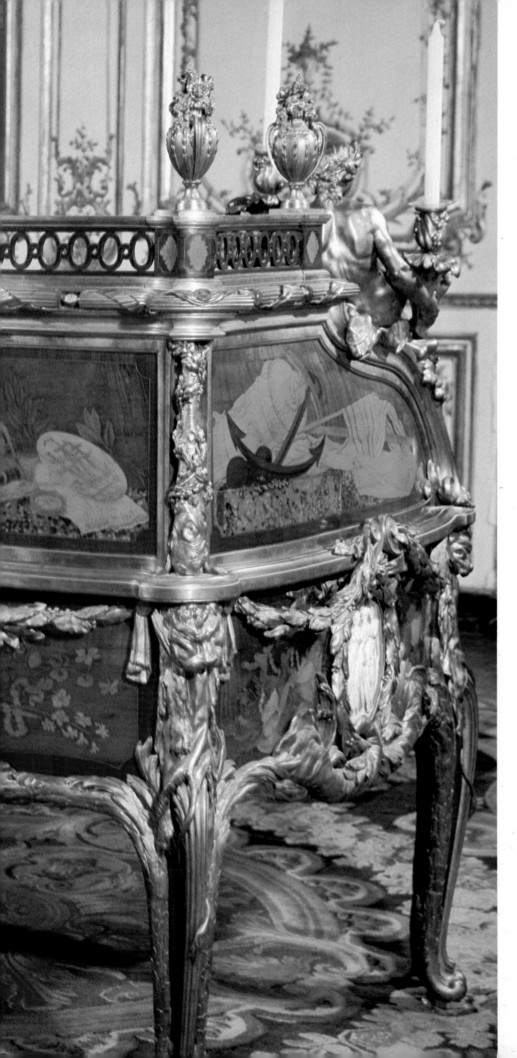

Children hold aloft a shield bearing the figure of Minerva, goddess of wisdom, in the gilt-bronze plaque on the back of the desk. At far left a celestial globe and emblems of astronomy are inlaid in marquetry; at near left are a terrestrial globe and the symbols of geometry. On the near side of the desk are the emblems of the French navy.

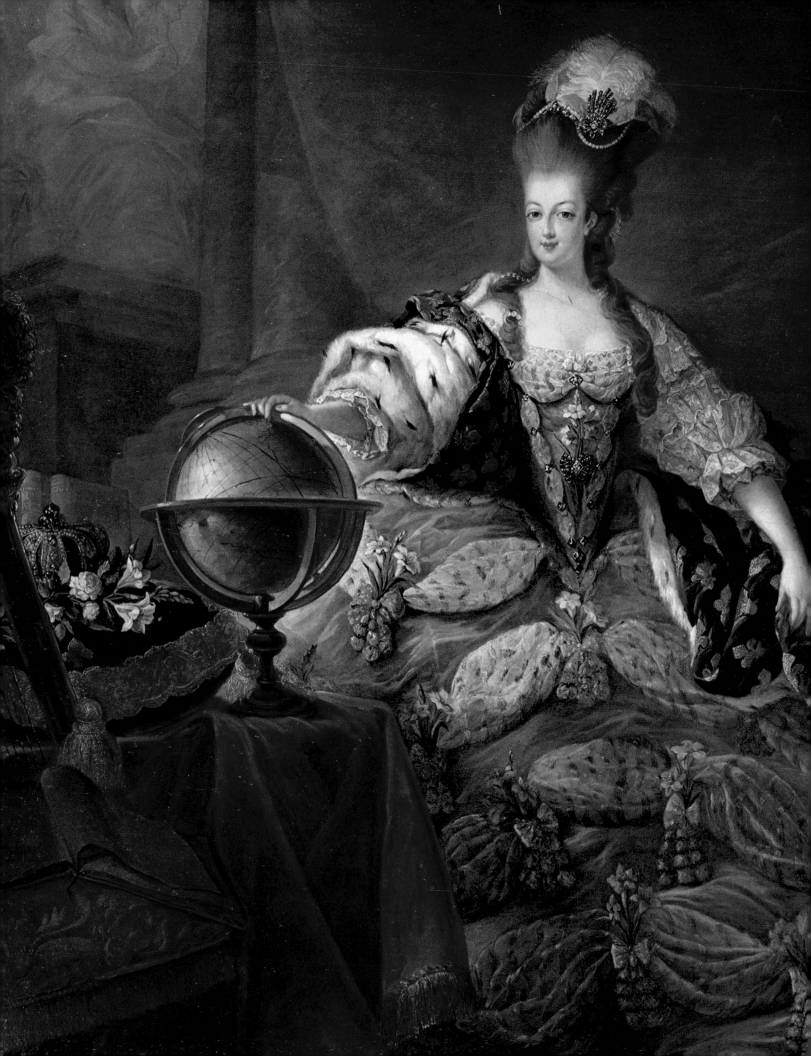

V

LOUIS XVI
AND MARIE
ANTOINETTE

THE MOMENT
BEFORE THE DELUGE

The nation was ripe for revolution. The interests of the monarchy had ceased to coincide with those of the people, and dissatisfaction grew on all sides—an accumulation of grievances that mere reforms and concessions were unable to assuage. The underlying cause of the political explosion that shook France from 1789 to 1795 was that the old institutions no longer corresponded to existing realities. The government remained monarchic and aristocratic; the economy had passed into the hands of merchants, lawyers, manufacturers, and engineers—all legally barred from enjoying the prerogatives reserved for the nobility—a privileged elite that, together with the clergy, constituted less than one percent of the population in a nation of twenty-four million. The French Revolution, therefore, was essentially the chaotic and often violent process by which political power passed into the hands of those who already possessed economic power. In the words of one modern historian, it made "the bourgeoisie mistress of the world."

Louis XVI succeeded to his grandfather's throne at the age of

Wearing an elaborate gown, Marie Antoinette poses by a globe in the palace at Versailles. At far left is her harp, which the youthful queen loved playing for friends.

nineteen, in 1774. To mark the occasion the aged apostle of the Enlightenment, Voltaire, published a "prophecy" in which he spelled out some long overdue reforms that the young king would accomplish. The nation's laws would be made uniform and apply equally to all people; churchmen would be prevented from holding more than one post and from living extravagantly. "To the poor who work hard will be given the immense riches of certain idle men who have taken the vow of poverty.... Minor offenses will no longer be punished as great crimes.... Torture will no longer be employed. There will cease to be two powers [state and church] because there can exist but one—that of the king's law in a monarchy, that of a nation in a republic. Lastly, we shall dare to pronounce the word 'tolerance.'"

Paradoxically enough, Louis XVI actually abolished many of the worst abuses of the ancien régime. He suppressed the infamous corvée, which involved the recruitment of forced peasant labor for building roads in rural districts. He liberated the serfs, prohibited the use of torture in obtaining confessions, emancipated the Protestants of France, and abolished the oppressive guild system of the Middle Ages. Even the Jews were no longer obliged to pay discriminatory taxes. He was a considerate king, who wanted to build more hospitals for the poor, foundling homes, and schools for the handicapped, but it was too late for these measures to stem the tide. There was a multitude of reasons, some of them only superficial irritants to the body politic, why the French people rose against their king when the storm broke. Foremost among these was the mindless extravagance of the court at Versailles. "Let them eat cake" is wrongly attributed to Marie Antoinette—it was already a well-known saying earlier in the century—but it sums up the combination of indifference and ineptitude that led to the downfall of the monarchy.

Four years before Louis acceded to the throne, he had married the Austrian archduchess Marie Antoinette—a union that symbolized the end of three centuries of rivalry between the Bourbons and the Hapsburgs. Her mother, the empress Maria Theresa, had carefully groomed her youngest daughter for this important role. "As

In this scene, set about 1786, a liveried servant offers a plate to the queen, who enjoys a meal in the gardens of the Petit Trianon with Louis XVI (seated at left) and their three children. Bored by affairs of state, the couple much preferred such informal moments to receptions at the palace.

she has been my delight," she wrote to her future son-in-law on the eve of her daughter's departure, "so I hope she will be your happiness. I have brought her up for this, because for a long time I have forseen that she would share your destiny."

The fourteen-year-old archduchess was blond, blue-eyed, and vivacious. Her arrival in France was the signal for general rejoicing. The nation was in the grip of a depression at the time but Louis spared no expense to make the wedding an occasion that would show the world that France could surpass everyone in public magnificence. A great display of fireworks was given in Paris so that hundreds of thousands of ordinary people would be able to celebrate, but 130 people were trampled to death in the panic and stampede that occurred at the end of the spectacle.

Other things had gone wrong from the beginning. The royal bridegroom suffered from phimosis (contraction of the orifice of the prepuce), and until the royal surgeon corrected this condition in 1777, he was unable to have intercourse with his queen.

The frustrated, childless Marie Antoinette indulged her passion for luxuries. She spent a fortune on her favorite residence, the Petit Trianon; on her stable of three hundred horses; on her sessions at the gaming tables; and on her clothes, which cost 100,000 livres a year. (Even great titled heads lived for a year on half that sum; fifty thousand livres per annum was a lavish income for the times.) She loved jewelry: her earrings of clusters of pearl-shaped diamonds from Charles Boehmer, the crown jeweler, cost 400,000 livres; her diamond bracelets cost 100,000 livres apiece. The Austrian ambassador at the French court tried to warn against these extravagances. "I did not conceal from Her Majesty," he wrote to Maria Theresa, "that under the present economic conditions it would have been wiser to avoid such a tremendous expenditure. But she could not resist—although she handled the purchases carefully, keeping them secret from the king." In any case no one could deny that the new queen looked utterly radiant in her magnificent clothes and jewels. "No woman ever carried her head better, and it was so set upon her shoulders that every movement she made was instinct with grace and

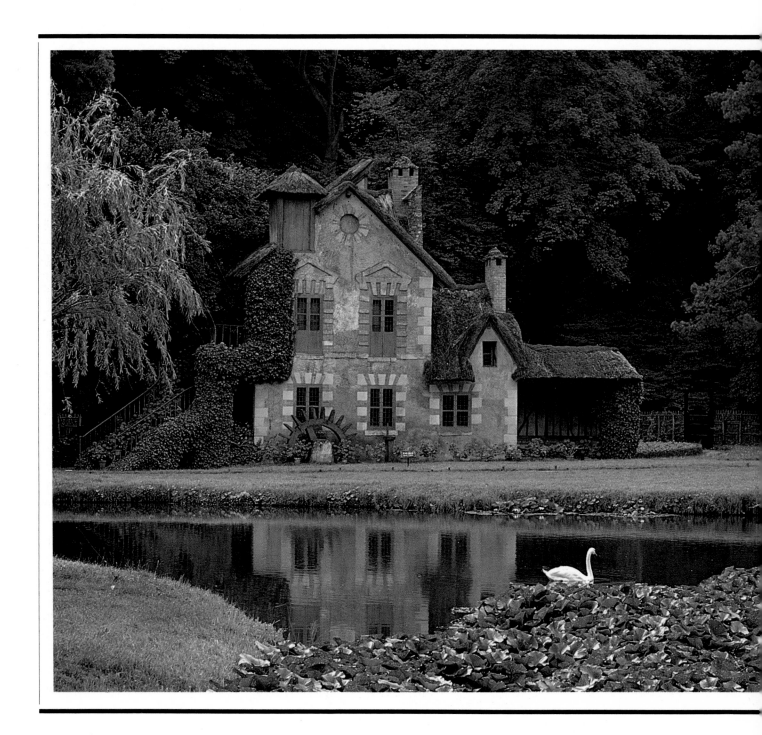

A ROYAL RETREAT

Marie Antoinette's reputation as a libertine, which she acquired not long after arriving at Versailles, was fueled largely by her desire for privacy. She found the French court insufferably stilted and soon embraced new attitudes, sparked by the philosopher Jean Jacques Rousseau, who urged a return to the simple life. As a stunning expression of this pastoral fantasy, Marie had a miniature village built on lush landscaped grounds in a corner of the park at Versailles. Designed by Richard Mique, her favorite architect, the *Hameau*, or hamlet, contained a house for the queen surrounded by thatched cottages, a barn and stables, a dairy, and a picturesque water mill (at left). It was a working farm, stocked with animals and managed by local peasants. The bucolic facade, however, veiled some palatial extravagances. The little house was decorated inside with elegant tapestries and furniture, while the dairy had marble walls and tables, and implements of fine porcelain for making butter and cheese.

In this contrived and secluded paradise, Marie liked to play the role of a country squire's wife. Dressed simply in white muslin, she would come with her children to feed the animals and carry milk. Here, too, she presided over gatherings of her favorites, a small coterie who banished serious talk for laughter, flirtation, and childish games.

The queen's circle caused deep resentment among the many excluded from it. In time these embittered aristocrats unloosed torrents of rumors, and Marie, who actually was rather prudish, stood accused of every sort of sexual excess. To the populace the Hameau became a symbol of waste and corruption and, like the queen herself, a focus for the discontent that boiled over into revolution.

nobility," wrote a perceptive official who was also a historian, Sénac de Meilhan. "Her gait was stately, yet light...and there was in her person a still rarer quality—the union of grace and of the most imposing dignity."

She had been brought up in the relative austerity of the Hapsburg household in Vienna, but now she seemed to be "drunk with the extravagance of this country," as her brother Joseph reported after a visit to Versailles. At least part of the problem was that she was impulsively generous, rewarding her favorite ladies-in-waiting with immense sums of money from the royal treasury. The princesse de Lamballe became superintendent of the queen's household at a salary of 150,000 livres. The impoverished comtesse de Polignac received 400,000 livres to pay her debts and 800,000 livres as a dowry for her daughter, as well as a dukedom for her husband.

But the queen was also eager to accomplish great projects of her own and to leave her mark on the great cumulative monument of Versailles. A woman of energy and taste, she set to work creating gardens with artificial ruins, grottoes, cascades, pavilions—the newly fashionable "delight in disorder" of the English garden. She built an imitation peasant village, the *Hameau*, where she could while away the hours in rustic simplicity playing milkmaid.

But the garden party she gave to inaugurate the Trianon gardens cost 200,000 livres. She had dressed the band of her Guards regiment in Chinese costumes for the occasion; a thousand Chinese lanterns provided the illumination, and a troupe of actors from the Comédie Française played charades for her guests on an open-air stage. All this, unfortunately, cost more and more money at a time when the French government's finances were in perpetual disarray On the eve of the Revolution, the royal family's household staff of 15,000 people, both military and civilian, accounted for about 13 percent of the total national budget—and interest payments on the national debt had risen to 300 million livres per year: a sum so great as to be meaningless, and the deficit rose annually.

Louis XVI and Marie Antoinette eventually had children, and the future of the dynasty seemed assured. But the well-meaning,

incompetent king was merely perplexed by his situation at the head of an autocratic government that had ceased to function properly. In the absence of an intelligent policy for dealing with the economic and social problems of the day, the court took refuge in outmoded forms of pomp and circumstance inherited from the days of Louis XIV. As a result Versailles and its inhabitants became all the more isolated from the real needs and desires of the nation. The Enlightenment had arrived, with its very definite ideas concerning the rights of man, yet Louis XVI continued to lead the life of a king who ruled by divine right. Like his forebears he was passionately fond of hunting, but unlike them he spent his happiest hours making locks and iron boxes in an attic workshop that had been set up for him by the master locksmith, who was his tutor.

People from the outside world who came to see them realized that the royal couple were trapped by court etiquette. The English traveler Arthur Young was struck by their unhappy situation when he visited their "island," Versailles, in May 1787. The royal couple, for example, were forced to dine ceremonially in public each day, as the kings of France had done since the Middle Ages. "The ceremony of the King's dining in public is more odd than splendid," Young noted in his diary. "The Queen sat by him with a cover before her, but ate nothing. . . . To me it would have been a most uncomfortable meal, and were I a sovereign I would sweep away three-fourths of these stupid forms. . . ."

It was an era of steadily worsening financial crises, traceable mainly to government mismanagement, since the resources of France were greater than those of any other continental nation. French merchants were growing rich on the profits of a triangular trade that brought slave-grown sugar, coffee, and other products from the Caribbean colonies of Haiti, Guadalupe, and Martinique to be processed at Nantes, Bordeaux, and Rochefort, then re-exported to central and northern Europe. At the same time, native French goods ranging from wine and flour to porcelain, textiles, and *articles de Paris* went both to the colonies and to other trading partners: by 1780 international exports accounted for nearly a quarter of the national

THE FLIGHT THAT FAILED

Louis XVI, disguised as a servant, shines a lantern to identify rescuer Axel Fersen in this dramatized engraving of the royal family's escape from their palace prison. In fact Louis, Marie Antoinette, and their children went separately to Fersen's carriage.

In October 1789 a mob stormed Versailles and forced the royal family to move into the Tuileries, a partially abandoned wing of the Louvre. There they lived as semiprisoners until the king grew desperate. He turned for help, ironically, to Marie Antoinette's most fervent admirer, a handsome Swedish count named Axel Fersen. Though probably not her lover, Fersen was in love with the queen and agreed to help plot and finance an escape.

Louis decided to go to northeastern France, where a loyal general, the marquis de Bouillé, commanded a large force. By smuggled notes Louis arranged with him for protection along

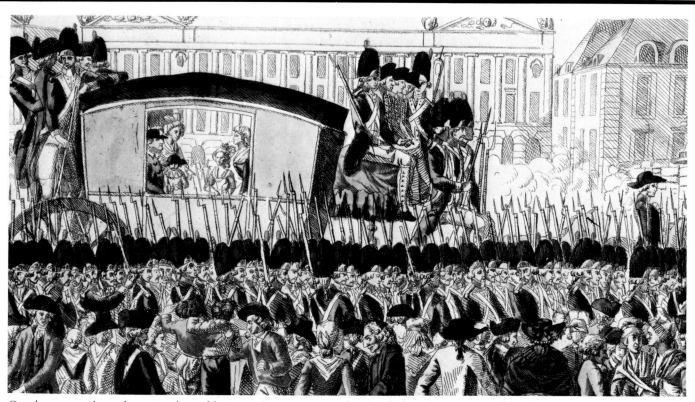

Guardsmen escort the coach returning the royal fugitives to Paris, as spectators show their disrespect by refusing to doff their hats.

the last leg of the route. Fersen ordered a coach built, elegantly outfitted and large enough for the entire family. He also brought them wigs and clothes for disguises; and after several delays they chose the night of June 20, 1791, to make the run.

Fersen, driving a hack, picked up the royal children and their governess first, then the king's sister. About midnight Louis joined them, followed by the queen. Once outside Paris the fugitives transferred to the new coach, bid a grateful farewell to the count, and lumbered off expectantly toward Pont de Sommevelle, 110 miles away, where the first

of the military escorts was to meet them.

As day broke the runaways relaxed, chatting and enjoying the landscape. But up ahead in the village, the presence of unfamiliar troops nearly caused a riot. When the coach was four hours overdue—the result of several mishaps—the commander panicked and pulled out. He also sent a note down the line: "There is no sign the treasure will pass today."

Thus when Louis arrived the whole district was in a state of alarm, and the escorts had evaporated. "I felt," the king later recalled, "as though the earth had been pulled from under me." Moreover, the handsome coach attracted

attention everywhere, until a townsman named Drouet finally recognized the occupants and gave chase.

In darkness again, at a bridge outside the town of Varennes, the bid for freedom came to an end. Drouet overtook the coach and alerted the National Guard, who blocked the path and forced the passengers out. The next day the coach was turned around. For four days it wound through the countryside so the French people could see the captives. At last on June 25, as crowds filled the streets, France's royal family passed through the gates of Paris for the last time.

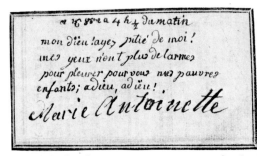

In a shaky hand, Marie Antoinette wrote this final note in her prayer book at four-thirty on the morning of her execution—October 16, 1793. "God have mercy upon me," she wrote, adding, "My eyes have no more tears to weep for you, my poor children."

income. Yet despite the inflow of wealth from abroad, a capricious system of taxation and an obsolete fiscal structure brought France, once again, to the brink of bankruptcy.

In a belated effort to economize, Marie Antoinette ceased buying costly jewelry. But Boehmer and Paul Bassenge, the crown jewelers, were unaware of her resolve. They put together the most magnificent diamond necklace of the century especially for her: a glittering masterpiece of large stones and small—637 diamonds weighing a total of 2,800 carats, with a row of large stones for the queen's shapely neck, then a triple chain of smaller diamonds to lie on her décolletage set off by strings of diamonds from which great clusters of pear-shaped ones were suspended. It had taken several years to assemble this treasure trove, priced at 1,600,000 livres. To Boehmer's dismay the queen refused to buy it: she was satisfied with the diamonds she already possessed. He offered the necklace to other royal clients, but none of the foreign monarchs could afford it either.

Yet an object of this kind generates momentum of its own. A gang of clever swindlers, headed by an unscrupulous pair, the comte and comtesse de La Motte, persuaded the powerful prelate cardinal de Rohan, that the queen wanted him to act as her intermediary in purchasing the necklace. Rohan received the diamonds from Boehmer, against a purchase contract on which Marie Antoinette's signature had been forged. However, the liveried royal messenger who came to call for it was not the queen's emissary but a confederate of the comte and comtesse La Motte, who broke up the necklace and sold its diamonds to unsuspecting buyers in France and England.

When the theft was discovered, in August 1785, Louis XVI had Rohan arrested and imprisoned in the ancient tower of the Bastille. His trial caused a sensation, for most people believed that he had tried to seduce and bribe the queen. Eventually he was acquitted, but the comtesse de La Motte was found guilty and sentenced to be flogged and beaten—naked—and to be branded on both shoulders with the letter V (for *voleuse*, "thief"). This medieval punishment turned the Paris mobs against the queen when they witnessed it in the courtyard of the Palais de Justice. As an eyewitness wrote:

Her whole body was revealed—her superb body, so exquisitely proportioned
.... The prisoner slipping from his grasp, the executioner—branding-iron in
hand—had to follow her as she writhed and rolled across the paving
stones.... The delicate flesh sizzled under the red-hot iron. A light bluish
vapor floated about her loosened hair. At that moment her entire body was
seized with a convulsion so violent that the second letter V was applied not on
her shoulder but on her breast, her beautiful breast.

The whole episode was a terrifying reminder of the absolute power
still wielded by the state under an obsolescent monarchy, and it
played a key role in preparing public opinion for the eventual trial
and execution of the king and queen. Indeed, no less acute an
observer than Napoleon Bonaparte, who was at this time an officer
in the royal army, afterward dated the beginning of the French
Revolution from the Affair of the Diamond Necklace. In any event
three years later the long-suppressed political energies of France
erupted against the ancien régime, which was found to have few
supporters even among the aristocracy. Actually there were two
revolutions: that of the lawyers and legislators of the newly con-
stituted national assembly, and that of the Paris working men and
women who stormed the Bastille in July 1789, and in October
converged on Versailles to bring the royal family back to Paris, to live
as virtual prisoners in the Tuileries palace.

In June 1791 Louis and his family tried to escape to Germany,
where an army of French émigrés was being mustered. They were
caught en route and later were tried for treason as the leadership of
the Revolution passed by stages from the moderates to the Jac-
obins—the radical party. After the king's execution in 1793—he
went to the guillotine as Louis Capet—it was Marie Antoinette's
turn to stand trial for counterrevolutionary activities. To satisfy the
hatred of her Jacobin accusers, she was also charged with having
instigated massacres and committed incest with her son, the four-
teen-year-old dauphin. The matter of the fateful necklace came up
again during her brief trial: "The woman La Motte... was she not
your victim in that deplorable affair?" She was questioned, too,
about her enormous expenses.

*The condemned queen, haggard but erect, rides with
her hands bound en route to the guillotine in this
eyewitness sketch. Her body was consigned to an
unmarked grave in the same cemetery where her
husband's had been buried nine months earlier.*

"Who paid for those fetes and entertainments at which you were the chatelaine?"

"It came from a special fund."

"It must have been a very large fund...."

She refused to admit any wrongdoing and went upright and unrepentant to her execution in the Place de la Révolution, once called the Place Louis XV. Even her enemies were forced to admit that "the jade went to the scaffold without flinching."

In the course of the Revolution the royal treasure vaults were robbed of many of their most valuable contents. The wholesale looting and burning of palaces was followed by great public auctions of royal property—though many objets d'art were simply destroyed by the mob as hated symbols of the ancien régime. Some of the missing treasures later reappeared in other contexts: the Sancy Diamond turned up in the collection of the Russian princess Demidov in 1838, the Sèvres dinner service commissioned by the luckless Louis for his own use ended up in the collection of King George IV of Great Britain, and the Hope Diamond reposes in the Smithsonian Institution in Washington, D.C.

Yet postrevolutionary France still had need of such treasures as emblems of its continuing wealth and prestige. Napoleon, the onetime revolutionary-turned-revisionist, knew how to employ such things in enhancing his image as emperor of France, and he designated the Louvre as the centerpiece of the great national collections of France. But somehow it was never quite the same after the Revolution: the treasures of the Napoleonic empire were self-conscious imitations, inspired by the imagined glories of another age. Henceforth everything produced in this genre was an evocation of something that had gone before: neo-Grecian, neo-Roman, neo-classic, neo-rococo. The myth of French kingship had been destroyed, and no one would ever be able to recapture the intrinsic magic of the treasures that had been made for kings under the old dispensation—the excellence, the boldness, the power of treasures meant for those who valued and caressed them, even as they held in their hands the destinies of France.

A QUEEN'S
FRIVOLITIES

Serpents of gilt bronze form the handles on this rock crystal goblet of Marie Antoinette's, who demanded elegance even in a utilitarian object only four and a half inches high.

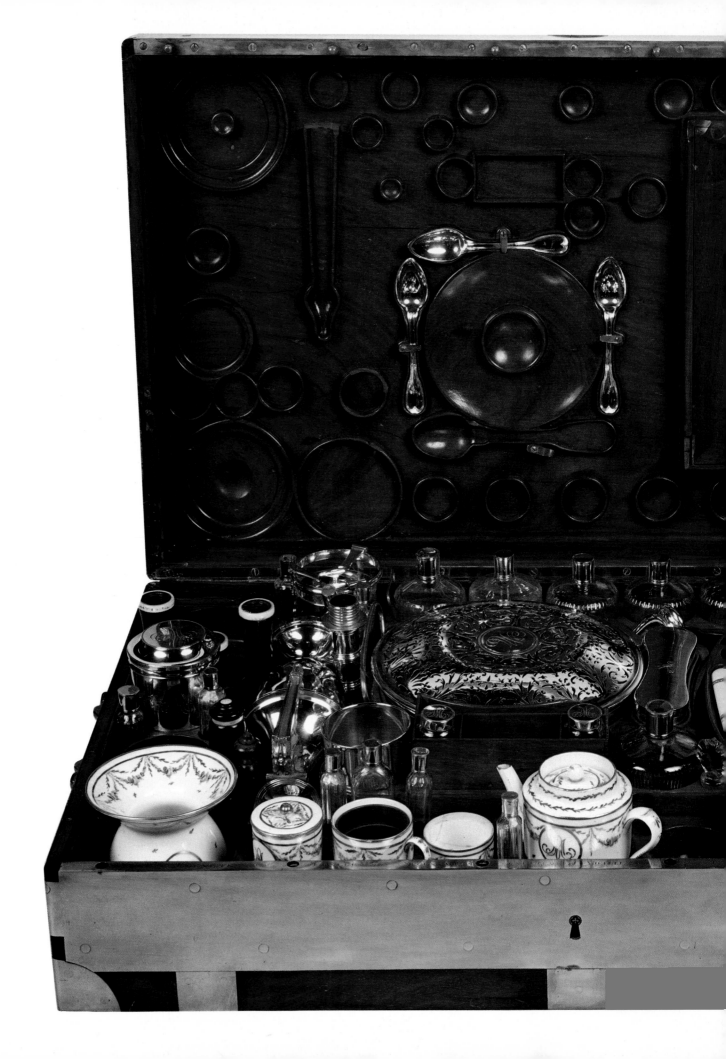

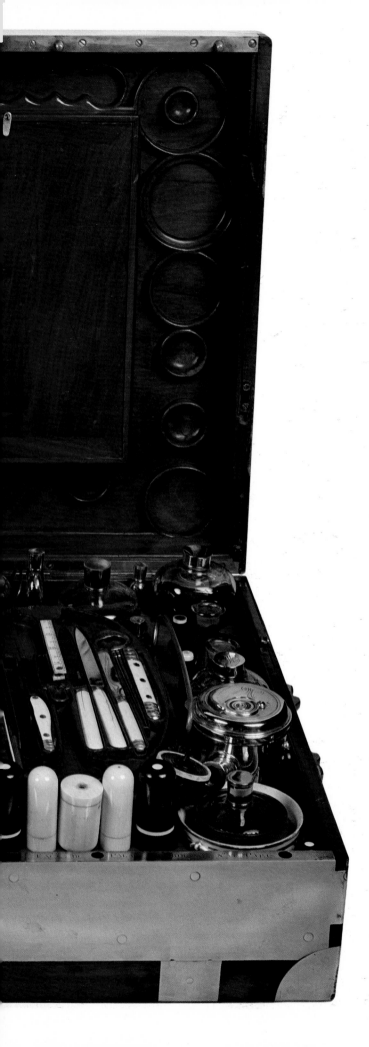

"Try to save my poor Versailles," Louis XVI beseeched an officer as the Parisian horde escorted him, Marie Antoinette, and their children into captivity in 1789. His plea was only partly successful. The buildings themselves did remain largely unscathed. But shortly after the family's coach departed, some two thousand carriages followed, filled with royal furnishings, books, art, and ornaments—to be dismantled, melted down, or sold.

From then on, starting at the bare and gloomy Tuileries, the royal family's freedom rapidly diminished—a process all of them bore with great dignity. Probably Marie Antoinette suffered the most, for in the end everything she held dear was taken from her. Invading crowds seized most of her clothes and all of her jewelry. Six weeks before the king's execution, the couple were separated until the eve of his death. And several months before she went to the guillotine, the regime separated Marie from her son and daughter. The queen who so loved her family and friends spent her last days in solitary confinement, with so few possessions that she did not trouble, as Louis had, to make out a will.

The objects here and on the following pages are among the handful of her personal treasures to survive. Some reflect Marie's taste for fine craftsmanship in furnishing her various rooms at Versailles. Others, ironically, are gifts from the people of France to their queen. Together they are poignant reminders of a naive monarch, of her pleasures, and of a dynasty's final surge of extravagance before the Reign of Terror arrived to take its place.

Marie Antoinette acquired this portable dressing case, called a nécessaire, *about 1787. Made of mahogany and brass, it contains no less than eighty-six little conveniences, among them sets of china and silverware, goblets, perfume bottles, mirrors, a bed warmer, manicure and sewing accessories, a mortar and pestle, and pots for cooking chocolate.*

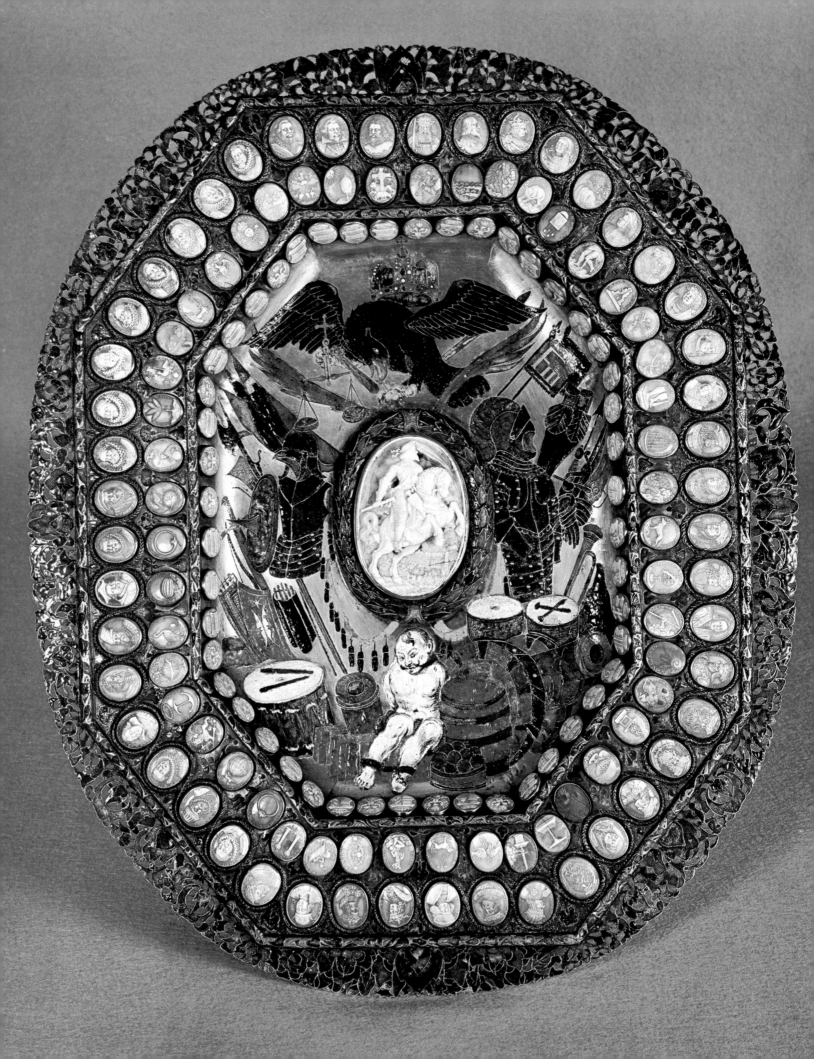

Resting on goat's-head stands, these breast-shaped bowls of Sèvres porcelain, about five inches high, reflect both the ribaldry and back-to-nature craze fashionable in the queen's circle. Marie Antoinette ordered them for one of her dairies, where visitors would fill them with milk. During the Revolution these novelties were rumored wrongly to have been modeled after the queen's own breasts.

One hundred forty-four cameos, engraved on sea-shells, adorn the seventeenth-century gilt and enamel tray, opposite, that Marie Antoinette acquired from her family in Austria. The portraits are all of princes of the House of Hapsburg, Austria's ruling dynasty, and the equestrian in the oval centerpiece is Emperor Ferdinand III, Marie's great-great-grandfather. Around his image are symbols of the Hapsburgs and their might: a fierce eagle, soldiers, drums, and a naked figure bound in leg-irons.

The queen reputedly received this layette box, in-
tended to hold a baby's garments, as a gift from the
city of Paris in honor of the birth of the dauphin,
Louis-Joseph, on October 22, 1781. About twenty-
seven inches long, the box is entirely wrapped in
white silk taffeta, which an artist covered with realis-
tic and allegorical scenes. The scene on the front base
portrays dancers in a pastoral setting, while the lid
bears cherubs frolicking around the queen's initials.

This gold and enamel boîte à portrait (box with a portrait), which features the queen's likeness on the lid and pastoral scenes on the body, was probably a gift from Marie to a favorite.

A delicately painted scene of a youthful couple graces the back of the gold and enamel watch (opposite), which hangs from a chatelaine—a chain ornamented with small plaques and usually worn at the waist. The queen made a present of the elegant timepiece to Madame de Tourzel, the governess who was imprisoned with the royal family.

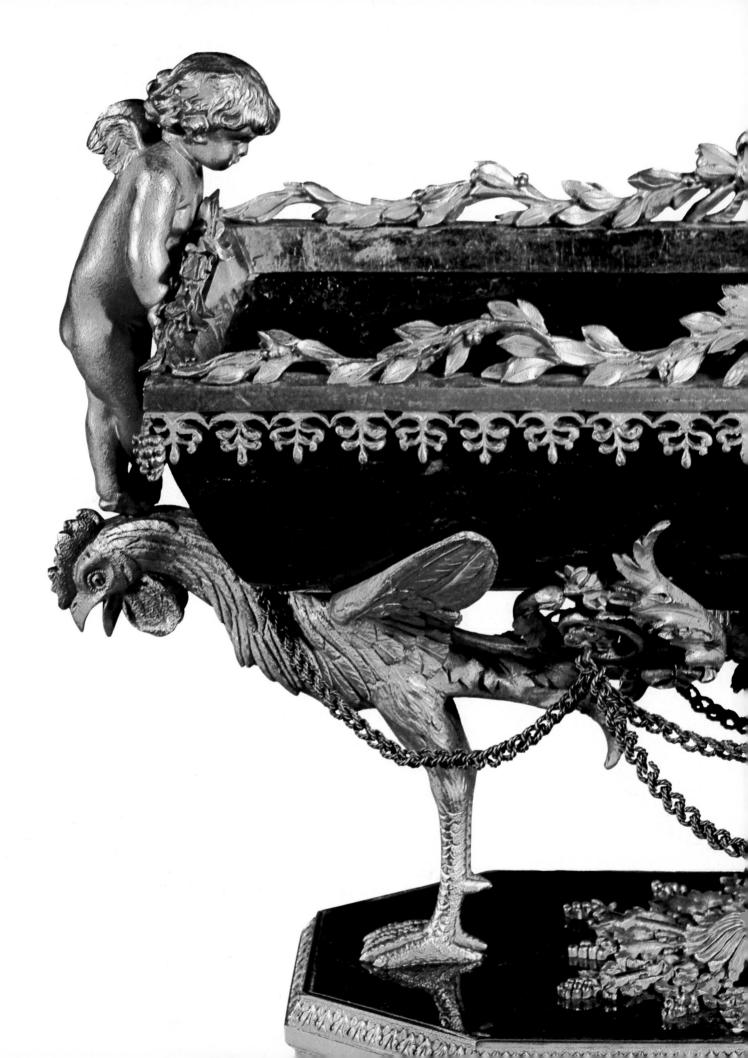

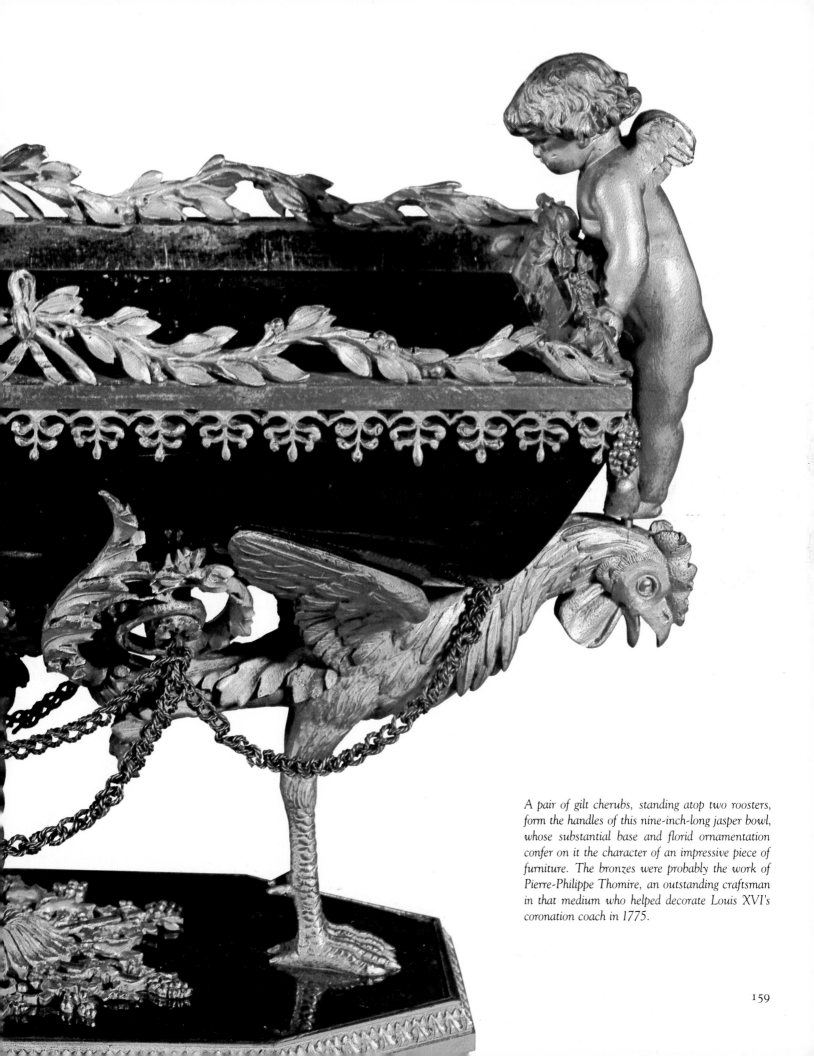

A pair of gilt cherubs, standing atop two roosters, form the handles of this nine-inch-long jasper bowl, whose substantial base and florid ornamentation confer on it the character of an impressive piece of furniture. The bronzes were probably the work of Pierre-Philippe Thomire, an outstanding craftsman in that medium who helped decorate Louis XVI's coronation coach in 1775.

To commemorate the dauphin's birth, Parisians gave the queen this musical clock of gilt bronze. Its decorative sculptures, in detail at right, include a rooster that symbolizes France; books that represent knowledge; a flag; and a winged staff that stands for prosperity. Below the dial an allegorical scene portrays Fertility handing the dauphin to a kneeling woman who represents France.

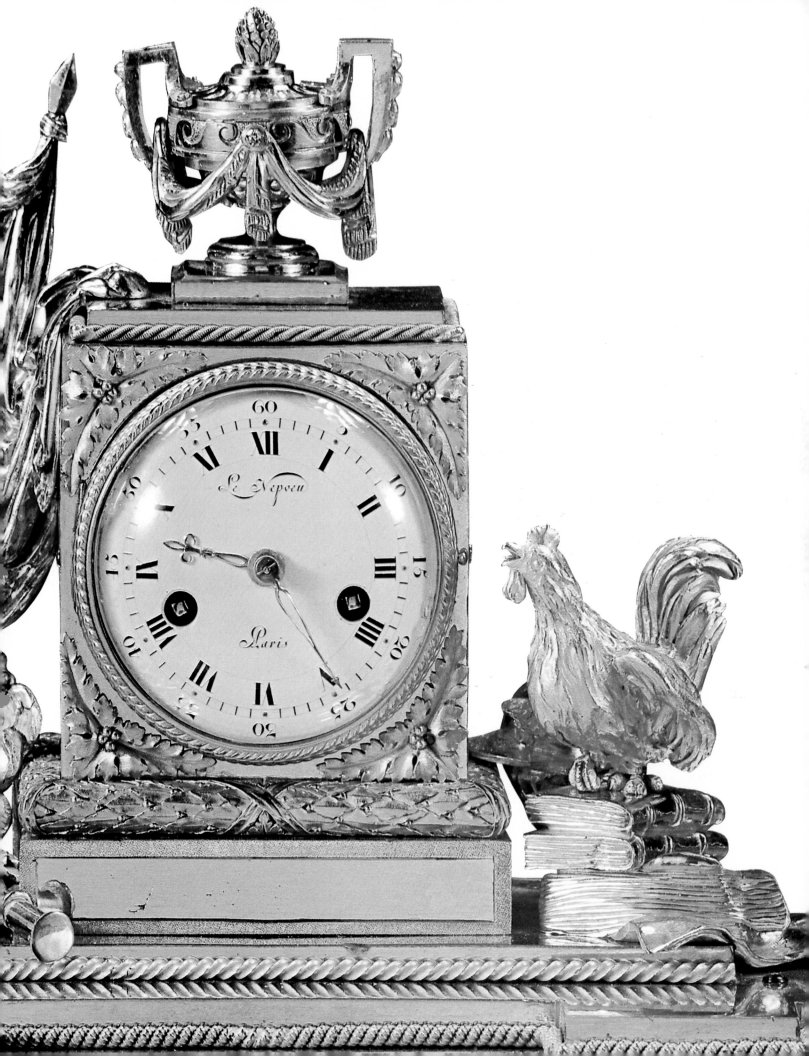

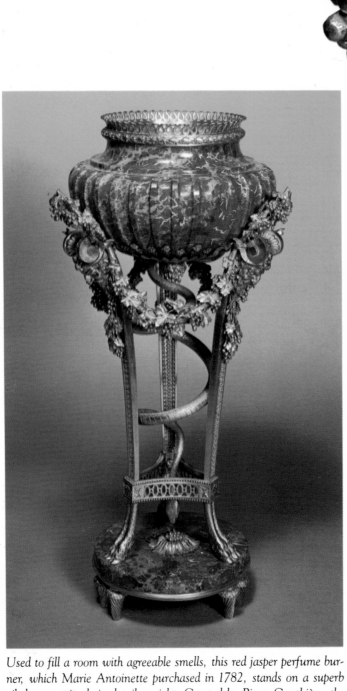

Used to fill a room with agreeable smells, this red jasper perfume bur-
ner, which Marie Antoinette purchased in 1782, stands on a superb
gilt-bronze tripod, in detail at right. Created by Pierre Gouthière, the
greatest craftsman of ornamental bronzes during Louis XVI's reign, it
bears chased leaf clusters and sculpted heads on each support and a
sinuous serpent entwined inside the legs.

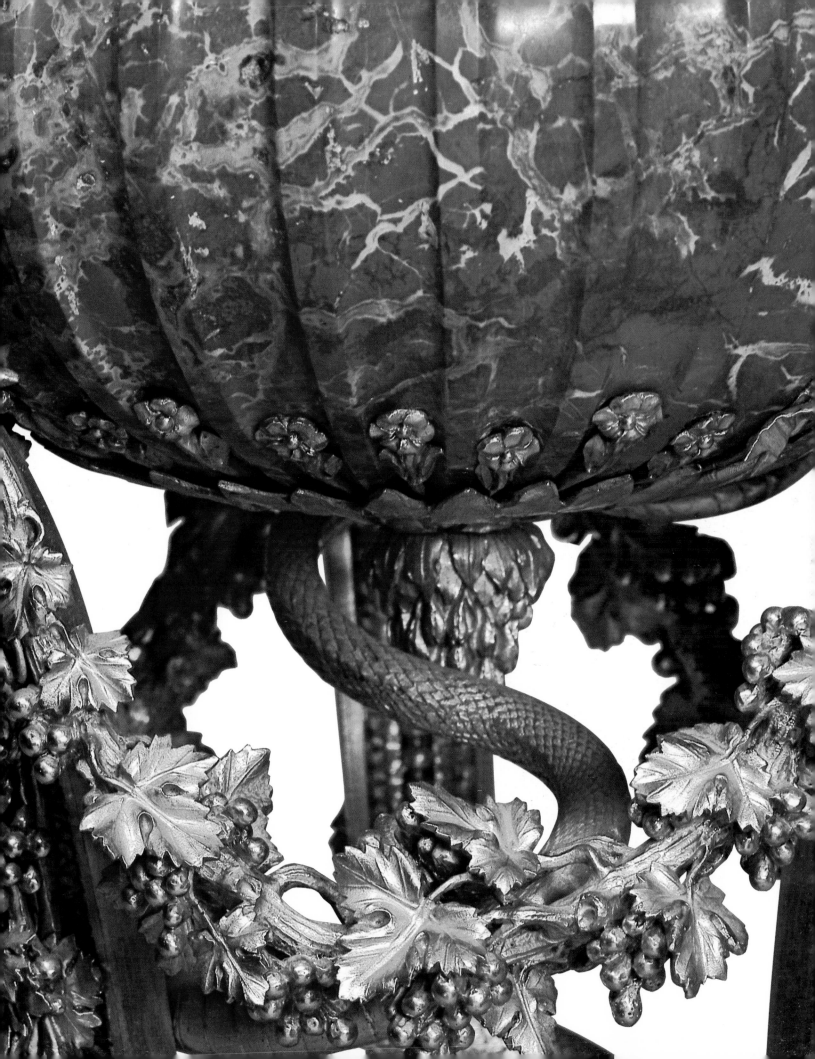

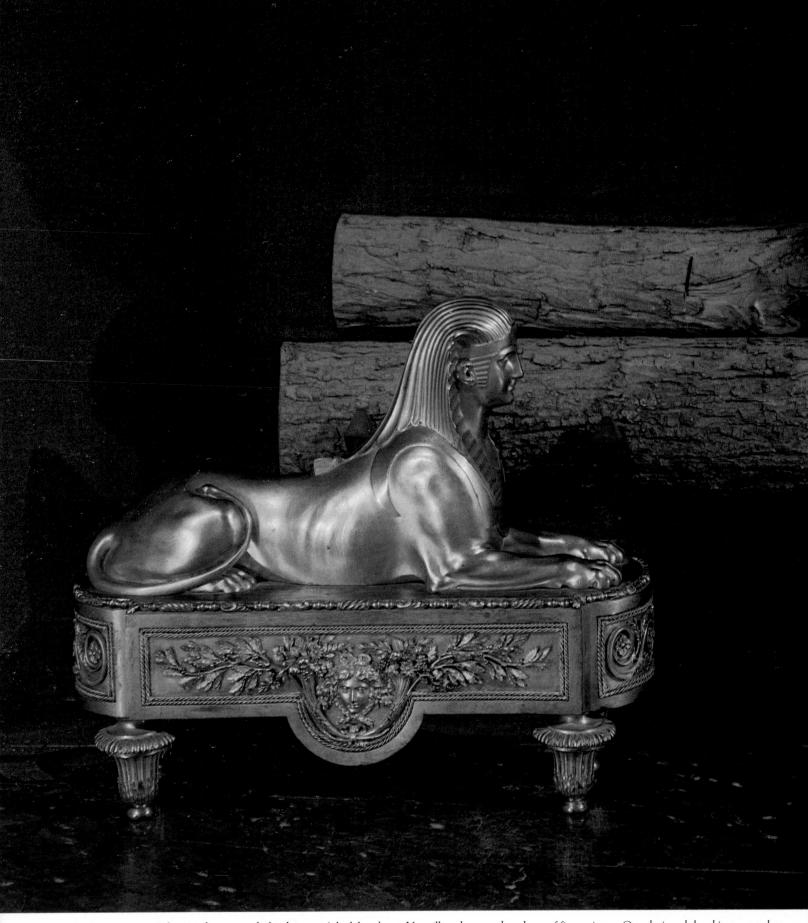

Sphinx andirons, made for the queen's bedchamber at Versailles, drew on the talents of five artisans. One designed the objects, another

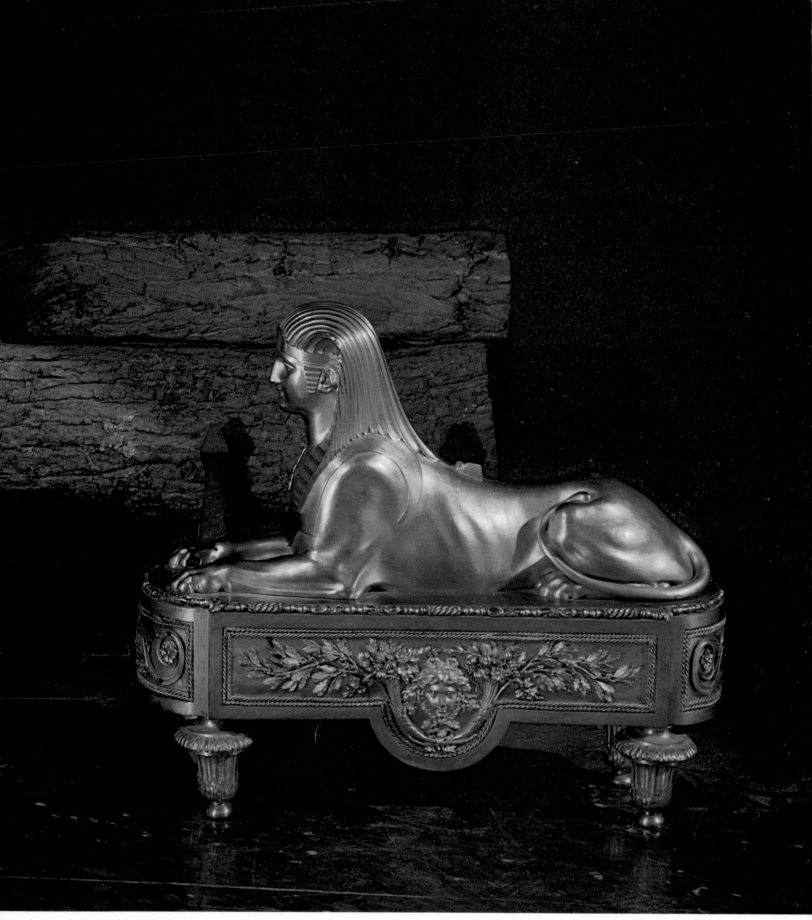

fashioned clay models, a third crafted molds for casting them in bronze, a fourth gilded them, and a fifth chased and polished them.

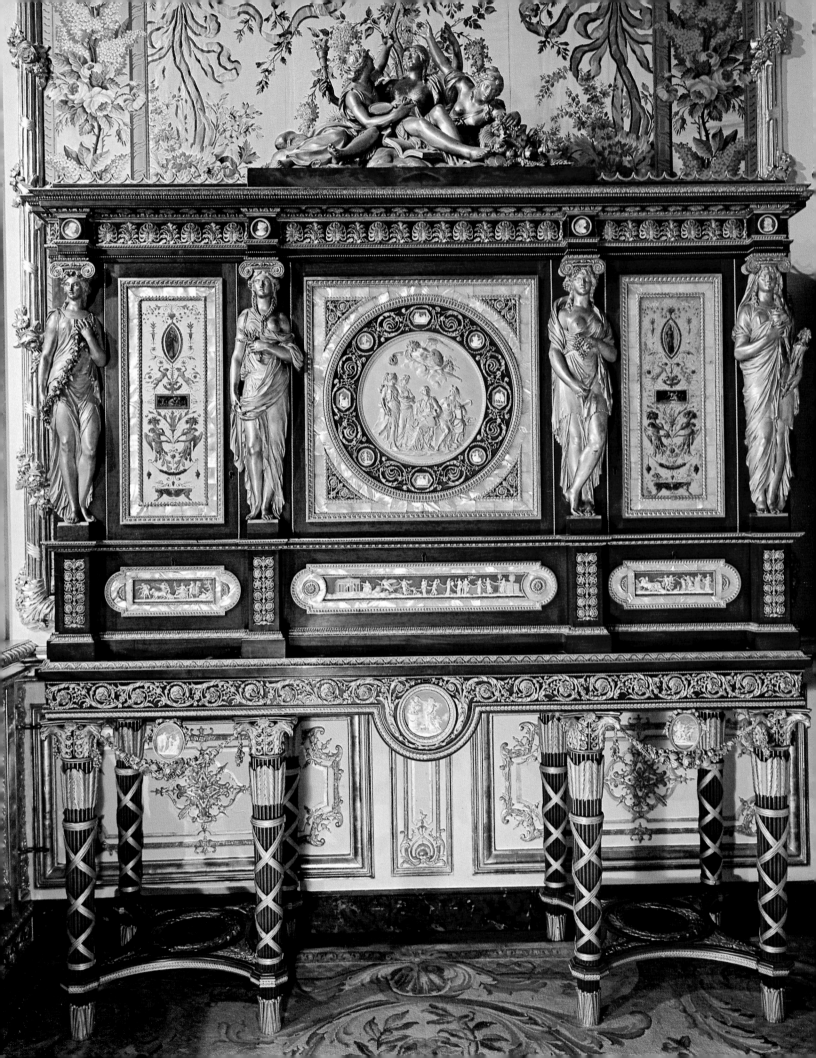

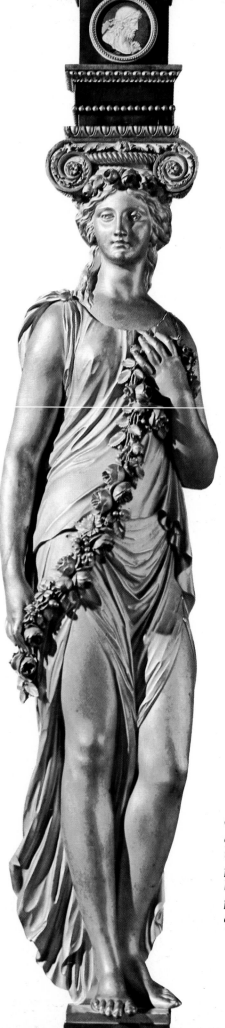

Nearly nine feet tall, the immense jewel cabinet (opposite), part of the queen's furnishings, boasts a mahogany veneer that all but disappears under the lavish adornments of painted glass panels, Sèvres porcelain medallions, mother-of-pearl inlay, splendid ornamental reliefs, and figures in gilt bronze (in detail at right) that represent the four seasons. A master cabinetmaker, Ferdinand Schwerdfeger, executed the design, and the city of Paris presented the sumptuous article to Marie Antoinette in 1787.

OVERLEAF: A gilt-trimmed ceiling, hangings of silk, a gilded bed rail, and family portraits are among the luxuries in the queen's bedchamber, now completely restored. Here Marie Antoinette spent her last night at Versailles. After the royal family departed on October 6, 1789, the palace was shuttered and closed, never again to be inhabited by royalty.

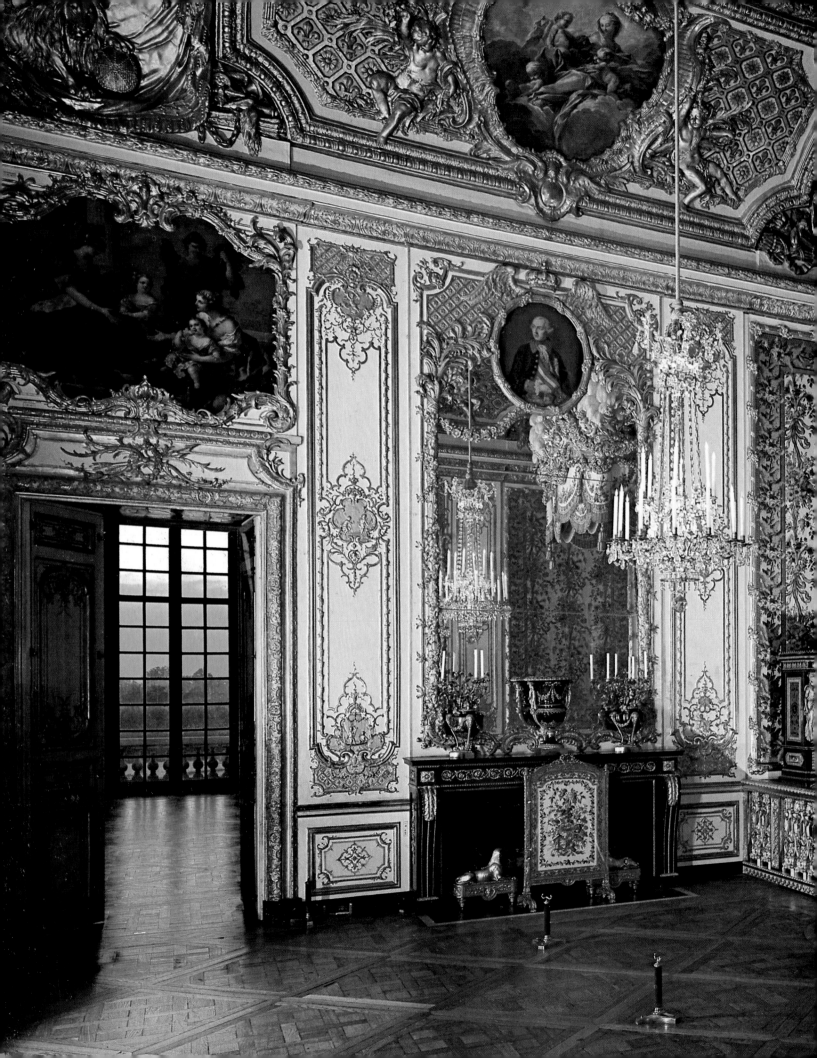

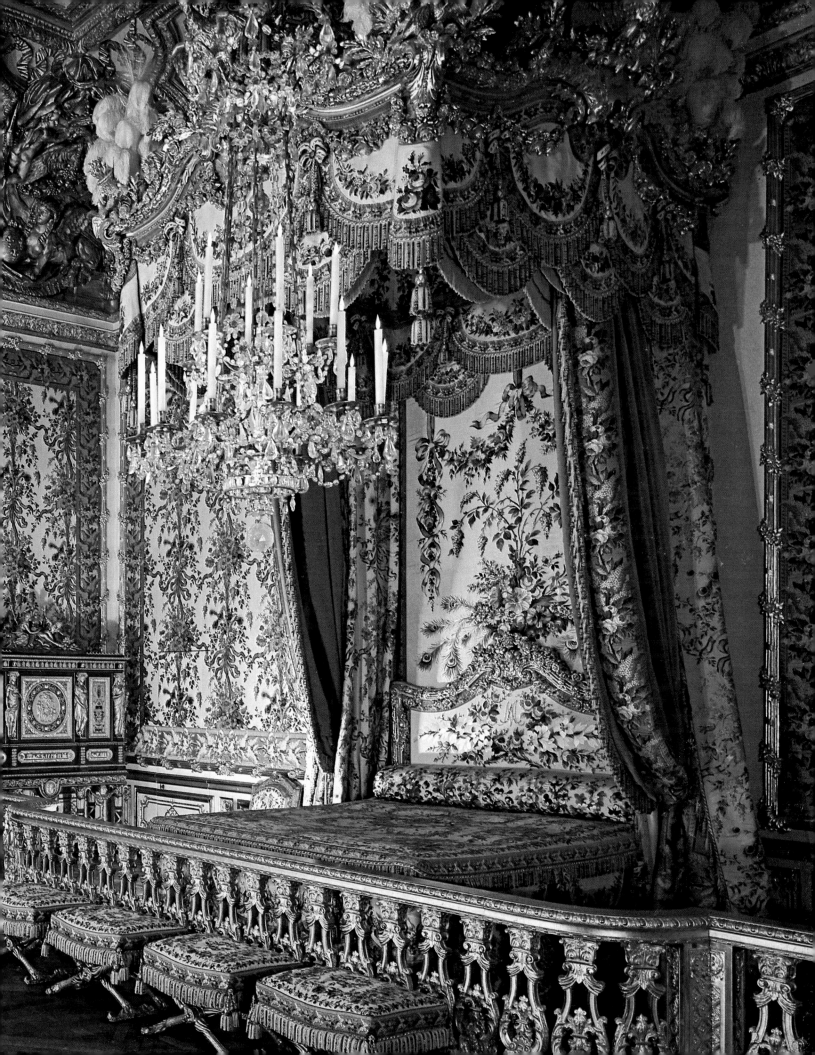

FRANCE: A CHRONOLOGY

		EVENTS			ART AND ARCHITECTURE
CAROLINGIANS	r. 768–814	Charlemagne, king of the Franks			
	778	Charlemagne invades northern Spain, inspiring later poem "Song of Roland"			
				794	Aachen chapel and palace built
	800	Charlemagne crowned Holy Roman Emperor		c. 800	Ecclesiastical art and religious icons venerated and patronized by Charlemagne
CAPETIANS	r. 987–996	Hugues Capet			
	1066	William, duke of Normandy, conquers England			
				1110	"Song of Roland" written
				c. 1150	Charlemagne's gilded reliquary made
				1163	Notre Dame cathedral begun
	r. 1180–1223	Philip Augustus (Philip II)			
				1194	Chartres cathedral begun
				c. 1200	Louvre palace begun
	r. 1223–1226	Louis VIII			
	r. 1226–1270	Louis IX			
	r. 1285–1314	Philip the Fair (Philip IV)			
HOUSE OF VALOIS	1338	Outbreak of the Hundred Years' War			
	1346	French defeated at Crécy			
	r. 1422–1461	Charles VII			
	1431	Jeanne d'Arc burned at the stake at Rouen			
	r. 1461–1483	Louis XI			
	r. 1498–1515	Louis XII			
	r. 1515–1547	François I			
	1515	Battle of Marignano; François I wins duchy of Milan			
				1516–1519	Leonardo da Vinci "First Painter, Engineer, and Architect" to François I
				1519	François I acquires *Mona Lisa*
	1520	François I and Henry VIII of England meet at the Field of the Cloth of Gold			
	1525	Battle of Pavia; captivity of François I			
				1528	Palace at Fontainebleau begun
					Baldassare Castiglione's *The Courtier*
	1533	Henri (II) weds Cathérine de Médicis		1533	François Rabelais's *Pantagruel*
				1533–1537	Gallery of Ulysses built at Fontainebleau
				c. 1540	The Lion Armor suit made for François I by the Negroli armory of Milan
					Benvenuto Cellini becomes court goldsmith and sculptor
				c. 1541	Cellini creates gold saltcellar for François I
				1541–1545	Francesco Primaticcio decorates rooms of Fontainebleau with stucco figures
	r. 1547–1559	Henri II		1547	Henri II gives Chenonceaux to Diane de Poitiers
	r. 1560–1574	Charles IX			
				1564	Tuileries palace begun under Cathérine de Médicis

EVENTS	ART AND ARCHITECTURE

HOUSE OF BOURBON

r. 1589–1610	Henri IV (of Navarre)
1600	Henri IV weds Marie de Médicis
r. 1610–1643	Louis XIII
1618	Thirty Years' War begins

1622	Peter Paul Rubens paints for Marie de Médicis

1624–1642	Cardinal Richelieu, prime minister
1635	France enters Thirty Years' War
1642–1661	Cardinal Mazarin, prime minister
r. 1643–1715	Louis XIV (Grand Monarque)
1653	Louis plays role of the Sun in *Ballet of the Night* and earns sobriquet the Sun King
1660	Louis XIV weds Maria Theresa of Spain

1661	Building of Versailles begun; Louis Le Vau, architect
1662	Louis XIV establishes Gobelins as royal manufactory

1664	*Les Plaisirs de l'Ile Enchanté* fete held at Versailles

1669	Versailles palace begun, with the Hall of Mirrors
c. 1670	Louis XIV installs his collection of treasures in the Gallery of Apollo at Louvre Molière, actor and playwright Jean Baptiste Racine, poet and playwright

1677	Louis XIV moves his court and government to Versailles

c. 1700	Hyacinthe Rigaud, portrait painter

1704	English defeat French at Blenheim
r. 1715–1774	Louis XV
1715–1722	Regency, under Philippe d'Orléans
1722–1726	Duc de Bourbon, prime minister
1725	Louis XV weds Maria Leszczynska
1726–1743	Cardinal Fleury, prime minister

c. 1730	Royal china factory produces Sèvres pottery

1740–1748	War of the Austrian Succession

c. 1750	Rococo style dominates art of the French court
1751	Denis Diderot's *Encyclopédie* published (co-edited with contributions by Montesquieu, Voltaire, and Rousseau)

1756–1763	Seven Years' War

1756	François Boucher paints *Madame de Pompadour*
1759	Voltaire's *Candide*
1760	Jean-François Oeben begins construction of Louis XV's desk
1762	Jean Jacques Rousseau's *The Social Contract*

1770	Louis (XVI) weds Marie Antoinette
r. 1774–1792	Louis XVI

c. 1780	Gilt-bronze, gold, and enamel objects and ornaments made for Marie Antoinette at Versailles The *Hameau*, designed by Richard Mique, is built for Marie Antoinette

1785	The Affair of the Diamond Necklace
1789	Storming of the Bastille
1791	Royal family attempts to flee France
1793	Louis and Marie Antoinette beheaded Reign of Terror begins

ACKNOWLEDGMENTS & CREDITS

Abbreviations:
MMA—Metropolitan Museum of Art, New York
RMN—Réunion des Musées Nationaux, Paris
BN—Bibliothèque Nationale, Paris

The editors are particularly grateful to Alice Jugie for her extensive picture research and coordination, and to Dmitri Kessel, Erich Lessing, Ann Münchow, Marc Riboud, and Nicolas Sapieha for special photography.

We would also like to thank the following for their assistance: Daniel Alcouffe, Conservateur, Département des Objets d'Art, Musée du Louvre, Paris; Marie Carousis, Clark Nelson Ltd., London; Deanna Cross, Photographic Services, MMA; R. Griffin, Keeper of the Collection, and Colonel A.R. Waller, Administrator, Waddesdon Manor, Aylesbury; Julia Harland, Lord Chamberlain's Office, London; Guy Kuraszewski, Chargé de Mission et de Documentation, and Pierre Lemoine, Conservateur, Musée des Chateaux de Versailles et de Trianon; W. J. Larkworthy, Wallace Collection, London; Dr. Manfred Leithe-Jasper, Kunsthistorisches Museum, Vienna; Dr. Herta Lepie, Schatzkammer, Aachen; Stuart W. Pyhrr, Associate Curator, Department of Arms and Armor, MMA; Russell Stockman, New York City; Germaine Tureau, Service de Documentation Photographique, RMN; Lavinia Wellicome, Curator, Woburn Abbey, Bedfordshire.

Maps by H. Shaw Borst
Endsheet design by Cockerell Bindery/TALAS

Cover: Candelier-Brumaire/Ziolo. 2: Ann Münchow, Aachen. 4–5: Bulloz. 6: MMA. 11: RMN. 12: Staatsarchiv, Koblenz. 13: BN. 15: Pierre Belzeaux, Time/Life Books. 16: Ann Münchow, Aachen. 17–19: BN. 21: Faillet/Ziolo. 22–27: Ann Münchow, Aachen. 28–29: Photo Meyer, Kunsthistorisches Museum, Vienna. 30: Vatican, Apostolic Library. 31: Victoria & Albert Museum, London. 32: Giraudon. 33: Photo Meyer, Kunsthistorisches Museum, Vienna. 34: Bulloz. 36: BN. 37: Bulloz. 38–39: New York Public Library. 40–45: Erich Lessing, Kunsthistorisches Museum, Vienna. 46–47: Copyright reserved, Collection of Her Majesty Queen Elizabeth II. 48: Bulloz. 49: Giraudon. 50: New York Public Library. 51: MMA. 52: Musée de l'Armée, Paris. 54–61: MMA. 62–63: RMN. 64: Nicolas Sapieha, New York. 66: BN. 67: Bulloz. 68: BN, Courtesy Newsweek Books. 70–71: RMN. 72: Ernst Heiniger, Zurich. 73: Claus Hansmann, Stockdorf. 74: RMN. 75: Claus Hansmann, Stockdorf. 76–77: Giraudon. 78: RMN. 79–88: Marc Riboud, Paris. 89–91: Rosine Mazin/Agence Top. 92–96: Marc Riboud, Paris. 97–103: Nicolas Sapieha, New York. 104: Dmitri Kessel, Paris. 105–107: Marc Riboud, Paris. 109: G. Nimatallah/Ziolo. 110–111: Giraudon. 112–113: Alte Pinakotech, Munich. 114–115: Giraudon. 116: Copyright reserved, Collection of Her Majesty Queen Elizabeth II. 117–120: Wallace Collection, London. 120–121: MMA. 121: National Trust, Waddesdon Manor. 122–123: EPA/Scala. 125: Giraudon. 126: Dmitri Kessel, Paris. 127: RMN. 128–137: Dmitri Kessel, Paris. 138: Bulloz. 140–141: Roger-Viollet. 142: Adam Woolfitt/Woodfin Camp. 144–147: Bulloz. 149–155: RMN. 156: Cleveland Museum of Art. 157: Giraudon. 158–161: RMN. 162–163: Wallace Collection, London. 164–169: Dmitri Kessel, Paris.

SUGGESTED READINGS

Bernier, Olivier, *Pleasure and Privilege.* Doubleday and Co., Inc., 1981.

Bollough, Donald, *The Age of Charlemagne.* Exeter Books, 1965.

Cronin, Vincent, *Louis & Antoinette.* William Morrow and Co., Inc., 1975.

Frégnac, Claude, *French Master Goldsmiths.* French and European Publications, Inc., 1966.

Guérard, Albert, *France.* The University of Michigan Press, 1969.

Law, Joy, *Fleur de Lys, The Kings and Queens of France.* McGraw-Hill Book Co., 1976.

Levron, Jacques, *Pompadour.* George Allen and Unwin Ltd., 1963.

Maurois, André, *An Illustrated History of France.* The Viking Press, 1957.

Meyer, Bernard S., ed., *Art Treasures in France.* McGraw-Hill Book Co., 1969.

Mitford, Nancy, *The Sun King.* Harper and Row, 1966.

Sedillot, René, *An Outline of French History.* Alfred A. Knopf, 1953.

Seward, Desmond, *The Bourbon Kings of France.* Constable, 1976.

Van der Kemp, Gerald, *Versailles.* The Vendome Press, 1978.

Wheeler, Daniel, *The Chateaux of France.* The Vendome Press, 1979.

INDEX

Page numbers in **boldface type** refer to illustrations and captions.